THE ART OF Disney ZOOTOPIA

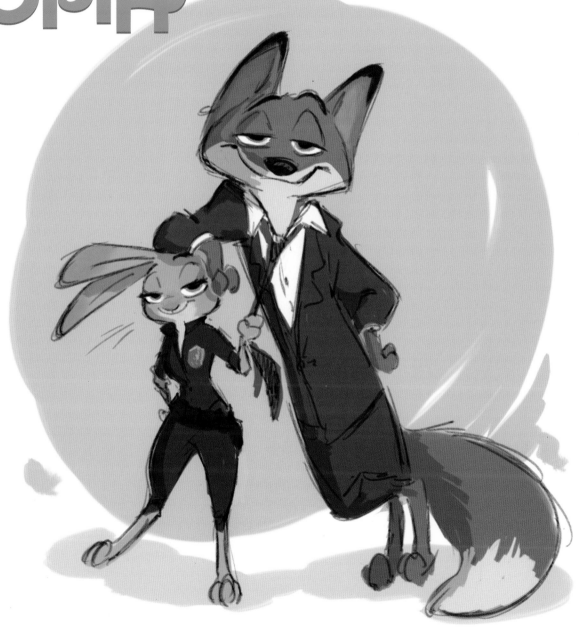

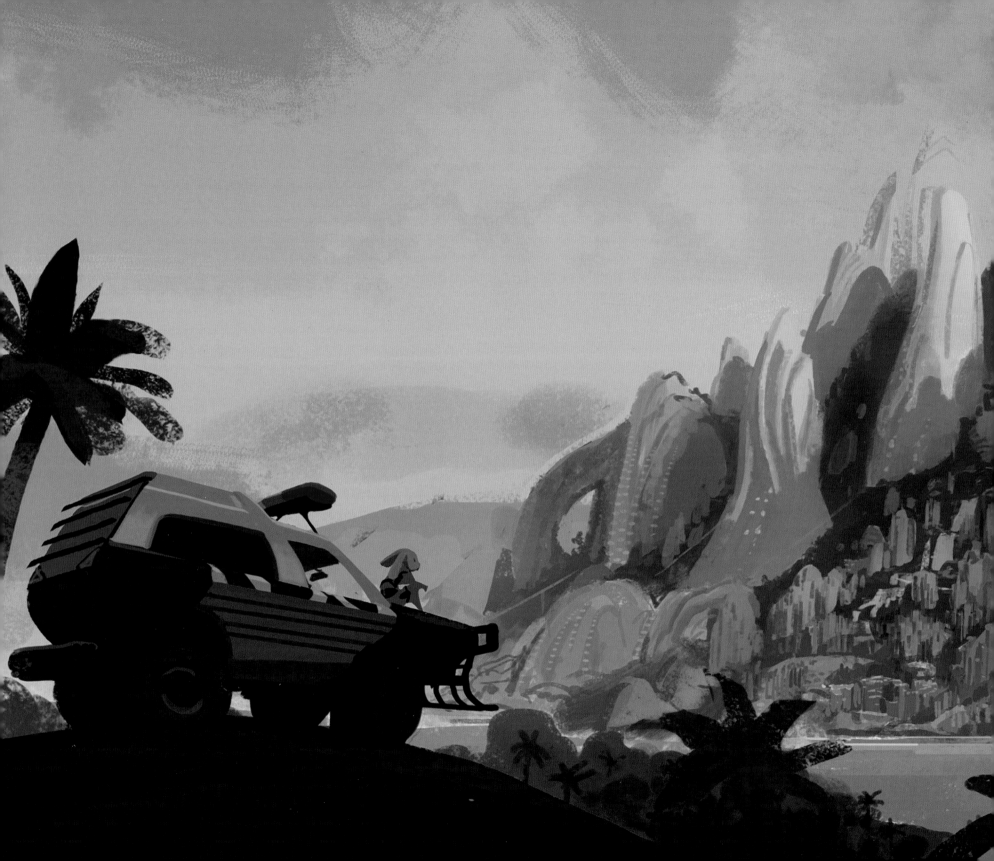

THE ART OF Disney ZOOTOPIA

By Jessica Julius

Preface by John Lasseter

Foreword by Byron Howard and Rich Moore

CHRONICLE BOOKS

SAN FRANCISCO

Creating an animated film involves years of inspired collaboration and the highest levels of artistry. Before the final rendered images of *Zootopia* were seen on screens around the world, the following artists contributed their talents to the digital images included in this book:

DIRECTORS
Byron Howard Rich Moore

WRITER & CO-DIRECTOR
Jared Bush

VISUAL DEVELOPMENT
Brett Albert
Manu Arenas
Dale Baer
Marty Baumann
Dan Cooper
Justin Cram
Jim Finn
Mac George
Andy Harkness
Shiyoon Kim
Matthias Lechner
Brittney Lee
Cory Loftis
Jim Martin
J Mays
Borja Montoro
Nick Orsi
Bill Schwab
Armand Serrano
Jennifer Stratton
Scott Watanabe
Victoria Ying

RIGGING
Bret Bays
Adam Cobabe
Iker de los Mozos Anton
Jennifer Downs
Joy Johnson
Christoffer Pedersen
Nicklas Puetz
Matthew Schiller

STORY
Paul Briggs
Jason Hand
Chris Hubbard
Nancy Kruse
Lauren MacMullen
Steve Markowski
John Ripa
Fawn Veerasunthorn

MODELING
Chris Anderson
Virgilio John Aquino
Sergi Caballer Garcia
Kevin Hudson
Suzan Kim
Jon Krummel
Brandon Lawless
Irene Matar
Florian Perret
Alena Wooten

ANIMATION
Darrin Butters
Youngjae Choi
Nathan Engelhardt
Mario Furmanczyk
Jennifer Hager
Kira Lehtomaki
Chad Sellers
Joshua Slice
Tony Smeed

FX
Dong Joo Byun

LOOK
Ian Butterfield
Sara Cembalisty
Ramya Chidanand
Paula Goldstein
Benjamin Min Huang
Katherine Ipjian
Chelsea Lavertu
Konrad Lightner
Vicky Lin
Jared Reisweber
Mitchell Snary
Pamela Spertus
Dylan VanWormer

LIGHTING
Joan Anastas
Christopher Erickson
Gina Lawes
Roger Lee
Alex Nijmeh
Amol Sathe
Mark Siegel
Diana Zeng

CLOTH / HAIR SIM
Francois Coetzee
Erik Eulen
Avneet Kaur
Hubert Leo
Edward Robbins
Mary Twohig
Xinmin Zhao

TECHNICAL ANIMATION
Navin Pinto
Jason Robinson
Jason Stellwag
Esther Trilsch

DEPARTMENT LEADERSHIP
Nick Burkard
Renato dos Anjos
Moe El-Ali
Katie Fico
David Goetz
Bobby Huth
Hans-Joerg E. Keim
Scott Kersavage
Dave Komorowski
Brian Leach
John Murrah
Ernie Petti
Fabienne Rawley
Jim Reardon
Michelle Robinson
Claudia Chung Sanii
Tony Smeed
Matt Steele
Lance Summers
David Suroviec
Michael Talarico
Ryan Tottle
Josie Trinidad
Cesar Velazquez
Nathan Warner

Library of Congress Cataloging-in-Publication Data:
Julius, Jessica.
The art of Zootopia / by Jessica Julius ; preface by John Lasseter ; foreword by Byron Howard.
pages cm
ISBN 978-1-4521-2223-6
1. Zootopia (Motion picture)—Illustrations. 2. Animated films—United States. I. Title.
NC1766.U53Z665 2016
791.43'72--dc23
2015023753

Manufactured in China

MIX
Paper from
responsible sources
FSC™ C104723

Designed by Glen Nakasako, Smog Design, Inc.

10 9 8 7 6 5

Chronicle Books LLC
680 Second Street
San Francisco, California 94107
www.chroniclebooks.com

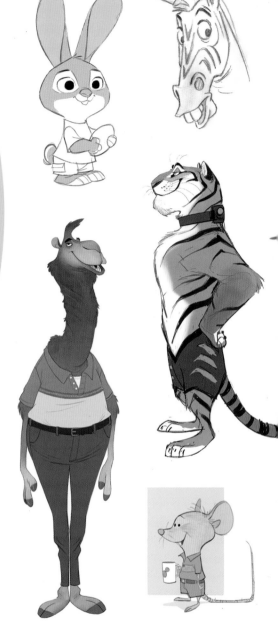

Front Cover: **David Goetz, Cory Loftis** / digital
Back Cover: **David Goetz** (posters),
 Cory Loftis (design print) / digital
Front Flap: **Byron Howard** / digital
Endpapers: **Marty Baumann, Cory Loftis,
 Mac George** / digital
Page 1: **Byron Howard** / digital
Pages 2-3: **David Goetz** / digital
Pages 4-5: **Cory Loftis, Borja Montoro, Shiyoon Kim,
 Nick Orsi, Bill Schwab, Dale Baer** / digital, graphite

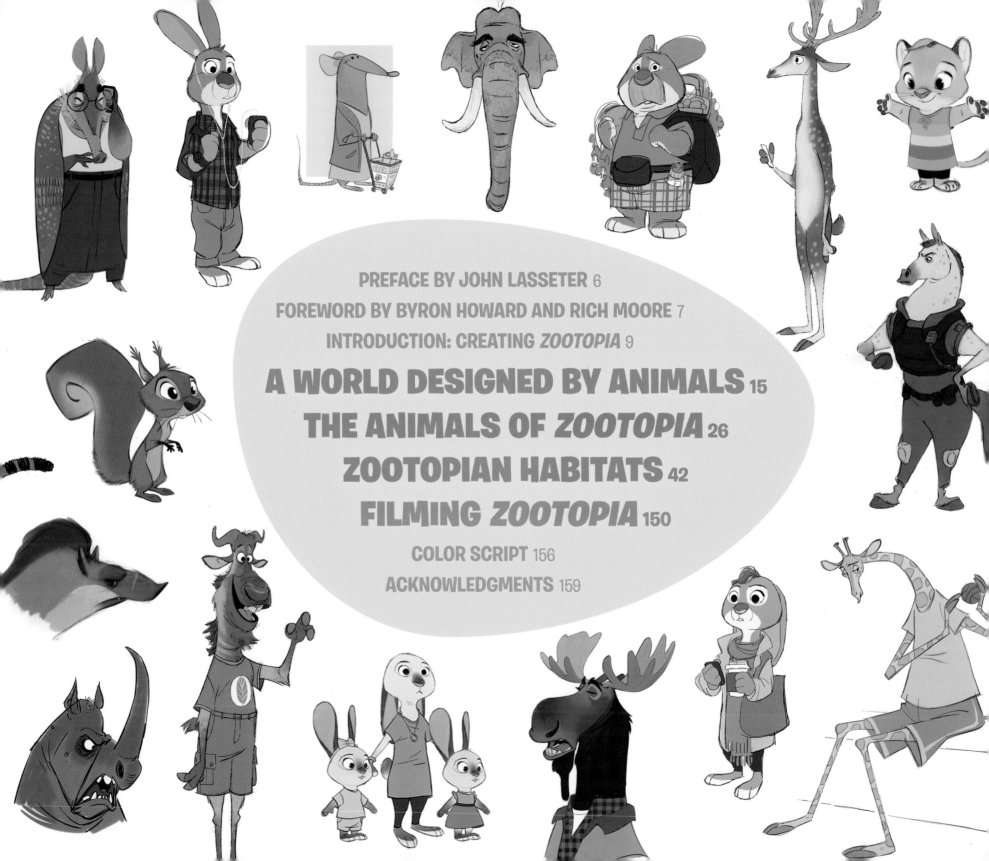

PREFACE BY JOHN LASSETER 6

FOREWORD BY BYRON HOWARD AND RICH MOORE 7

INTRODUCTION: CREATING *ZOOTOPIA* 9

A WORLD DESIGNED BY ANIMALS 15

THE ANIMALS OF *ZOOTOPIA* 26

ZOOTOPIAN HABITATS 42

FILMING *ZOOTOPIA* 150

COLOR SCRIPT 156

ACKNOWLEDGMENTS 159

PREFACE

I have always had a deep love for Disney animated films, where animals talk, walk upright, and wear human clothing. Shortly after *Tangled* was released, I discovered that film's co-director, Byron Howard, shared this affection. Movies like *Robin Hood*, *Wind in the Willows*, and *Pinocchio* are so entertaining. These kinds of films are classically Disney, but we hadn't done one in a while, and we were inspired to make such a film for modern audiences. Byron is a funny, quirky, charming director, and the ideas he pitched were so fun and appealing. We also wanted to create a Disney animated feature that pushed the filmmaking and storytelling to the highest possible level. With that in mind, Byron and his team began to develop *Zootopia*.

From the beginning, I was so excited about what this all-animal world could be. Most of the time, stories in animal films are really just human tales—if you replace the animals with humans, it would be exactly the same story. So we brought in Rich Moore to shepherd the storytelling. He always turns the expected on its head and comes up with ideas that are surprising and fun. I challenged the filmmakers to imagine Zootopia as a world that is truly and uniquely animal, where there are no people and mammals have evolved to human levels of intelligence. For inspiration, I encouraged them to dive deeply into research on animals and their habitats.

As with the story, the filmmakers did not want to design just a human world with animals living in it. Zootopia had to look like a realm created by animals, for animals. Yet it also had to be relatable to audiences as a big city. The visual development team, led by production designer Dave Goetz, researched animal habitats, asking, Which mammals live in each place? How do they live? What is each environment like? Inspiration came when they realized the city of Zootopia could parallel melting pot neighborhoods of human metropolises like London and New York. But rather than Chinatown or Little Italy, in Zootopia there is Tundratown and the Rainforest District, and the animals built infrastructure to support the diverse climates. The artists applied the research brilliantly, creating a world that is logical yet appealing and unique.

The team always sought to find the familiar while also being animal-specific, and Dave and Matthias Lechner, the art director of environments, brought so much imagination to the fun details that constitute Zootopia. One of its foundations is the idea that public spaces must be accessible to everyone. A mouse should have as equal access to a building as an elephant. So everything—doors, escalators, walkways—is constructed so all types of mammals can safely live together without fear of being squished or stepped on. Door handles that hooved animals can open as easily as animals with paws, or traffic signals that animals of all sizes can see, are essential to making Zootopia functional and believable. The city also has vehicles of all kinds, so we brought in the brilliant J Mays, former head of design at the Ford Motor Company. He came up with entertaining solutions to the unique issues of this world, from trains that have double-height areas for giraffes and rows of seats for smaller creatures beneath the bigger animals' seats, to automobiles that are super tiny for mice or have extra-heavy-duty suspensions to carry the weight of elephants and rhinos.

The characters themselves also had to be distinctively of this all-animal world. They had to talk and walk upright, yet maintain the essence of the animal itself. Cory Loftis led the character design team, and every department in the pipeline worked together to study the way, say, a camel versus a bear walks, or how a bunny versus a fox moves. The character team captured each animal's individuality on-screen.

The challenge of creating a talking-animal film that would raise the bar for our artists and storytellers pushed everyone in the studio to their highest levels of achievement. Our dream is that audiences will fall in love with *Zootopia*. We hope every scene will be surprising and funny and make you think, "of course that's what a DMV or a train would be like in a world of animals!" I believe the cleverness and fun add up to make *Zootopia* one of the most entertaining films we've ever made. At its heart, it's pure Disney. But it's also unlike anything seen before in animation.
—John Lasseter

FOREWORD

Zootopia had to be something new. We knew that from the beginning. There have been dozens of animated animal films, many from our own studio, so we were determined to make our film unique by asking ourselves one big question: Who created this world?

Zootopia is a world created entirely by animals, for animals. Walt Disney Animation has a wonderful legacy of films where animals talk and walk upright, from *Pinocchio* to *The Jungle Book* to *Robin Hood*. Our love for those movies inspired us to make a film like that for today's audiences. But figuring out what, exactly, this world, its creatures, and its story would look like was its own evolutionary process. The talents of hundreds of people, and many thousands of ideas, all came together to create a film that we hope will stand alongside those Disney classics and open up new worlds for our audiences.

Initially, we envisioned Zootopia as a futuristic, idealized City of Tomorrow. But through our research, we came to understand that cities are a reflection of their inhabitants' history and lifestyles, and that Zootopia had to evolve as a human city does. It had to have layers built up over time to make it feel like a place that truly exists. John Lasseter challenged us to find the cool details that are specific and unique in this world, which would help make *Zootopia* so fun and appealing. Practical needs like accommodating animals of all sizes are solved with the design of multiscaled buildings and trains. Real-world biological details, such as the fact that in nature prey animals outnumber predators ten-to-one, affect how the characters behave and move through their lives. Audiences also need to relate to what's on-screen in order to feel truly immersed in the film's world and invest in the characters. They should recognize their own experiences, but with an animal twist. So, of course the DMV is staffed by sloths! All of this creates those extra layers to make Zootopia feel like a real, functional city and a believable animated world.

The *Zootopia* team did months of research: visiting zoos and museums, talking to experts in multiple fields, even travelling thousands of miles to observe wild animals in the grasslands of Kenya. We then distilled all we had learned—about how human cities grow, what creatures need when they're gathered together in large populations, the personalities of different animals—into the soul of this all-animal world. Zootopia quickly took on a life of it's own, and it was bigger and more alive than any of us had ever imagined. The city has thousands of elements, from multiple environments like desert, rainforest, and tundra to mammals of all kinds, in every possible size, each with distinct types of fur. It also has all the things that make human cities distinct—a blend of ancient and modern architecture, lots of vehicles, and dust in the atmosphere.

Over the course of four years, the film's story changed drastically. What began as a 1960s-era spy caper morphed into a mystery set in the present day underscored by a theme of how bias affects all of us. But our artists were always resilient and so steeped in research that they were able to evolve their designs along with the changing story. A huge amount of amazing artwork for characters and environments was created. Many of these pieces got repurposed for other uses, but some of our favorites didn't end up making it into the film in the end. But in our minds, the city of Zootopia is a big enough place that it contains a lot more stories, locations, and inhabitants than can be seen in a single film. This book is a small way to showcase some of the remarkable art that doesn't appear on-screen, as well as the art that does.

Zootopia is a film about recognizing that our world is complicated, that life is complicated . . . for all of us. The film also says that the challenges we face each day are made bearable by leaning on one another and learning together. In making this film, we have leaned on and learned from every one of the brilliant filmmakers that surround us here at Disney Animation, and their brilliance shows in every frame of *Zootopia*.

—Byron Howard and Rich Moore

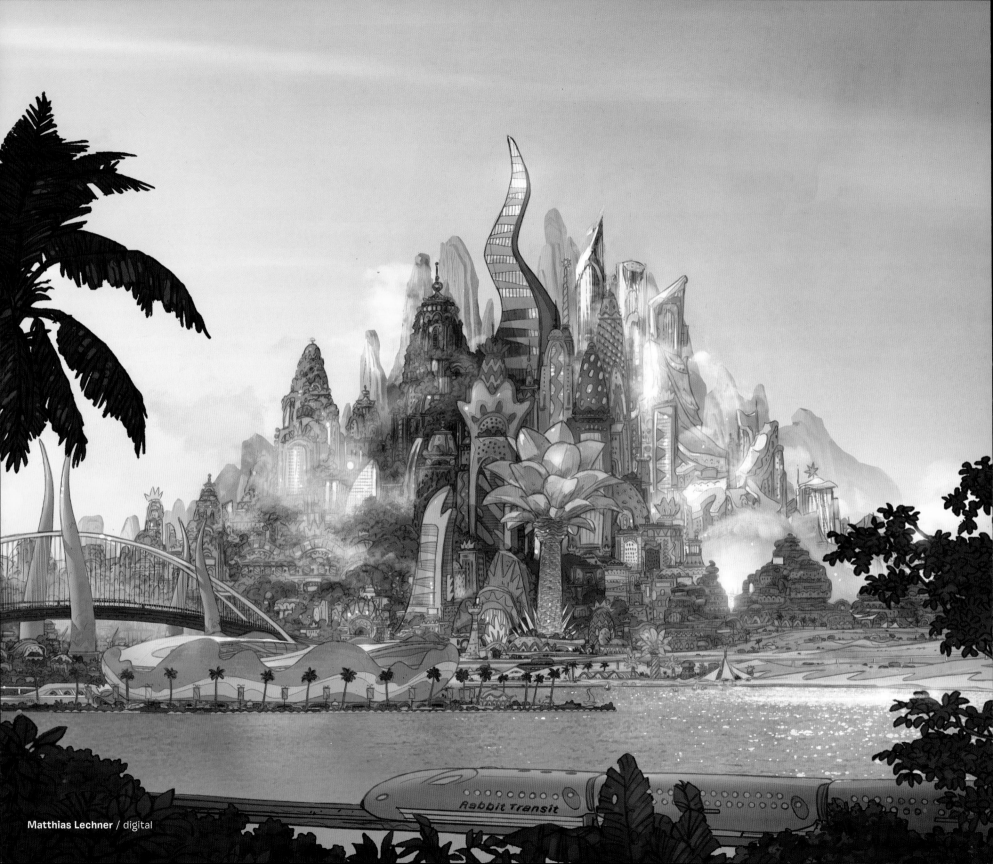

Matthias Lechner / digital

INTRODUCTION:
CREATING ZOOTOPIA

What if animals evolved to human-levels of intelligence and civilization? What if they lived in a world inhabited only by them? What would a city built by animals look like? These were the imagination-stirring questions that inspired Walt Disney Animation Studios' *Zootopia*.

Zootopia began as all feature films do at Walt Disney Animation Studios: as one of several different ideas pitched by a director to chief creative officer John Lasseter and president Ed Catmull. In the case of *Zootopia*, director Byron Howard (*Tangled*, *Bolt*) pitched six ideas, including an all-animal twist on the classic literary tale *The Three Musketeers*, a 1960s B-movie–style story about a six-foot-tall mad doctor cat on a deserted island who turned children into animals, and a film about a bounty hunter pug in space. "John loved the quirky quality of the 1960s world and the animal characters from the space pug concept," recalls Howard. "It was his idea to mesh the world of one with the characters of the other."

Howard began developing a new idea that blended those elements together. When he pitched his new take for the film, it had evolved into an espionage story called *Savage Seas*. "The protagonist was a rabbit spy, very James Bond in nature, named Jack Savage," Howard laughs. "It was fun, but every time we pitched it, everyone always said that the first act, which was set in the animal city, was the most interesting part. So we lost the spy element, as well as the '60s vibe, and let the animal city inspire the whole movie." Howard kept the bunny character as well, and started brainstorming ideas for the other creatures that could populate this all-animal universe. "I kept drawing a fox character. Foxes are natural predators of rabbits, so I thought it would make a great buddy dynamic."

What began to emerge was a comedic detective story set in an all-animal city starring Judy Hopps, an optimistic bunny cop, and Nick Wilde, a scam artist fox. It would become the fifty-fifth feature film from Walt Disney Animation Studios.

It was time to hire a screenwriter. Howard read scripts and met with a few candidates. Then he sat down with Jared Bush, a writer best known at the time for his work in television (*Penn Zero: Part Time Hero*; *All of Us*). "I knew immediately Jared was the guy. His writing is insanely smart, but it also has a playful quality that I love, especially in animated films. It was just so clear he was the dude to do this."

Bush was thrilled to work with Howard, on *Zootopia* in particular. "When I met Byron, it was like we'd known each other for a thousand years," he says. "Our sensibilities for this movie were so similar. Since I was a kid, I have obsessively loved animals of all kinds. When I was hired, it was still a spy movie, and my dad and grandpa had been in the CIA. And the pitch had all the elements that inspired me to become a screenwriter in the first place—real stakes, fun character dynamics, and an unbelievable, expansive new world to play in."

The film Howard and Bush were imagining was hugely ambitious in scope, and Howard knew he would need a crackerjack production crew to help realize that vision. With that in mind, Howard asked Clark Spencer

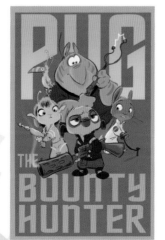
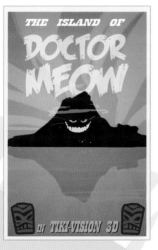

Byron Howard / digital

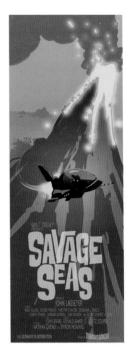
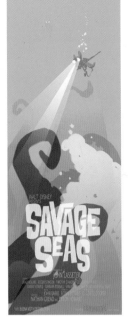

Byron Howard / digital

(*Wreck-It Ralph*, *Bolt*, *Lilo & Stitch*) to produce *Zootopia*, certain Spencer would lead and assemble just the right team. The two had worked together on *Bolt*, and Spencer was glad the chance to collaborate again finally appeared with *Zootopia*. "From the minute I heard the pitch, I was excited," he says. "It was a fantastic animated world, with engaging characters and a great script, but it also had a compelling message. Byron and Jared were talking about the challenging and important topic of bias. I deeply wanted to be part of this project."

The breadth and depth of *Zootopia* engendered many challenges, including an ambitious, emotionally complex narrative. To ensure the story's integrity during times of competing production needs, Howard, Spencer, and Bush asked veteran animation director Rich Moore (*Wreck-It Ralph*, *The Simpsons*) to come on board as director of the film, working alongside Howard. Moore was excited by the wealth of material presented by the world and characters of *Zootopia*. "It was beautiful and relatable and well thought-out. There was so much good stuff in the story and this world

that we had to be careful not to get lost in the mire, and to stay focused on Hopps and Nick's relationship. Theirs is just one story among many that can be told in Zootopia."

From the beginning, executive producer John Lasseter challenged the filmmakers to create a uniquely animal world, one in which humans never existed but animals had evolved to human-level intelligence. Lasseter encouraged the team to dive deeply into research before they began thinking about story, plot, or characters. The team spoke with zoologists, animal behavior specialists, and scientists who study animal evolution. They embarked on field trips to the Natural History Museum to examine animal pelts, visited the Los Angeles and San Diego Zoos and Disney's Animal Kingdom to study animal behavior and artificially created animal habitats, and even went on safari in Africa to observe animal behaviors in the wild. All of this research greatly inspired the film's story and visual development.

The visual scope and scale of the all-animal realm of *Zootopia* began to take form when the team asked Dave Goetz (*Tangled*, *Atlantis*) to come on as production designer. Says Howard, "We brought Dave on early. Evolving the city of Zootopia would have been nearly impossible without a production designer on the development team. Jared and I would discuss peculiar ideas we wanted to explore in the story, like animal scale, organic architecture, even the separate environmental districts. Dave took those ideas and turned them into images so compelling that they inspired us to make Zootopia even bigger and more immersive."

Goetz had been looking for a way to collaborate with artist Matthias Lechner for years. "I saw his website years ago, and his work was exceptional." Lechner, who was a German citizen living in Vancouver, worked on *Zootopia* remotely for two years, before eventually moving to California to become art director of environments. "I had wanted to work at Disney since I was a kid and I loved this project. It's my style of silliness and simple charm," says Lechner. Spencer adds, "Matthias is fast, his work is so detailed, and he's conscientious. He always has a reason for every decision he makes; it can't just look cool."

Since *Zootopia* takes place on a planet populated entirely by animals, it needed a spectacular character designer, so the filmmakers asked Cory Loftis (*Wreck-It Ralph*, *Wildstar* videogame) to join the team as art director of characters. "Cory comes from the video game industry, and the guy can do anything," says Spencer, who first worked with Loftis on *Wreck-It Ralph*.

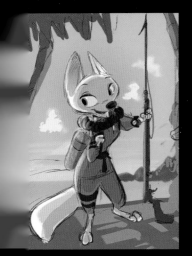

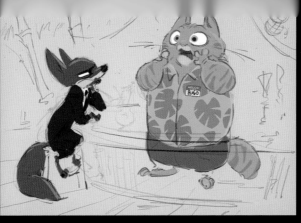

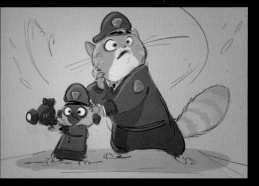

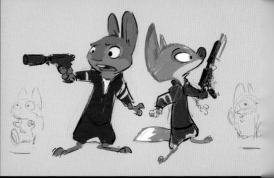

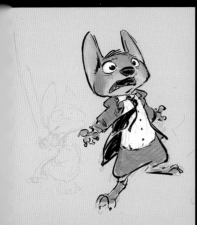

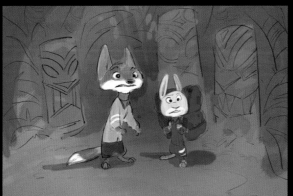

Spencer continues, "When 2-D designs are translated into 3-D models it can be difficult to maintain their appeal—the charm inherent in a character that is artistically enjoyable to look at. Cory expertly managed that process." Howard concurs. "Cory is a mad genius. He designed hundreds of unique animals for this movie. And the 3-D model of every character looks like a beautiful drawing from every angle."

Loftis worked closely with the department heads of modeling, rigging, simulation, and look development to make the designs work, and he's proud of the entire design team. "There are so many characters in this film that it was tough for everyone to sit in one room to evaluate everything. So we worked in smaller teams, with the department supervisors for each character working together so everyone was on the same page." Loftis continues, "It's a huge movie and it would be out of control if we didn't trust each other."

The filmmakers set out to bring a variety of voices into the story and editorial departments. They hired Fabienne Rawley (*The Insider*, *Monster House*), an editor with mostly live-action experience, because, Spencer says, they liked her approach. "She is very thoughtful about how to edit films, and cares deeply about this project. Fabienne asks the right questions about the characters and story, and she's great with emotion." Josie Trinidad

Byron Howard / digital

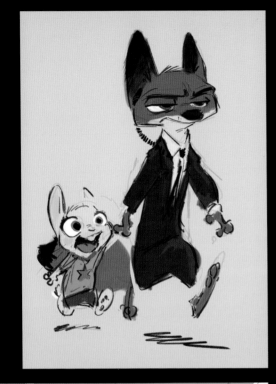

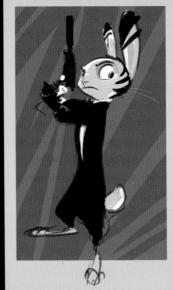

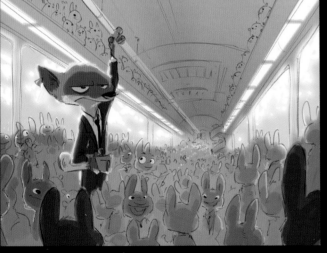
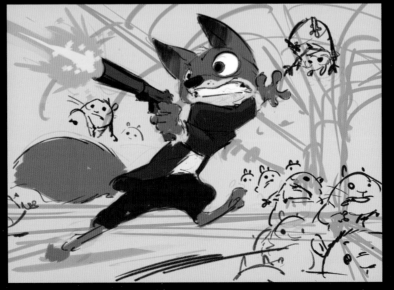
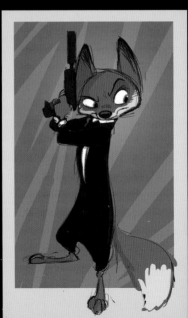

Byron Howard / digital

joined the crew early on as head of story, her first time in the role. Bush was especially pleased to have Trinidad leading the story artists. "The concept of the film was a bit weird and dark for a lot of people early on. Prejudice is a tough idea to talk about. But Josie got it." They also asked Jim Reardon (*Wreck-It Ralph*, *Wall-E*) to be co-head of story. The pairing worked well. "Josie and Jim are a great team," says Moore. "Josie is always thinking about emotion and character, while Jim is focused on comedy and structure. They balance each other well."

Spencer and Howard selected Scott Kersavage (*Wreck-It Ralph*, *Brother Bear*) for VFX supervisor. Spencer, who had worked with Kersavage on

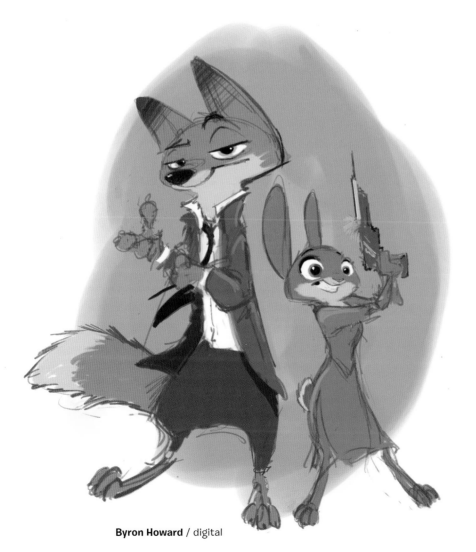

Byron Howard / digital

Wreck-It Ralph, says, "Scott's very smart and strategic, but he also deeply cares about the art." That combination was important because *Zootopia* had a fundamental artistic ambition that directly influenced a massive technical challenge—creating believable fur. "We have a cast of furry characters who we want to look believable, not like stuffed toys," says Kersavage. "We have foxes, bunnies, sheep, polar bears, porcupines, as well as animals like elephants and rhinos with thick, scaly hides. They all have fur, but each type of fur is different in how it moves, how light bounces off it, whether it looks coarse or fluffy. We had to develop a brand new tool in Hyperion [Disney's proprietary rendering software] for that."

The rest of the production team came together quickly. As co-heads of animation, Renato dos Anjos and Tony Smeed led their department with passion and tenacity. "Renato is able to articulate what the directors are seeking in the movement, timing, and believability of the animation," says Kersavage. "And Tony has a great sense of acting and emotion." Brian Leach and Nathan Warner were brought on as directors of cinematography, with Leach focused on lighting and Warner on layout. Both have strong backgrounds in photography but were new to leadership roles. "Brian and Nathan are impressive artists, and they're also good collaborators," says Kersavage. Together, Leach and Warner pushed boundaries in their departments, using new types of lenses, innovative camera movements, and lighting that captures dust or water vapor in the air to give a sense of atmosphere.

Spencer says his team-building philosophy is all about balance. "On this film, we worked with a lot of new people—new to the studio or new in their roles. You don't want everyone to be first timers, but it's also nice to give people an opportunity—just like Hopps gets her chance in the film as the first bunny cop on the ZPD [Zootopia Police Department]." Spencer smiles as he reflects on the crew. "We have a great team that really gelled. Everyone feels supported and enjoys what they're doing, which shows up onscreen."

"This film has a lot of inherent challenges," says Howard. "Even so, I wanted it to have the playfulness I love in films like *Robin Hood*, *Monster's Inc*, and *Charlie and the Chocolate Factory*. We're wrestling with big themes in *Zootopia*. But a sense of humor permeates everything because there are so many elements to play with—the scale, the variety of animals, the parallels between human behavior and animal experiences. It's a rich environment we hope audiences want to immerse themselves in."

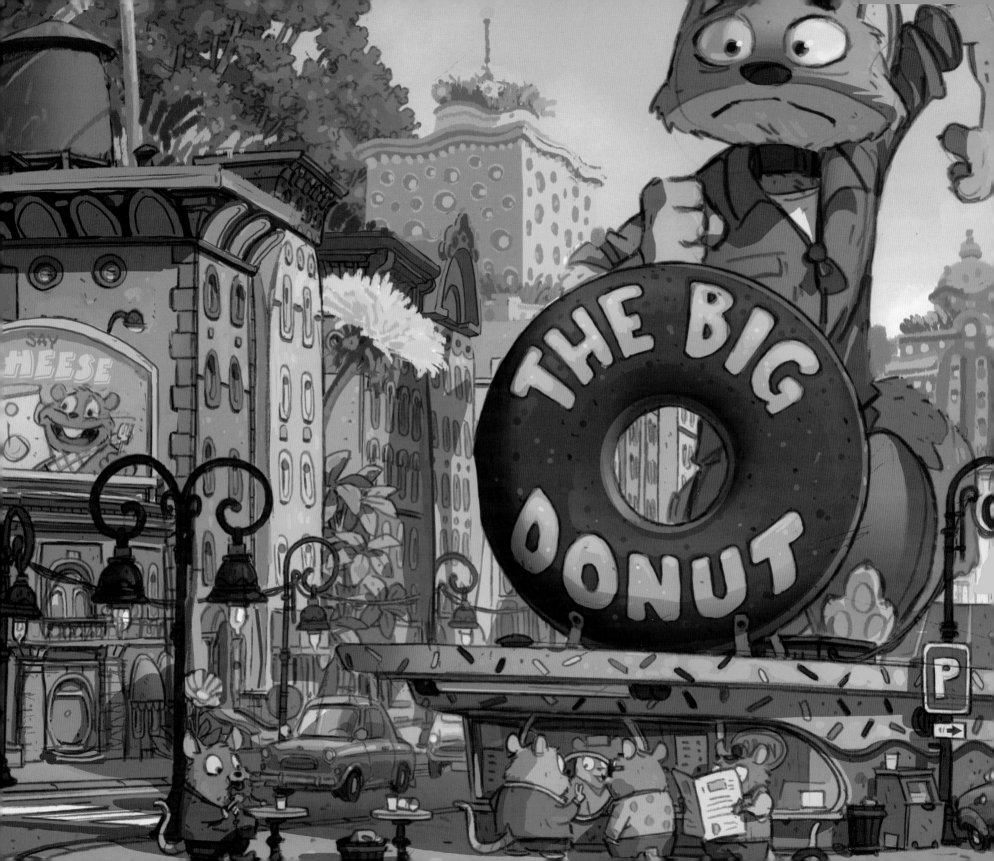

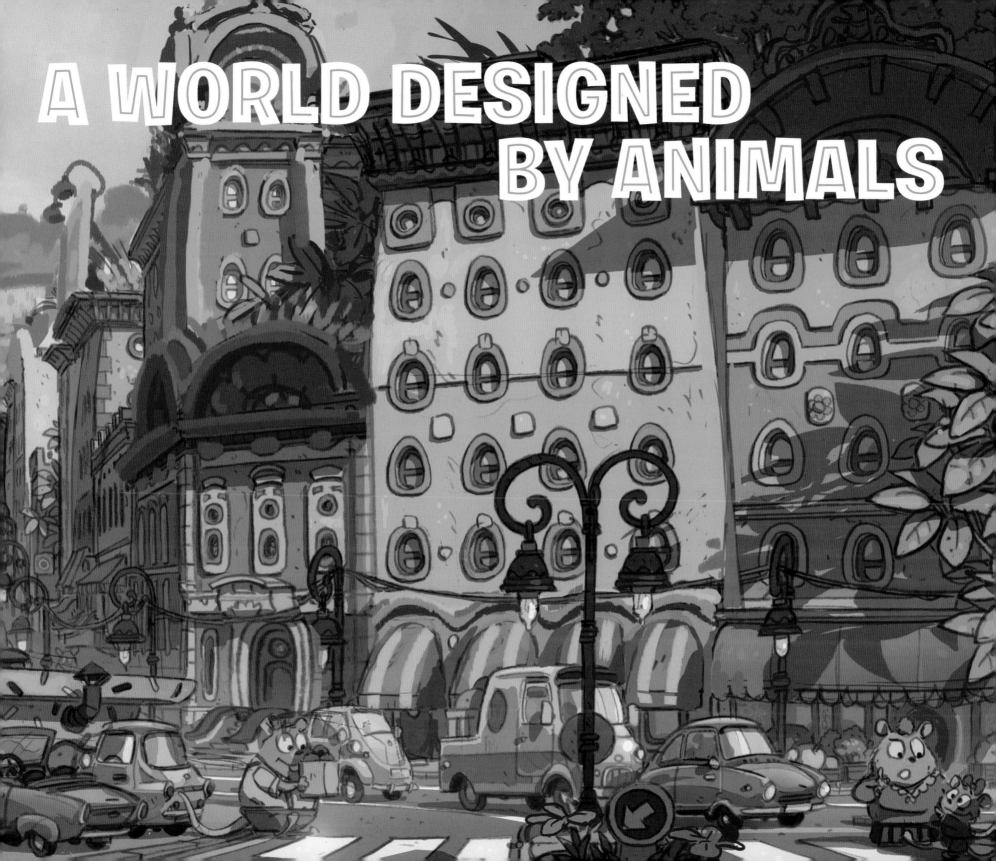

Zootopia takes place in an all-animal parallel-universe planet where humans never existed. The city of Zootopia is a modern metropolis created entirely by animals, and it is a vast place. It has elements of New York, San Francisco, and Los Angeles, but also hints of Dubai, Moscow, Brasilia, and Berlin. "There's a richness and variety of architecture," says production designer Dave Goetz. "We included buildings of all ages and styles, because we found that the more we mixed it up, the more it felt like a real place."

The filmmakers thought a lot about how animals would design and build a city that would still be recognizable to humans. "We used organic shapes to soften volumes, and nature-based motifs to embellish environments," says Matthias Lechner, art director of environments. "We tried to incorporate elements that alluded to natural habitats, such as tree structures, rock formations, cave openings and burrow walls. And we added lots of foliage everywhere."

The pendulum swung in different directions as Goetz and Lechner were designing the film's visual aesthetic. "Dave and Matthias did an immense amount of research. They wanted everything to make complete sense for the characters, while also being a milieu we've never seen before," says producer Clark Spencer. "But it still has to be relatable to humans or the audience will be taken out of the film. The more abstract or futuristic it felt, the less it felt warm and friendly and appealing. We had to find the right balance."

Zootopia is home to mammals of all sizes, from enormous elephants to tiny shrews. To accommodate them all, scale played an essential factor in the design process. Sometimes multiple versions of the same object were created, such as small entrances within larger doorways, or multi-level trains. Other times, parts of items were blown up or shrunk down, such as stove knobs and drawer handles. Goetz and Lechner ultimately decided to stick to four main sizes: tiny, for mice; small, for bunnies; regular, which is comparable to human size and works for everything from sheep to cows; and jumbo, for elephants. They discovered that scale is often communicated in the details. "Take a mouse vehicle," says Lechner. "If you use a regular-size car and shrink it down, it just looks like a human car made small, not something created by and for mice. But if you take details like door handles and blow them back up a bit, suddenly it feels mouse-like."

Scale was a factor when designing the look of the characters as well. The filmmakers knew audiences would view Nick and Hopps as equivalent to human-size, so they set them as the standard and scaled everything bigger or smaller off them. One example of this is the characters' clothing. Says Michelle Robinson, the character look supervisor, "Mice are basically wearing doll clothes. But what does a t-shirt on an elephant look like? What's it made of? Do all the animals get their cloth from the same place? Do they have the same size sewing machines? Or do the mice have tiny tailors with tiny sewing machines?"

"Zootopia is a meticulously designed chaos," says Goetz. "Everything has to function properly." Windows have to open. Drawers have to close. Clothes have to fit. "But," Lechner adds, "the overall style of Zootopia is more playful, organic, and imperfect than reality."

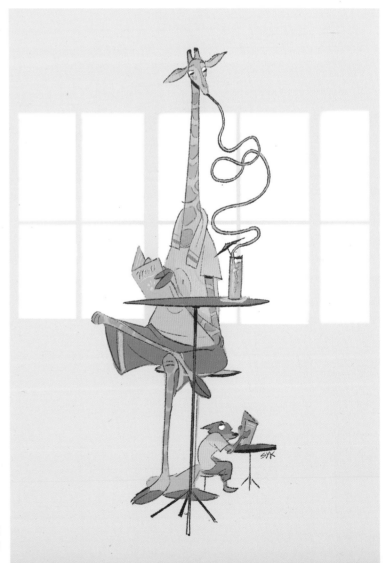

Shiyoon Kim / digital
pages 14-15: **Matthias Lechner** / digital

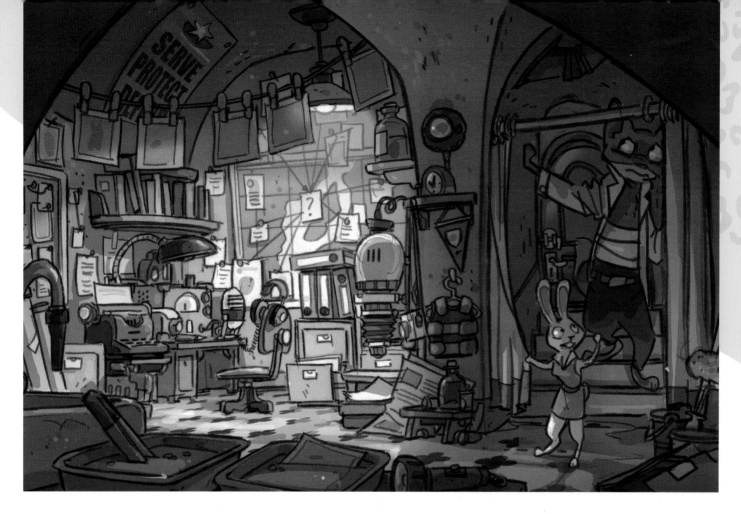

GROUPING AND COMPOSITION

ZOOTOPIA is meticulously arranged chaos. Don't place items "randomly" - always think of interesting rhythms and ways to support the flow of the composition. Everything relates to everything else - you don't necessarily have to follow the design 100 percent - just keep this in mind: Entertain with Variations. the shapes and the grouping are part of the same composition. Guide the eye. The love you will put into this fills the set with life.

A CONSCIOUS WORLD

ZOOTOPIA is a world where animals evolved to a level of human consciousness. A way to play with the premise of raised consciousness is to also infuse the environment with spirit. Objects are NOT LITERALLY alive, but whenever possible give them ATTITUDE in the form of "line of action" and don't shy away from subtle reference to faces. It's a fine balance – more of a subliminal thing.

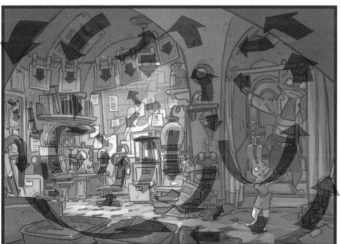

simple composition in 2D - similar shapes make the eye flow and variation is entertaining

The same composition also works in 3D. Think of the arrangement as a sculpture and it will work from all angles

Think like that with everything - even plant arrangments

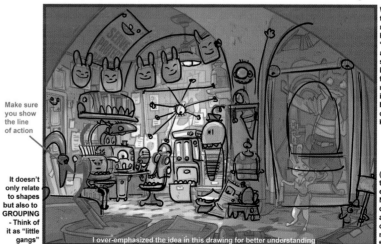

Make sure you show the line of action

It doesn't only relate to shapes but also to GROUPING - Think of it as "little gangs"

I over-emphasized the idea in this drawing for better understanding

When you transform the designs into models, you must be aware of the "CHARACTERS" that are hidden in the shapes. Do not add obvious faces though. A model is successful if the "life" is felt, but the audience doesn't really know why.

(This doesn't relate to such obvious examples only - No matter what the design, there will always be an emotion or attitude that should not be lost in translation)

Matthias Lechner / digital

ANIMALIZING THE WORLD

We used natural shapes and animal patterns throughout Zootopia, like giraffe spots on a building. If you look closely, you'll see lots of animal faces and teeth, multiple horn and tail shapes.
—Matthias Lechner, art director of environments

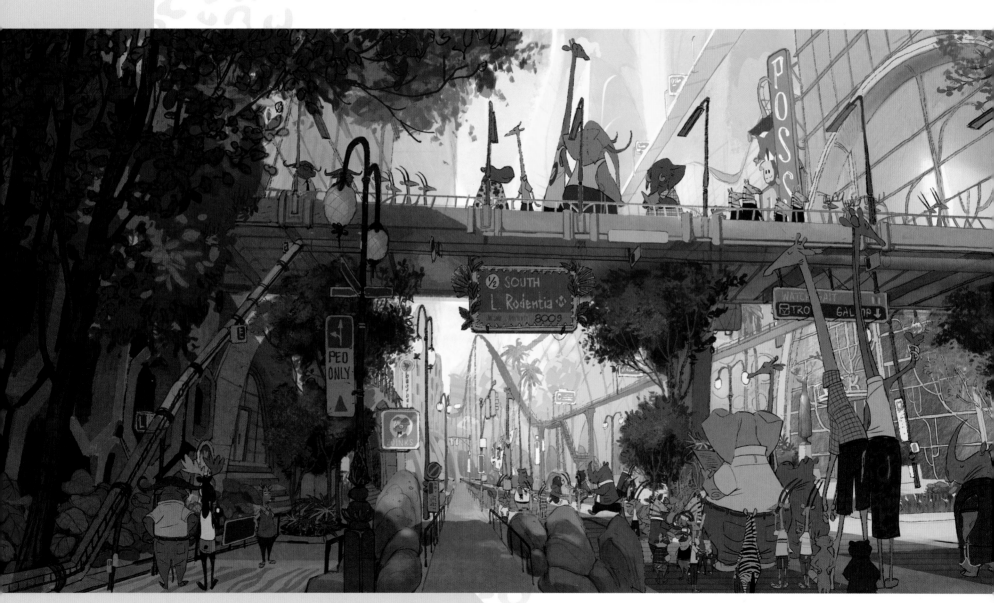

Cory Loftis / digital

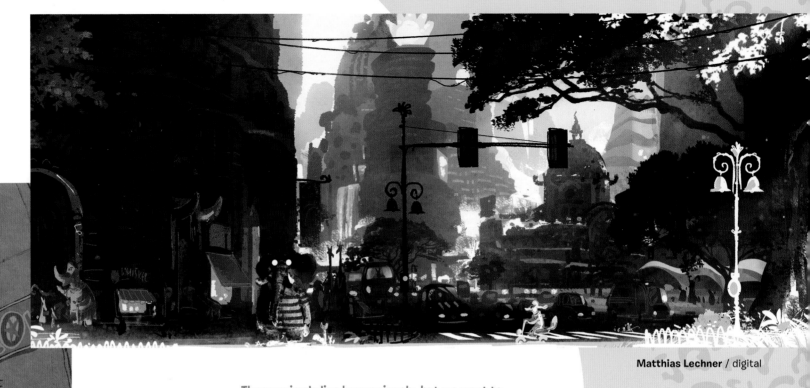

Matthias Lechner / digital

These animals live harmoniously, but we want to maintain their animal nature. They're not people in animal suits. They have their own animal qualities, and they've built their surroundings in their mindset.
—Scott Kersavage, VFX supervisor

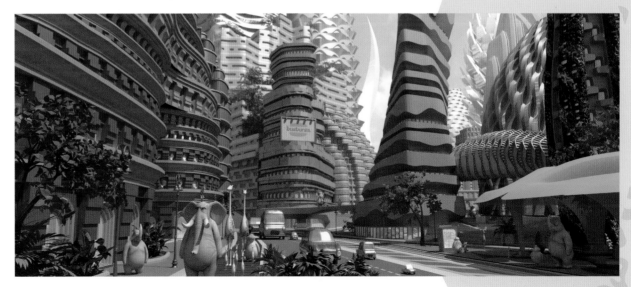

Brett Albert / digital

ARCHITECTURE

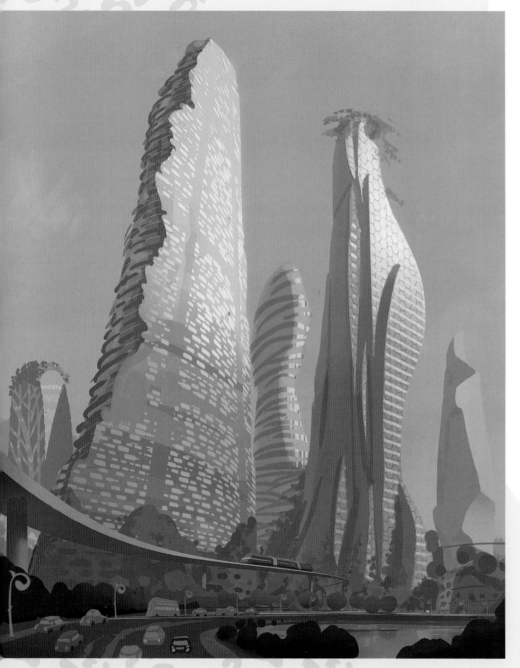

David Goetz / digital

David Goetz / digital

David Goetz / digital

These animals have evolved to a human level of consciousness so we put thought and love into everything surrounding them. That imbues every building and object with an attitude, a soul, which makes it appealing. —Matthias Lechner, art director of environments

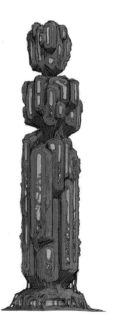

Armand Serrano / digital

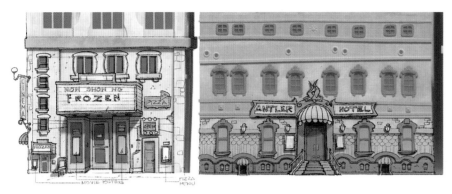

Armand Serrano / digital

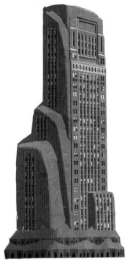

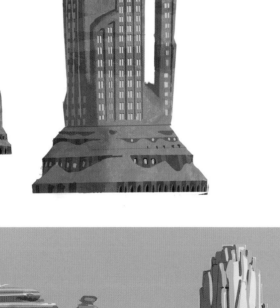

Mac George / digital

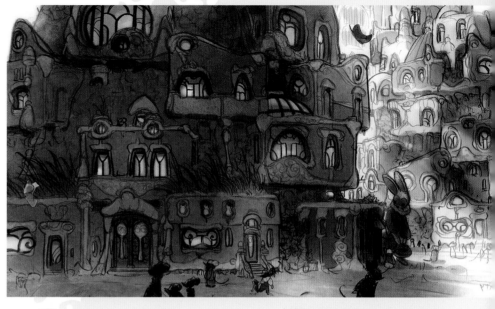

Manu Arenas / pencil and marker

In an early iteration of the film, prey animals were dominant in Zootopia, so the motifs used in buildings reflected their reality. We used vegetable patterns, leaf shapes, and flower murals in the architecture.
—Dave Goetz, production designer

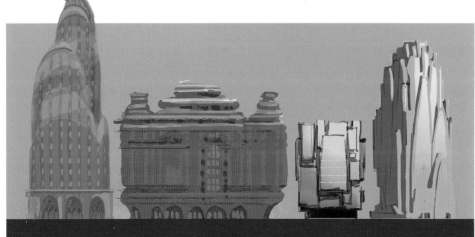

David Goetz / digital

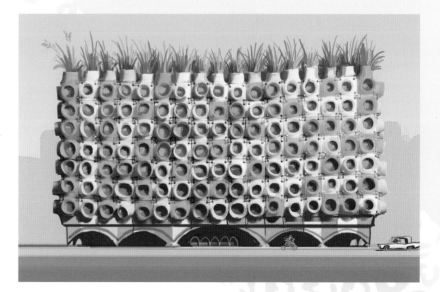

David Goetz / digital

ACCOMMODATING ALL SIZES

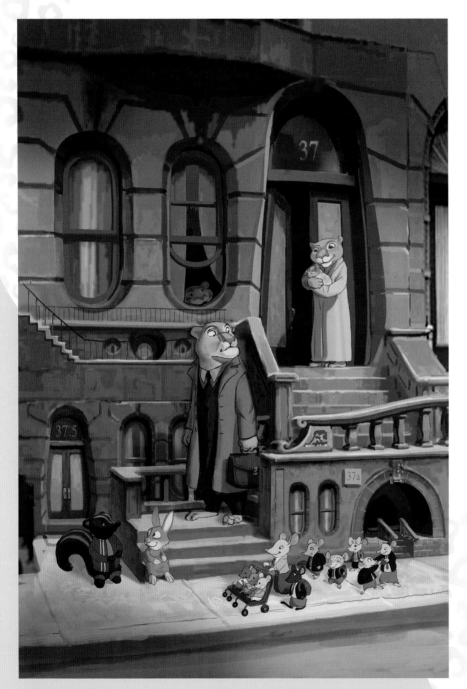

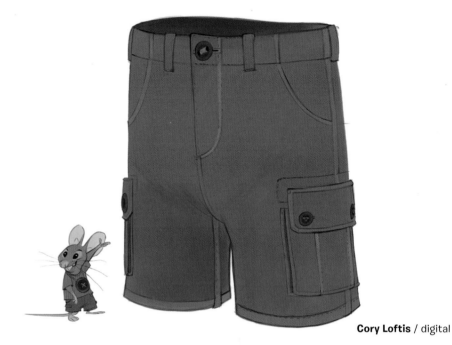

Cory Loftis / digital

In order to indicate scale, we kept certain details a consistent size, like buttons, zippers, or stitching on clothing. A mouse shirt only has room for one button, but an elephant's has lots of buttons and the stitches are doubled up.
—Cory Loftis, art director of characters

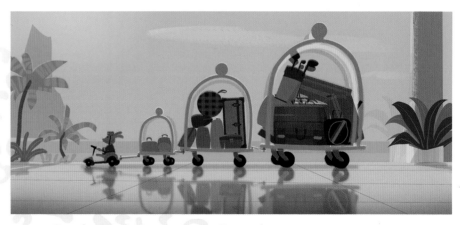

David Goetz / digital

David Goetz / digital

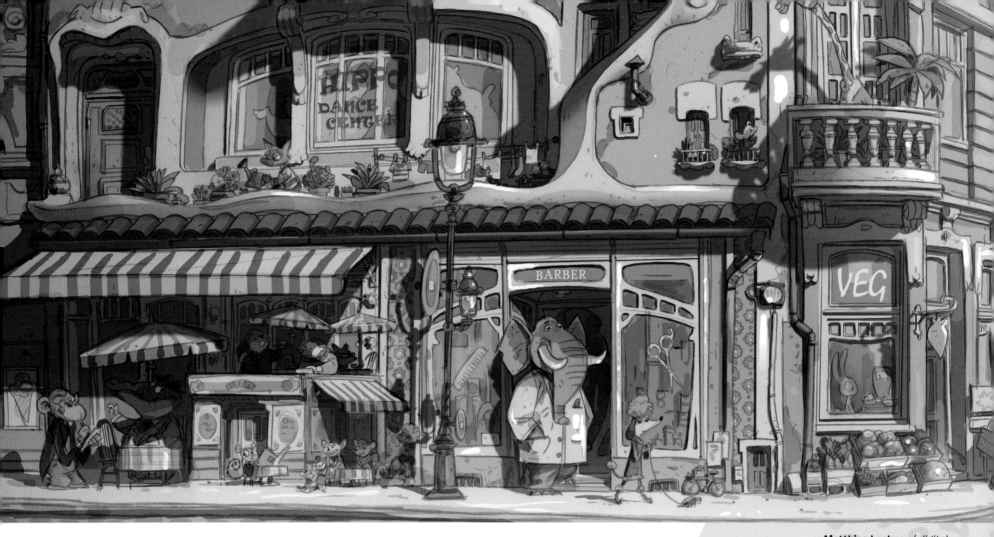

Matthias Lechner / digital

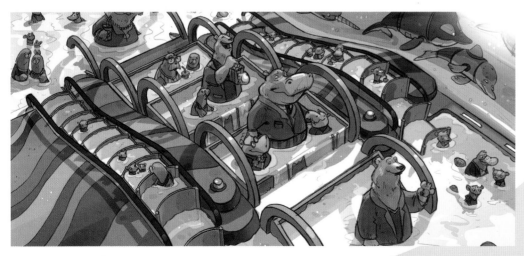

Matthias Lechner / digital

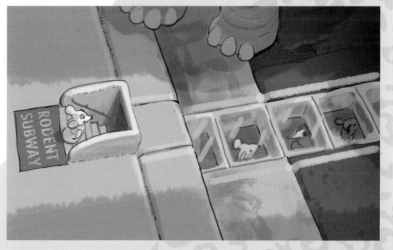

David Goetz / digital

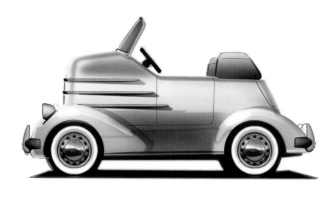

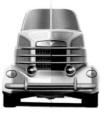

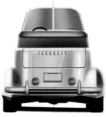

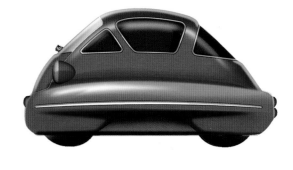

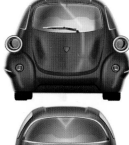

J Mays / digital

J Mays / digital

Former head of design at the Ford Motor Company J Mays designed vehicles with fun solutions to the unique problems of this world. For example, a giraffe's car is very tall. To alleviate the centrifugal force on their necks when changing direction, the upper half of it rotates and leans into the turn.
— John Lasseter, executive producer

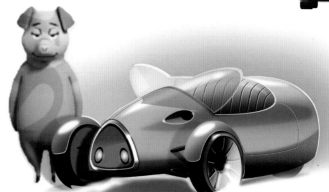

J Mays / digital

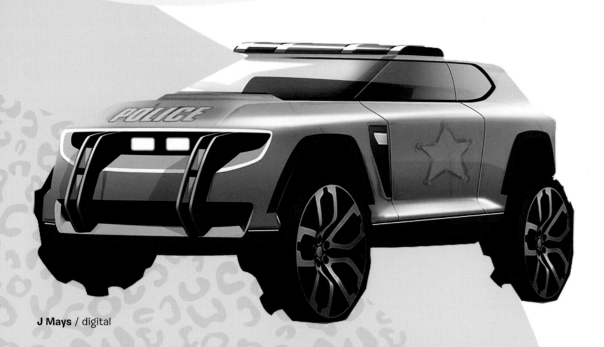

J Mays / digital

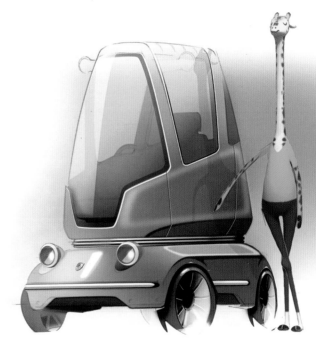

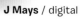

J Mays / digital

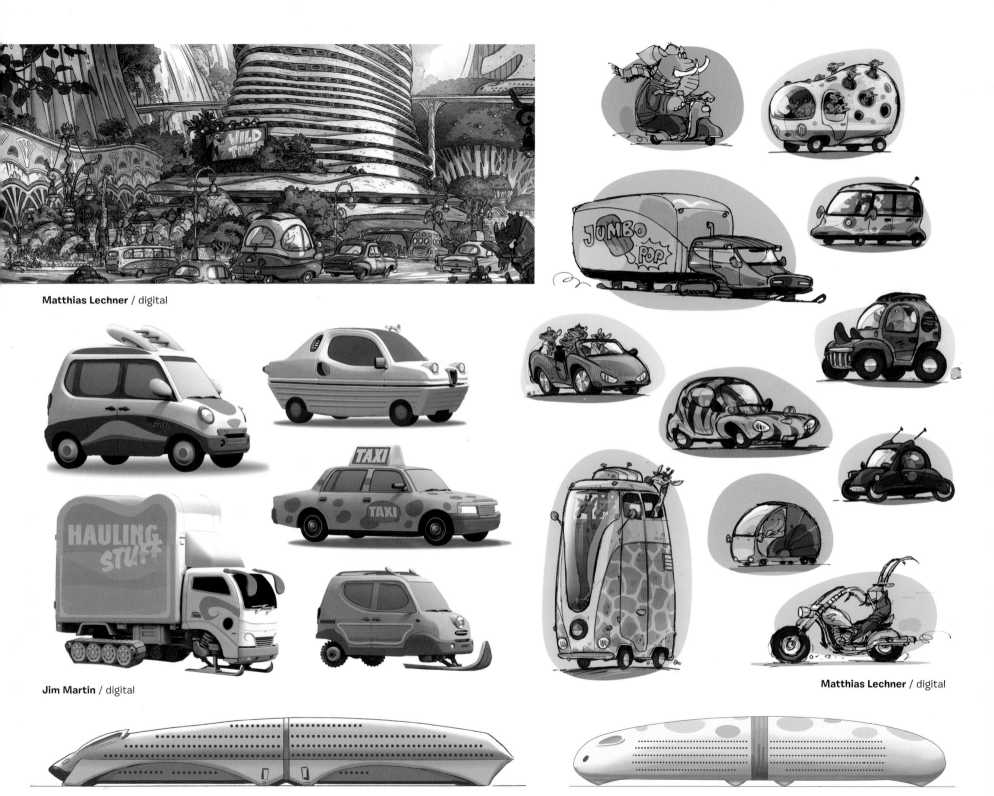

Matthias Lechner / digital

Jim Martin / digital

Matthias Lechner / digital

David Goetz / digital

David Goetz / digital

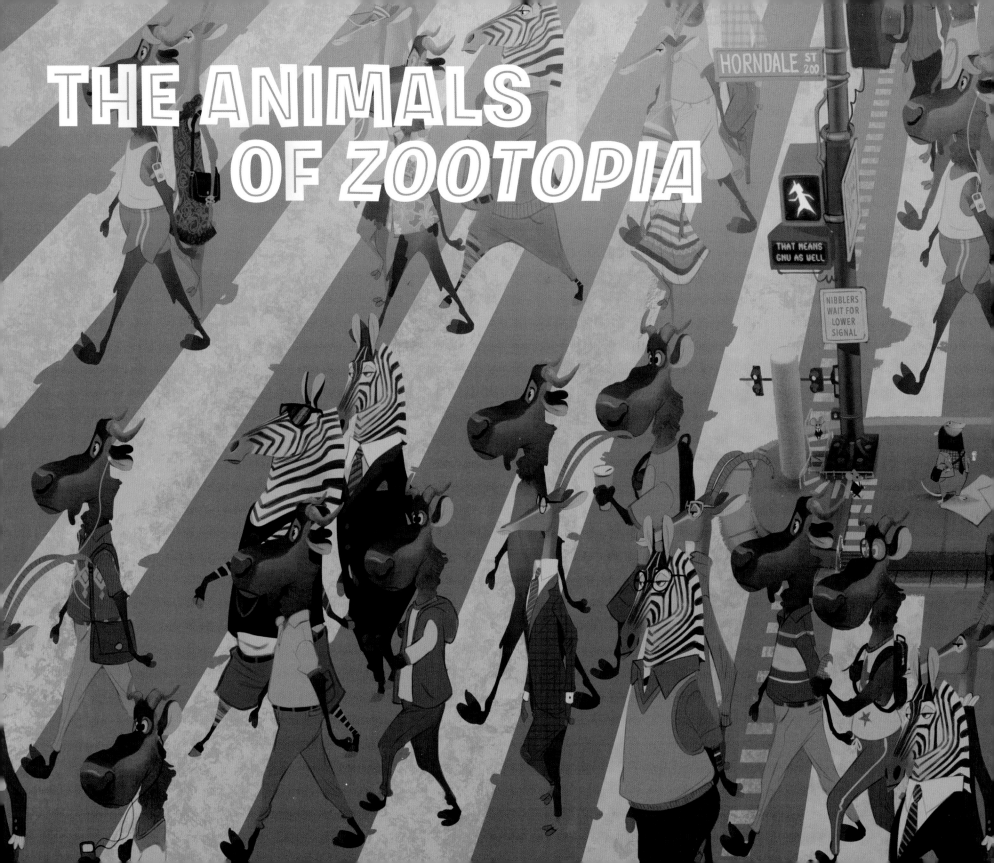

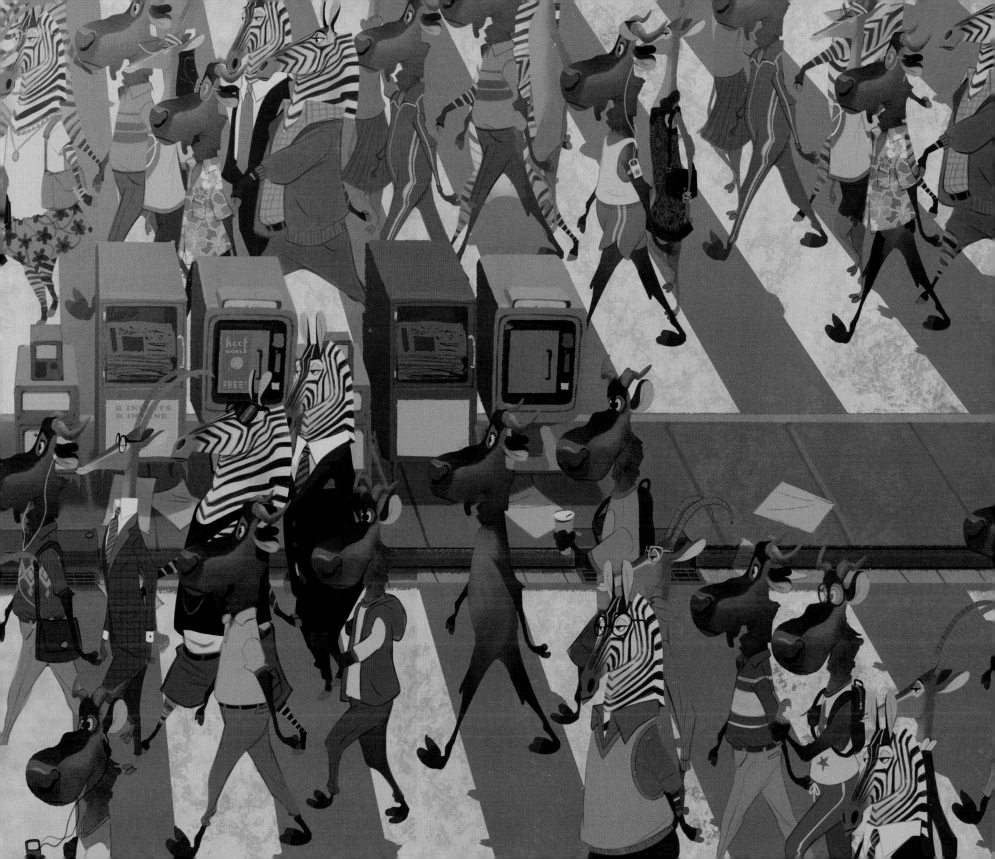

Executive producer John Lasseter challenged the filmmakers to create the kinds of unique animal characters that would populate an animal-only world. He encouraged the team to dive deeply into research before they began thinking about story, plot, or characters. "My rule for research is that, if at any point on a subject you think 'oh, wow, that's fascinating,' your audience will think that too. Remember those 'aha!' moments, and let them guide you," says Lasseter.

The team spoke with zoologists, animal behavior specialists, and scientists who study animal evolution. Based on what they discovered, the filmmakers decided to limit the film's animals to mammals, although "reptiles and birds and other animals do exist on this planet. We just don't go to those continents," says screenwriter and co-director Jared Bush. This constraint led to an "aha!" moment that became a central tenet of *Zootopia*—that mammals are divided into two groups: predators and prey, and prey animals outnumber predators ten-to-one.

In early versions of the story, this division was overt, with prey animals exploiting their strength in numbers to dominate predators, who were forced to wear collars that prevented accidental expressions of their natural aggression. "But," says director Rich Moore, "the world was so negative. And [director] Byron [Howard] is such a positive person. We wanted the story to reflect his vision and personality more." So that early concept developed into a more nuanced story of a city torn apart by inadvertent, underlying bias. Adds Howard, "We wanted to see these characters living together happily at first, so the audience roots for the world to return to that harmony. But we also wanted to show how bias and prejudice can so easily divide a culture." So *Zootopia* depicts a city where mammals of all species coexist peacefully until the events of the film shake things up.

Giraffes are so big that their scale is weird. They look like they're in slow motion when they're running full speed. It's like they're walking on the moon— graceful and silent, really effortless for their size. The animators captured that effect on two feet. —Jared Bush, screenwriter and co-director

Research also influenced Howard's choice of species for the film's protagonists. "It's a buddy movie, so they had to be in conflict. Bunnies are very clearly prey animals—they're passive, defenseless, and soft. And foxes are their natural enemies." There was some discussion whether the main predator character should be bigger, perhaps a bear or a tiger, but Howard liked that a fox's size allows them to become prey themselves. "It kept Hopps and Nick relatable to each other despite their differences."

Cory Loftis, art director of characters, worked closely with Howard when designing the creatures of *Zootopia*. "Byron's character designs have such an appealing style. They are very charming and instantly funny," says Loftis. "The challenge was to maintain that appeal while also making them seem like real animals, with working skeletons and muscles." However, Loftis did have to stray from reality at times. "All our animals have opposable thumbs because they need to execute too many tasks that require thumbs. So we made it part of the logic of this world—they evolved that way," says Loftis.

Howard had a specific design in mind for each character, which the artists found extremely valuable. "You can talk about design in terms of shapes and proportions, but that is superficial if you don't have the subtext of personality to base it on," says visual development artist Shiyoon Kim. Nick Orsi, the visual development artist who drew the original character lineup, agrees. "When we draw, we're thinking about personality. How is this character going to emote, how will she act? Byron's characters all have strong personalities."

Much of Howard's sense of personality for the characters in *Zootopia* developed during a research safari in Kenya. Their guide, a fourth-generation Kenyan named William Carr-Hartley, gave the team great insight into animal characteristics and personality. "Other experts told us how the brain or physiology of an animal works. But William would say, 'warthogs are prissy and nervous. Wildebeests are big dumb idiots. Cape Buffalo are just grumpy all the time,'" recalls Howard. "He was describing personality, which is what we need for animation." It was another "aha!" moment for the team. Adds Bush, "We had been trying not to put human characteristics onto our characters. But seeing human personalities reflected in these animals led us to thinking about stereotypes in the story—of viewing a whole group as a certain way."

There are an enormous number of animals in Zootopia, and each species presented a new design challenge. Loftis recalls the difficulty in getting the balance for each creature just right. "There's a universal aesthetic as

Borja Montoro / digital
pages 26-27: **Cory Loftis** / digital

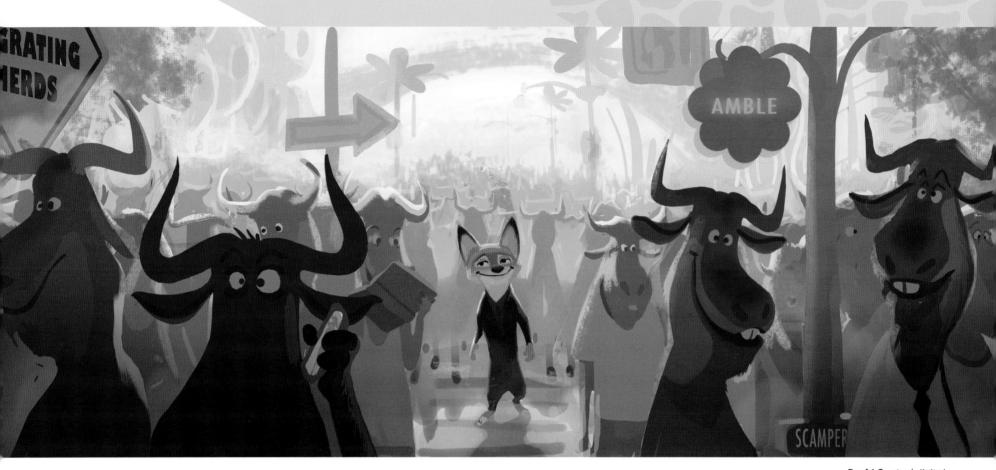

David Goetz / digital

audience members, a communal sense of what's weird," he says. "We had to manipulate each animal's anatomy differently—what would a bunny versus an elephant look like standing upright? A design can become too close to the uncanny valley if it's too realistic, but it can feel like a stuffed toy if the design is too simple." The team worked hard to maintain the believability of *Zootopia*, rather than going for a more cartoony, stylized look. "What if this animal did just stand up on two feet, put clothes on, and groomed himself? That was how we approached each character," says simulation supervisor Claudia Chung Sanii.

Tails were a particular challenge. "How does a tail emerge from a pair of pants? We tried cutting a hole in the pants, but then the tail didn't feel connected to the animal's body. We tried building a fly in the back with a

button, but that looked weird, too. We tucked the tail in but that lost some of its animal nature," Sanii laughs. "Every animal's tail is different so each one was a new problem." Certain types of human clothes also looked odd. For example, the team experimented with shoes but, recalls Howard, "it felt bizarre to put leather or plastic things around their feet. Hooves and claws are part of what makes animals unique."

There were nearly one hundred unique animal species designed for *Zootopia*. Each one moves differently and looks distinct from the others. VFX supervisor Scott Kersavage marvels, "We have such an astonishing cast of characters—not just main characters, but secondary, and tertiary ones—and we gave them all the same love and attention." Loftis agrees. "Every animal was an adventure and a struggle. It was so fun."

Judy Hopps

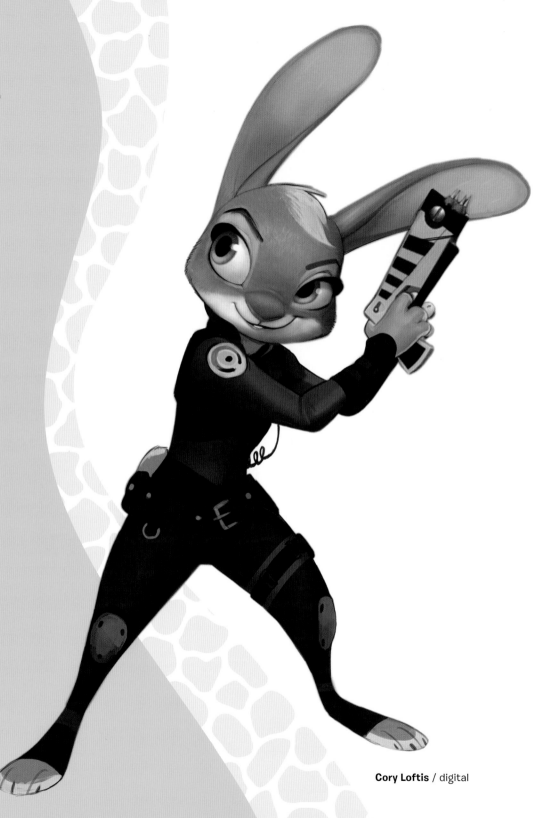

ZPD Officer Judy Hopps begins her journey in Zootopia as an optimistic bunny from Bunnyburrow, a suburban dweller entering the big city. She learns some difficult truths during the film, but she retains her optimistic spirit and even gains an unexpected new friend in Nick Wilde, a streetwise fox.

As the story evolved, Hopps's personality became more optimistic and naïve, which influenced her design. Her face became more open, her eyes got rounder and brighter. "But," says Nick Orsi, the visual development artist who initially designed Hopps, "Judy mostly stayed the same throughout all the versions of the story. She is a small bunny trying to break into this large-mammal-dominated police force, so we really played up the size and scale difference. She's an underdog who has to try way harder than the others, just to prove that bunnies can be cops."

Art director of characters Cory Loftis recalls that the biggest challenge for Hopps was making her look like a tough bunny. "Literally that phrase was the hardest part. Because everything we know about bunnies is cute, soft, adorable." Loftis adapted her anatomy, giving her heavier thighs and arms than real rabbits have, so Hopps can kick things or wrestle a criminal if she needs to. Loftis accentuated her muscle mass rather than hiding it in her fluff. Small details, like the sporty black tip of her ears, helped add some edge.

Overall, though, Hopps's design process was relatively easy for the team. "Hopps is one of those lucky instances where we captured her character in the design early on and have just been refining her ever since," says Loftis. "She hasn't had many problems and has been a touchstone whenever we've had difficulties designing other characters. Everything just worked on her."

Cory Loftis / digital

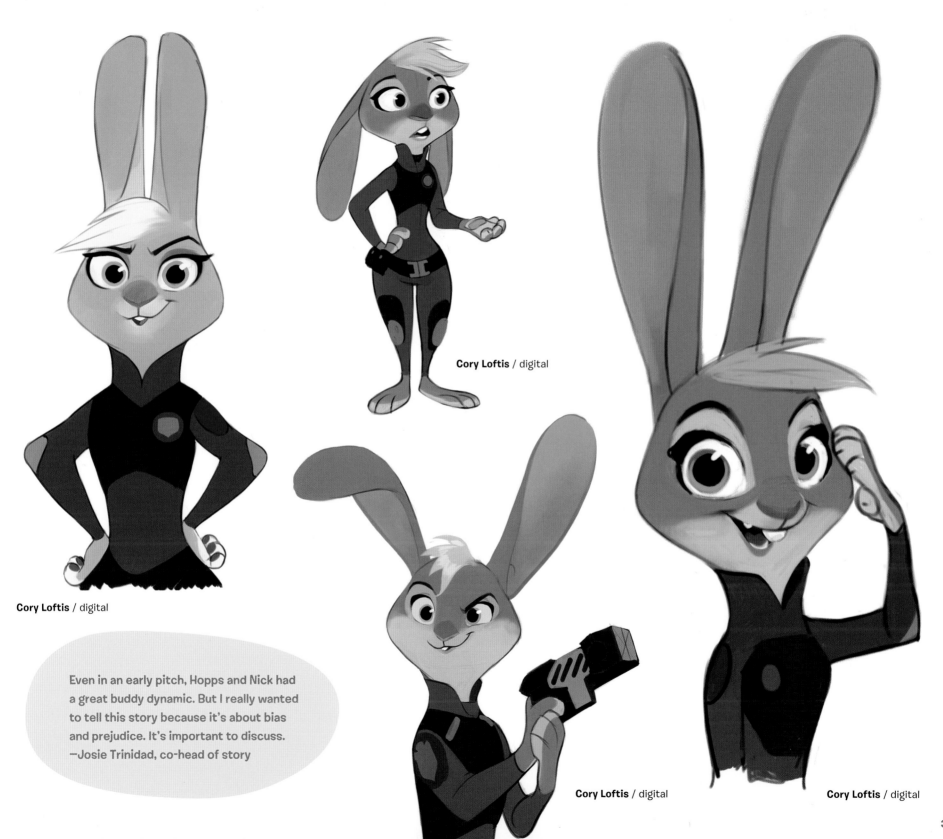

Cory Loftis / digital

Cory Loftis / digital

Even in an early pitch, Hopps and Nick had a great buddy dynamic. But I really wanted to tell this story because it's about bias and prejudice. It's important to discuss.
—Josie Trinidad, co-head of story

Cory Loftis / digital

Cory Loftis / digital

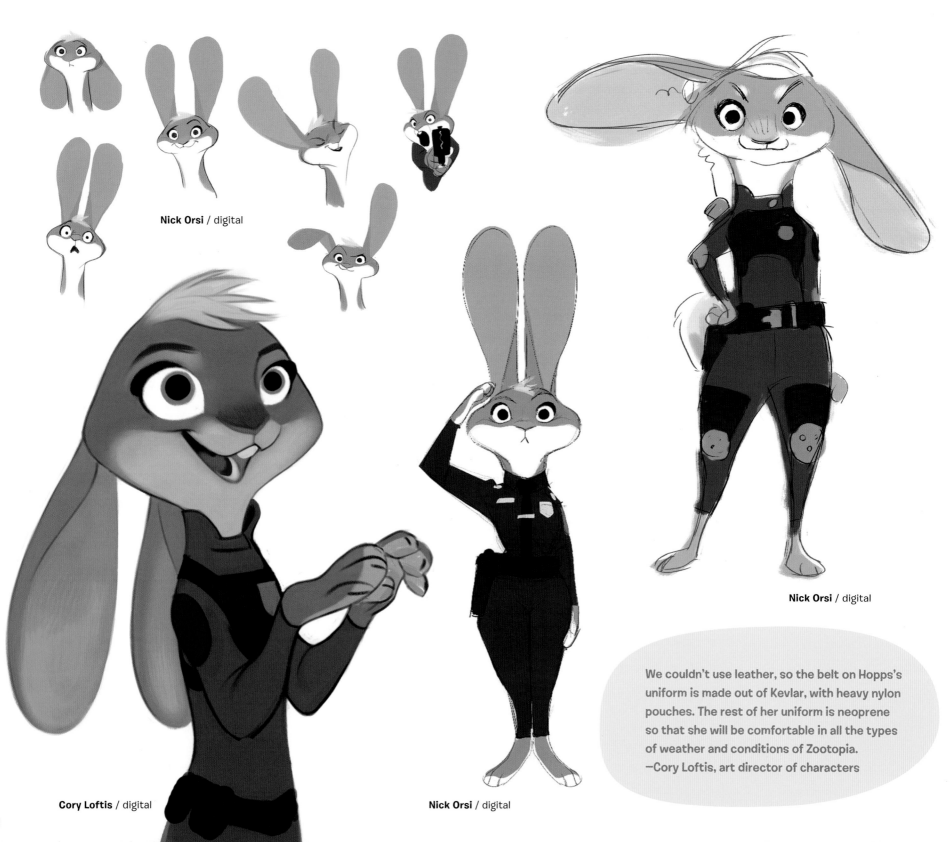

Nick Orsi / digital

Cory Loftis / digital

Nick Orsi / digital

Nick Orsi / digital

We couldn't use leather, so the belt on Hopps's uniform is made out of Kevlar, with heavy nylon pouches. The rest of her uniform is neoprene so that she will be comfortable in all the types of weather and conditions of Zootopia.
—Cory Loftis, art director of characters

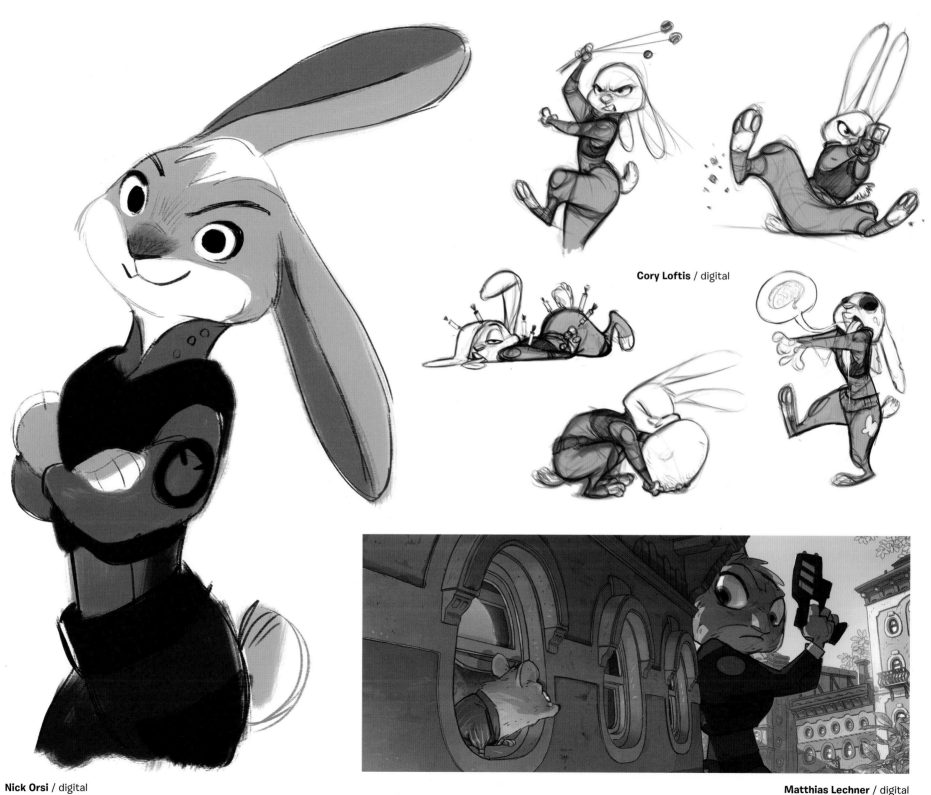

Nick Orsi / digital

Cory Loftis / digital

Matthias Lechner / digital

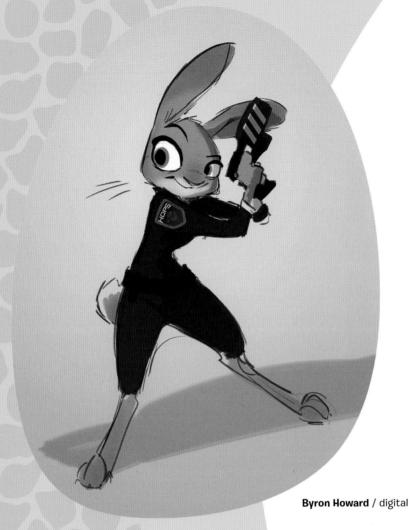

Byron Howard / digital

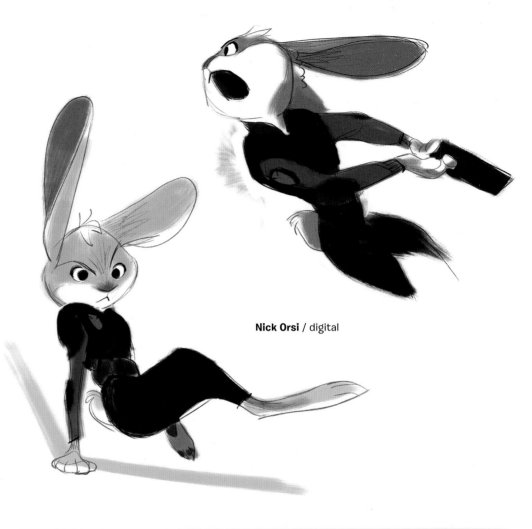

Nick Orsi / digital

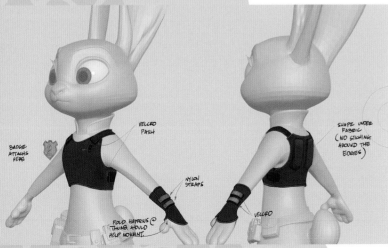

BADGE
ATTACHS
HERE

VELCRO
PATCH

NYLON
STRAPS

FOLD HAPPENS @
THUMB, SHOULD
HELP MOVANT.

VELCRO

SHAPE UNDER
FABRIC
(NO STICHING
AROUND THE
EDGES)

Cory Loftis / (draw over) digital

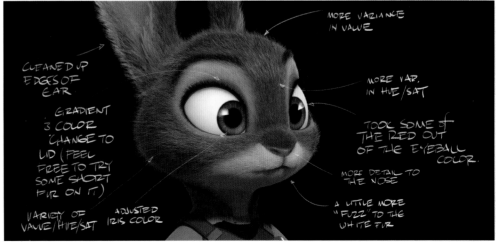

CLEANED UP
EDGES OF
EAR

GRADIENT
3 COLOR
CHANGE TO
LID (FEEL
FREE TO TRY
SOME SHORT
FUR ON IT)

VARIETY OF
VALUE/HUE/SAT

ADJUSTED
IRIS COLOR

MORE VARIANCE
IN VALUE

MORE VAR.
IN HUE/SAT

TOOK SOME OF
THE RED OUT
OF THE EYEBALL
COLOR

MORE DETAIL TO
THE NOSE

A LITTLE MORE
"FUZZ" TO THE
WHITE FUR

Cory Loftis / (draw over) digital

34

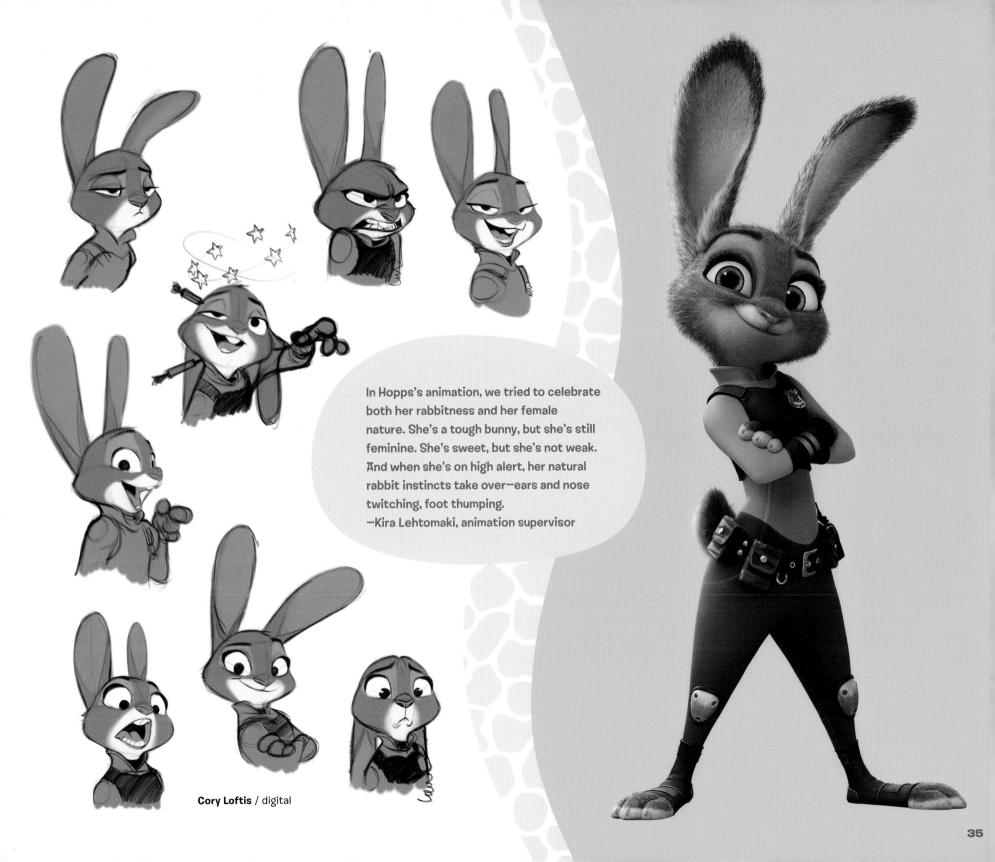

In Hopps's animation, we tried to celebrate both her rabbitness and her female nature. She's a tough bunny, but she's still feminine. She's sweet, but she's not weak. And when she's on high alert, her natural rabbit instincts take over—ears and nose twitching, foot thumping.
—Kira Lehtomaki, animation supervisor

Cory Loftis / digital

Nick Wilde

At the beginning of *Zootopia*, Nick Wilde seems to wholeheartedly buy into his stereotype as a sly fox. It's not until he tangles with ZPD Officer Judy Hopps that he starts to believe he could be something more than just a conman. "He's an honorable guy," says visual development artist Nick Orsi. "He took to the streets because he had to get by any way he could."

Nick was the first character designed for *Zootopia*, although his look changed quite a bit as the film progressed and his personality evolved. "He started out a slippery, Vegas-style conman, so everything about him was slicked back—sleek head design, sleek ears, snappy suit," says Cory Loftis, art director of characters. As the story developed, Nick became rougher around the edges and more laid-back. "If a character is too slick or too rough, it's hard to feel sympathy for them. We had to find the right balance with Nick. He's a hustler but he has a big heart and he's capable of being a good friend, so we softened him up a lot."

Nick's anatomy set the tone for all the other animals in Zootopia, and it was influenced by the reality of what the characters have to do in the film. "He has to wear pants, reach over his head, turn a doorknob, type, use a phone. He has to walk upright, so we had to decide whether his feet should be planted on the ground or if he would walk on his toes. We found middle ground for the anatomy, with some animal and some human aspects," says Loftis.

The biggest challenge for Nick was his fur. "Fox fur is complex. The way it clumps, the quality of the hair, the different colors in it—all that can distract focus from his face, where the emotion is," says Loftis. "We had to find a balance between design and realism."

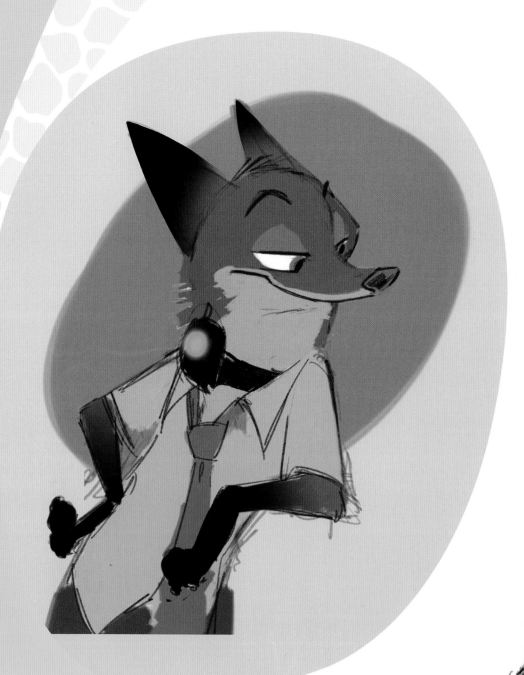

Byron Howard / digital

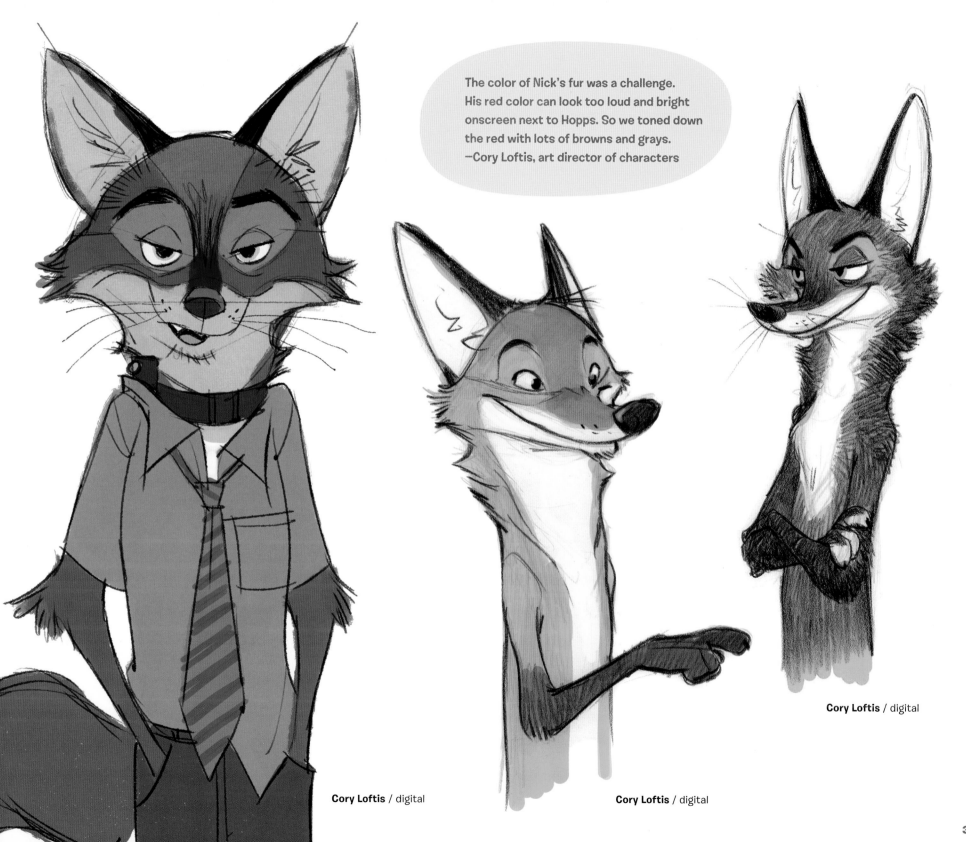

The color of Nick's fur was a challenge. His red color can look too loud and bright onscreen next to Hopps. So we toned down the red with lots of browns and grays.
—Cory Loftis, art director of characters

Cory Loftis / digital

Cory Loftis / digital

Cory Loftis / digital

Byron Howard / digital

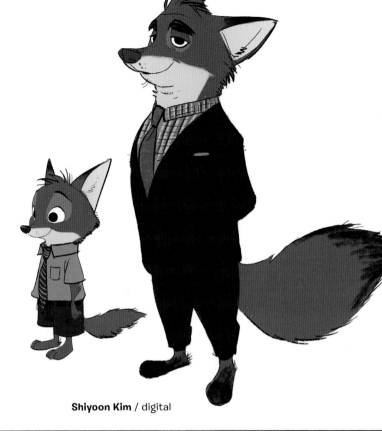

Shiyoon Kim / digital

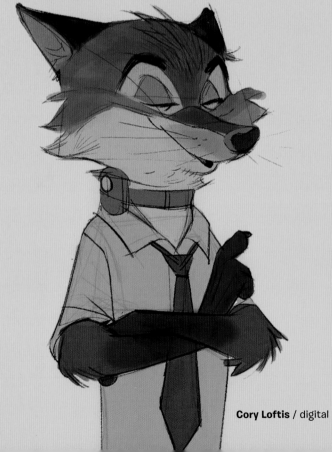

Cory Loftis / digital

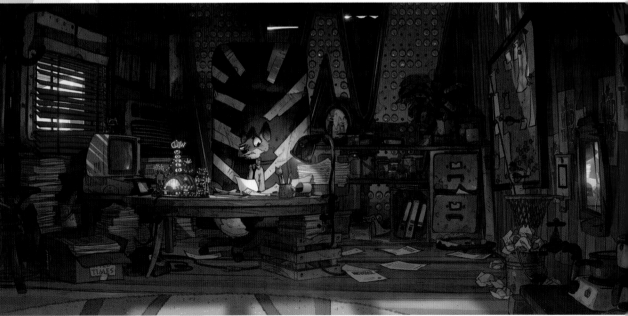

Matthias Lechner / digital

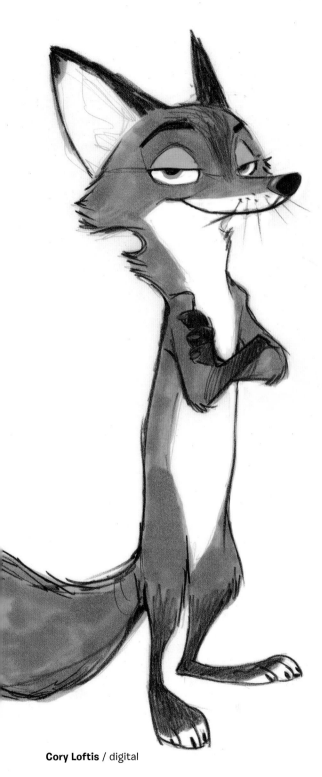

Cory Loftis / digital

Byron Howard / digital

Nick's a little lazy, which shows in his clothes. His shirt and tie are mismatched, the shirt isn't tucked in, and he probably tied the knot in his tie once and then just takes it off still knotted every night.
—Cory Loftis, art director of characters

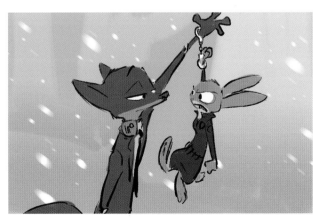

Byron Howard / digital

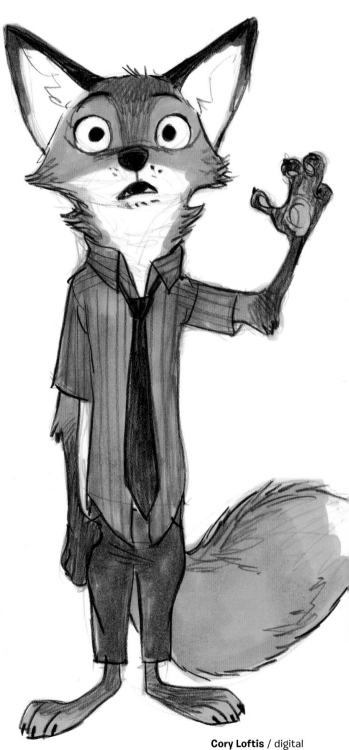

Cory Loftis / digital

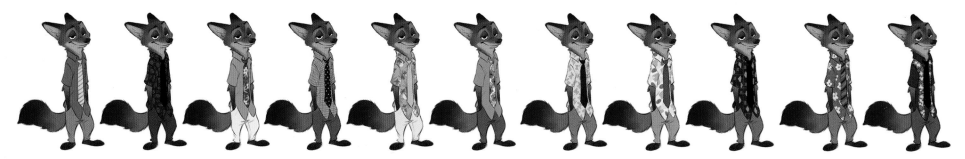

Cory Loftis / digital

Real foxes are efficient, quick, and very intelligent. Their thought process overlaps with their action—they think and react almost simultaneously. We tried to get that sense into Nick's animation.
—Tony Smeed, co-head of animation

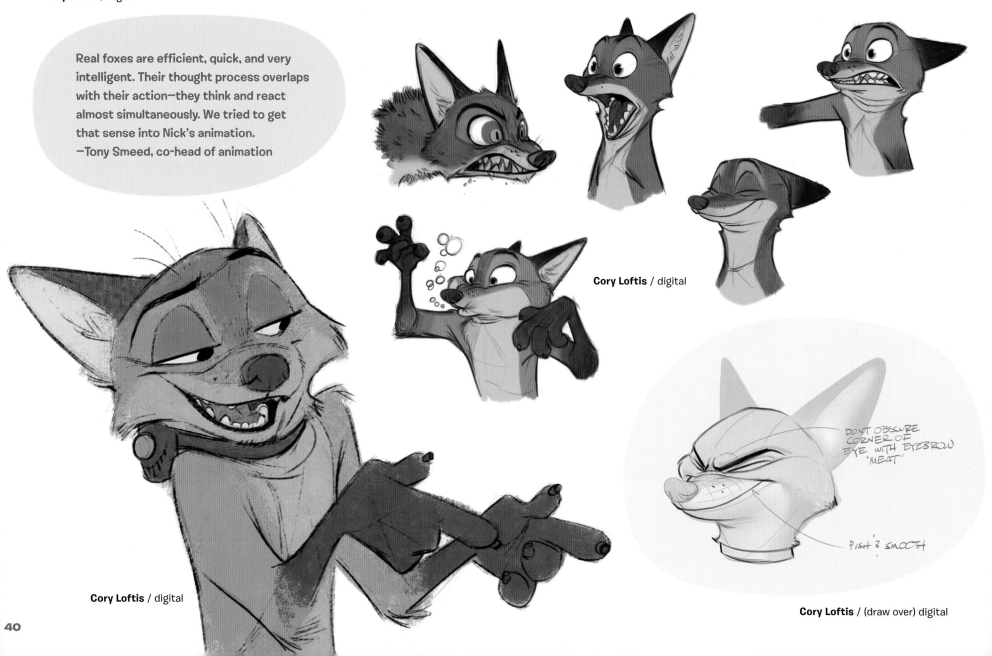

Cory Loftis / digital

Cory Loftis / digital

DON'T OBSCURE CORNER OF EYE WITH EYEBROW "MEAT"

PISH 3 SMOOTH

Cory Loftis / (draw over) digital

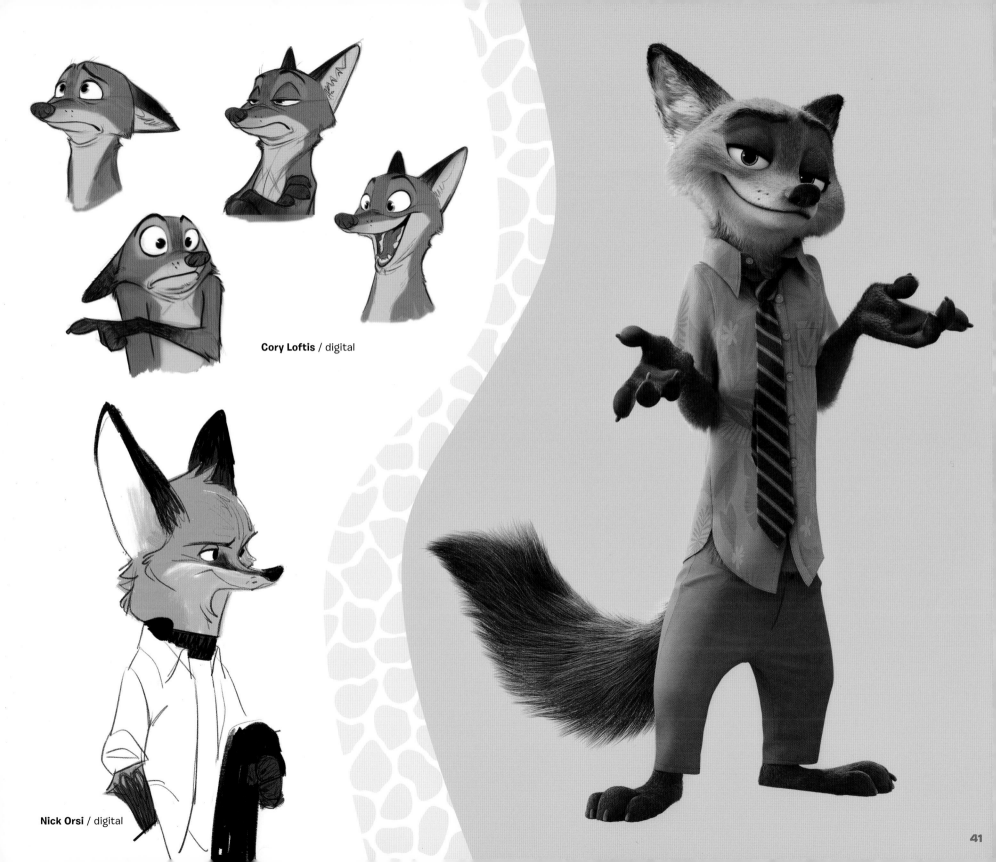

Cory Loftis / digital

Nick Orsi / digital

ZOOTOPIAN HABITATS

The city itself is a character in *Zootopia*. But how did this animal-created urban habitat come to be? How did the filmmakers determine where each neighborhood would go? "It was a long, wandering process," production designer Dave Goetz laughs. "[Executive producer] John Lasseter is a stickler for logic, so there had to be some rational basis for how this place developed."

Diving into research, Goetz discovered that animals in the wild often gather around a watering hole, an idea that was reinforced during the group's safari in Africa. Screenwriter and co-director Jared Bush was inspired by the sight. "All the animals hung out together. Natural enemies, predators and prey, were at peace. They weren't fighting or eating each other. It made us understand that our city shouldn't be divided along those lines either." The natural division for Zootopia's boroughs became environmental instead of animal-specific. Imagining that historically animals would have built their city around such a gathering place, art director of environments Matthias Lechner placed the watering hole at the center of the city and began to design the neighborhoods surrounding it.

The team visited Disney World's Animal Kingdom and several zoos to learn what an artificially created environment made by animals might look like. "Zootopia isn't a naturally occurring environment. All these animals together built this awesome place and they had the technology we do," says Bush. Director Byron Howard elaborates. "We tried a natural formation when trying to figure out how the city fit together. But that lost the idea that it's an artificially created place. In the end, it's designed almost like a theme park, like Disneyland." Lechner was pleased with the result. "The city center is in the middle, as it should be, with the different boroughs radiating out from it. You can get to any borough quickly but also travel around from district to district easily."

The actual layout ultimately came down to climate logic. Goetz and Lechner tried several different approaches the animals might have taken. Should it be based on precipitation levels? Elevation? Story progression? Nothing seemed quite right until the team landed on the idea of a climate wall. "It's basically a giant barrier filled with enormous heaters that warm the land the heaters point toward. The heaters themselves are powered by the exhaust from the huge air conditioners pointing the other direction to cool that side," explains Goetz. "So the desert of Sahara Square and frozen land of Tundratown always had to be adjacent, in order to share the climate wall."

Each borough has a distinct feel that the filmmakers hope will delight audiences. "They're animal environments mashed up with a human equivalent. Sahara Square is the desert plus Dubai, with lots of Moroccan architecture. The Rainforest District feels like the jungle plus Southeast Asia. Tundratown has a Russian feel," Bush enthuses. "And the bunnies dwell outside of the city in endless suburbs, because they need room to expand." Howard laughs. "I love every district for different reasons. I wish we could spend more time in each one, to explore even more in this Zoo-niverse."

David Goetz / digital
background: **Matthias Lechner** / digital
pages 42-43: **Matthias Lechner** / digital

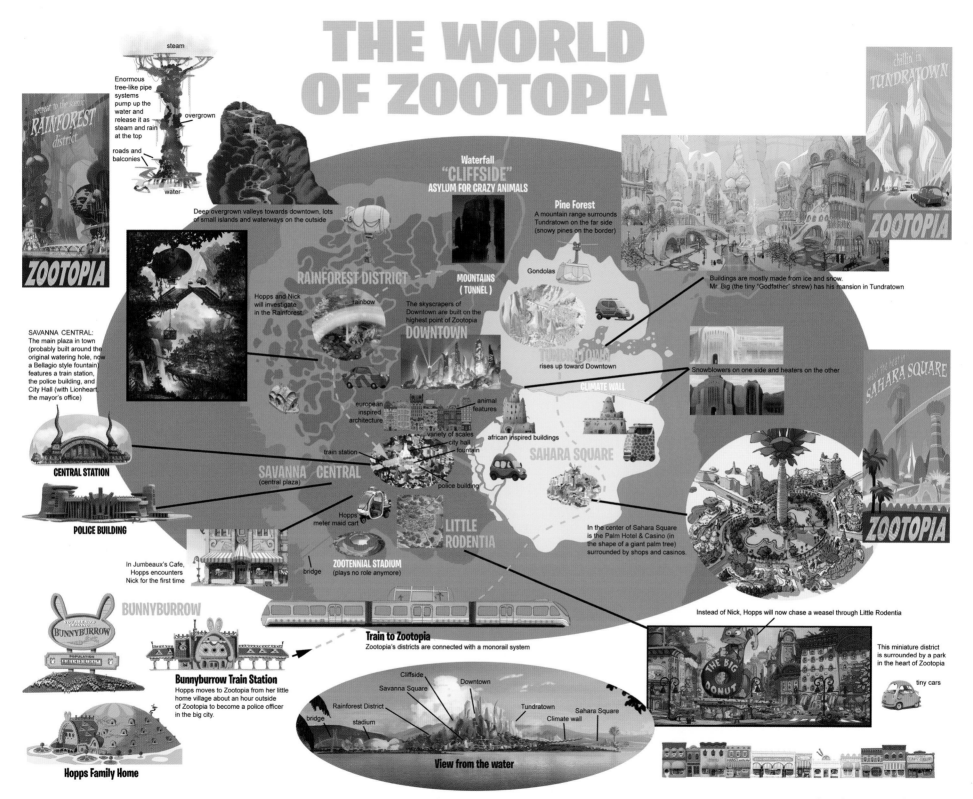

THE WORLD OF ZOOTOPIA

steam

Enormous tree-like pipe systems pump up the water and release it as steam and rain at the top

overgrown

roads and balconies

water

chillin in **TUNDRATOWN**

retreat to the scenic **RAINFOREST** district

ZOOTOPIA

Deep overgrown valleys towards downtown, lots of small islands and waterways on the outside

Waterfall
"CLIFFSIDE"
ASYLUM FOR CRAZY ANIMALS

Pine Forest
A mountain range surrounds Tundratown on the far side (snowy pines on the border)

ZOOTOPIA

RAINFOREST DISTRICT

Hopps and Nick will investigate in the Rainforest.

rainbow

MOUNTAINS (TUNNEL)

Gondolas

Buildings are mostly made from ice and snow.
Mr. Big (the tiny "Godfather" shrew) has his mansion in Tundratown

SAVANNA CENTRAL:
The main plaza in town (probably built around the original watering hole, now a Bellagio style fountain) features a train station, the police building, and City Hall (with Lionheart, the mayor's office)

The skyscrapers of Downtown are built on the highest point of Zootopia

DOWNTOWN

TUNDRATOWN

rises up toward Downtown

CLIMATE WALL

Snowblowers on one side and heaters on the other

meet the best in **SAHARA SQUARE**

european inspired architecture

animal features

variety of scales

city hall

fountain

african inspired buildings

SAHARA SQUARE

ZOOTOPIA

CENTRAL STATION

train station

police building

In the center of Sahara Square is the Palm Hotel & Casino (in the shape of a giant palm tree) surrounded by shops and casinos.

POLICE BUILDING

SAVANNA CENTRAL
(central plaza)

Hopps meter maid cart

LITTLE RODENTIA

In Jumbeaux's Cafe, Hopps encounters Nick for the first time

bridge

ZOOTENNIAL STADIUM
(plays no role anymore)

Instead of Nick, Hopps will now chase a weasel through Little Rodentia

BUNNYBURROW

YOU ARE NOW LEAVING **BUNNYBURROW**
POPULATION

Train to Zootopia
Zootopia's districts are connected with a monorail system

THE BIG DONUT

This miniature district is surrounded by a park in the heart of Zootopia

tiny cars

Bunnyburrow Train Station
Hopps moves to Zootopia from her little home village about an hour outside of Zootopia to become a police officer in the big city.

Cliffside

Savanna Square

Downtown

Rainforest District

bridge

stadium

Tundratown

Climate wall

Sahara Square

View from the water

Hopps Family Home

Matthias Lechner / digital

45

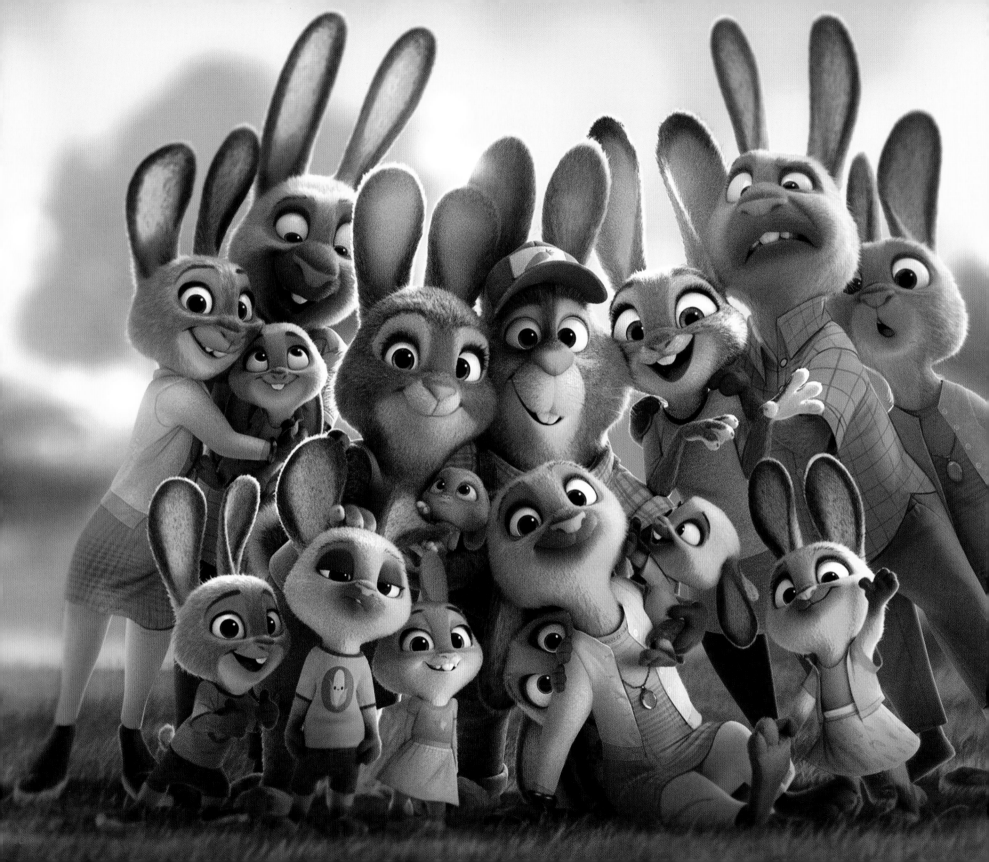

BUNNYBURROW

Bunnyburrow is a suburb on the outskirts of Zootopia, full of rolling fields and farmland. It's home to the bunnies, including the Hopps family. In earlier versions of the story, Judy was one of many bunnies in a family so large her father didn't even know her name, so the Bunnyburrow was designed to be a bit faceless as well. When the story evolved, so did the Bunnyburrow, becoming less of a massive mega-suburb and more of a perfect little small town, which Judy leaves behind to follow her dream of becoming a cop in Zootopia.

Production designer Dave Goetz and art director of environments Matthias Lechner initially envisioned a super-cute aesthetic for the area, with everything styled to suit a rabbit's needs, including a bunny-sized train station. "It feels like rabbit warrens, as if they were designed by Antoni Gaudí and Friedensreich Hundertwasser, combined with Sanrio. There are flowery tiles in the walls, no straight lines, and lots of little round holes like every bunny has a cubby," says Lechner. "Even the Easter egg–inspired colors reflect a bunny's point of view."

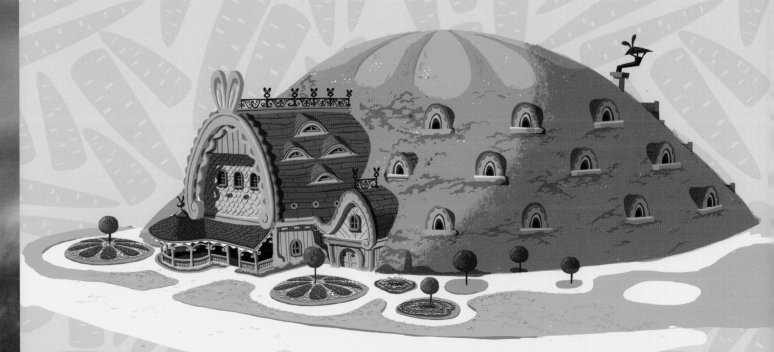

Cory Loftis / (paint over) digital

Mac George / digital

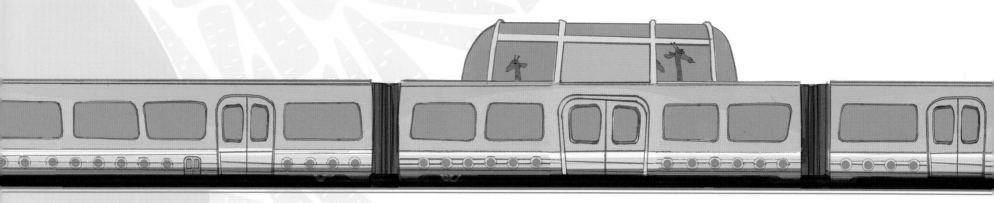

Justin Cram / digital

Trains in Zootopia are multi-scaled for animals of different sizes, with the bigger windows up top and smaller windows at bottom, and little seats underneath the larger seats. Since the Bunnyburrow train station is built for small animals, it only serves the bottom part of the train.
—Matthias Lechner,
 art director of environments

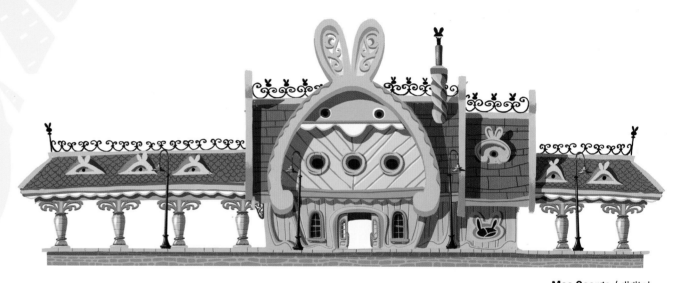

Mac George / digital

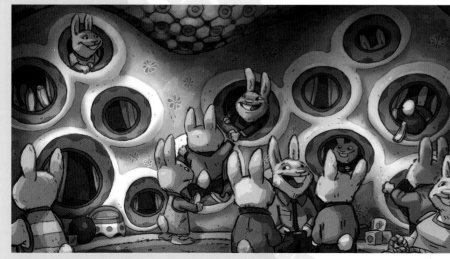

Matthias Lechner / digital

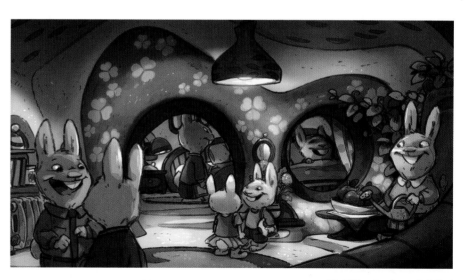

Matthias Lechner / digital

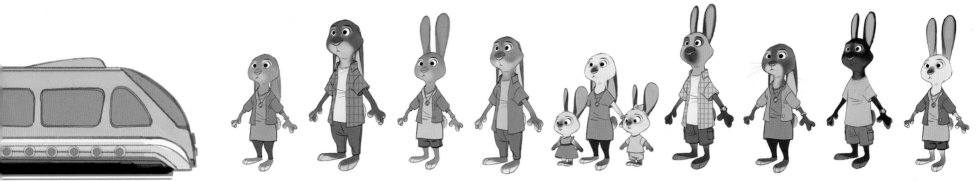

Cory Loftis / digital

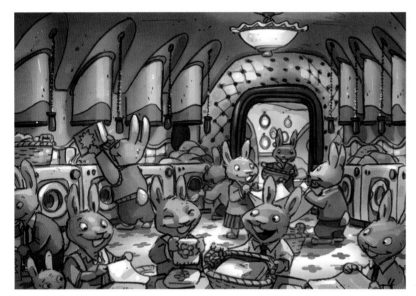

Matthias Lechner / digital

Matthias Lechner / digital

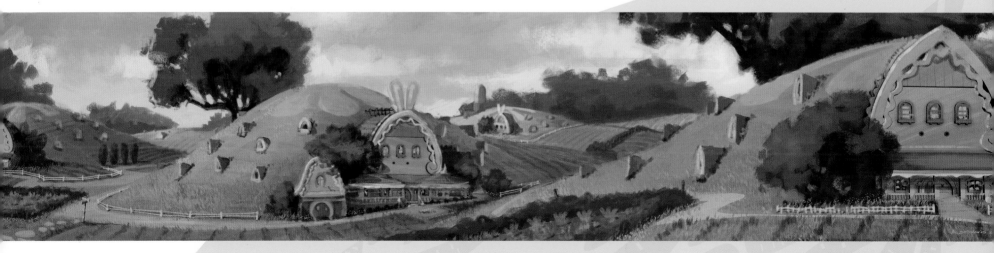

Armand Serrano / digital

The Hopps House

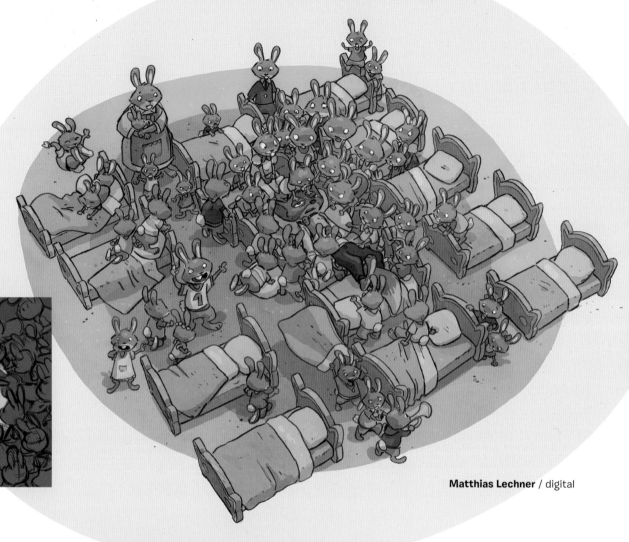

Matthias Lechner / digital

Nancy Kruse / digital

Matthias Lechner / digital

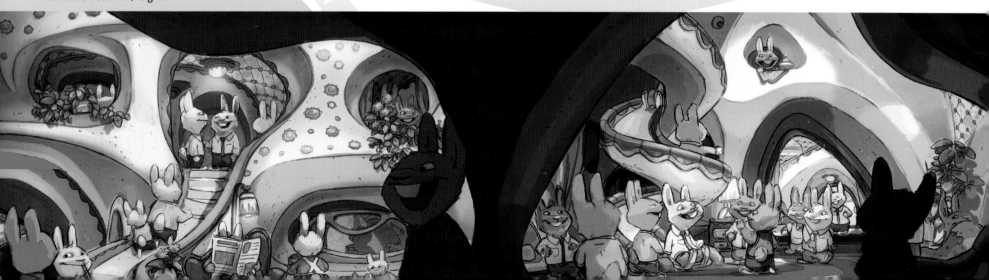

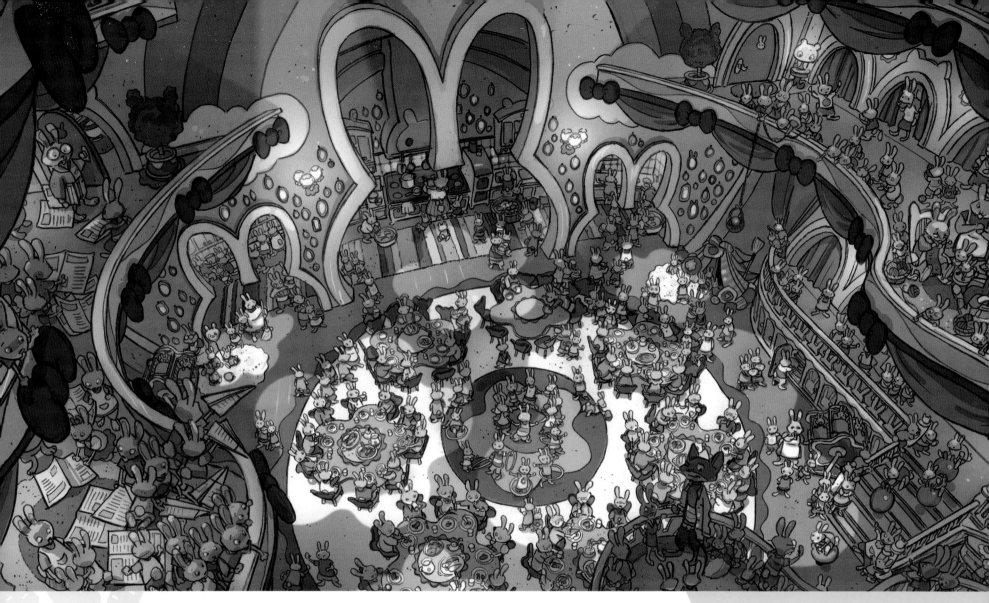

Matthias Lechner / digital

I drew a version of Hopps's family home that has 200 bunnies in it. There's a system to it. The interior is organized around a kitchen since they'd constantly have to cook. The dining area rotates, so everyone has time to eat while it turns. As diners leave, a team of children clears plates and sets the next table, so more bunnies can sit down to eat. That continues all day, just feeding everyone.
—Matthias Lechner, art director of environments

Mac George / digital

YOU ARE NOW LEAVING
BUNNYBURROW
POPULATION
0 8 1 4 3 5 7 1

Mac George / digital

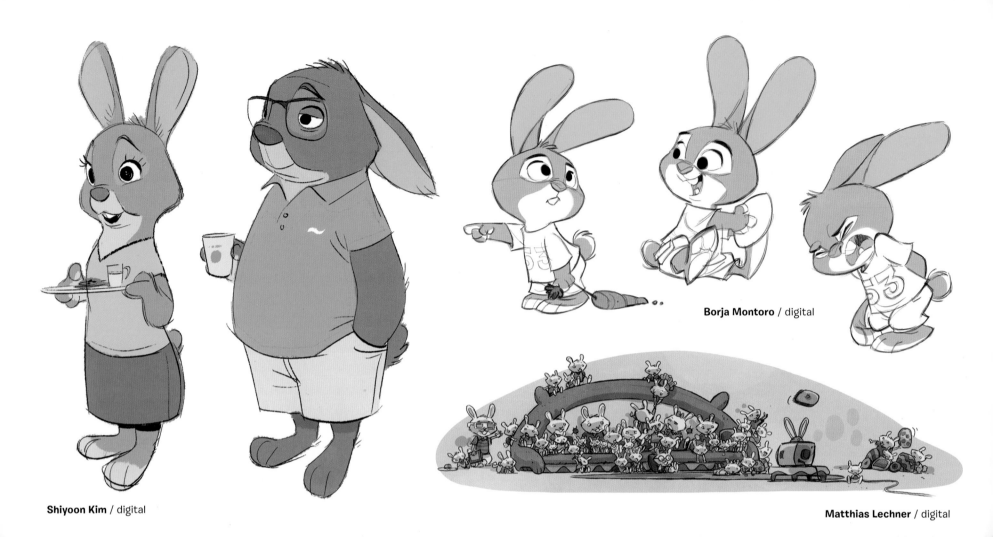

Shiyoon Kim / digital

Borja Montoro / digital

Matthias Lechner / digital

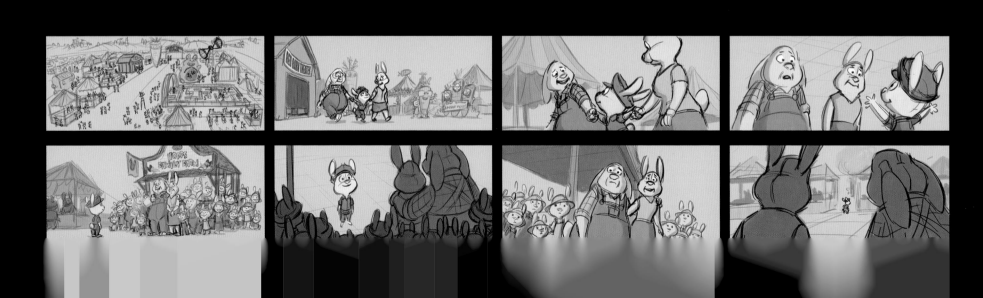

Matthias Lechner / digital

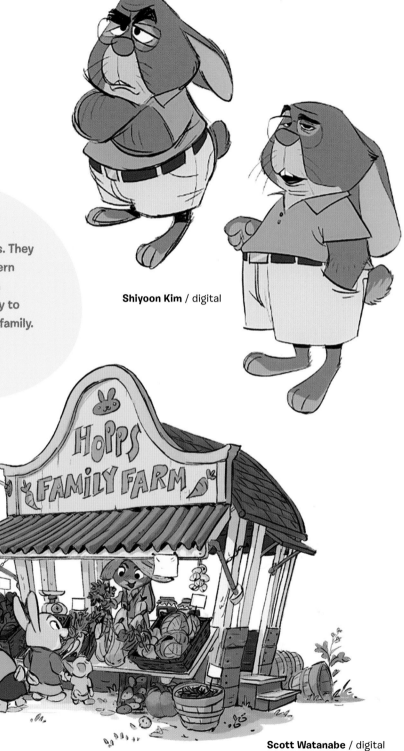

Shiyoon Kim / digital

For Hopps's family we designed softer, more traditional bunnies. They all have the same masking pattern around the face and eyes, and a similar range of colors from gray to light brown to identify them as family. —Cory Loftis, art director of characters

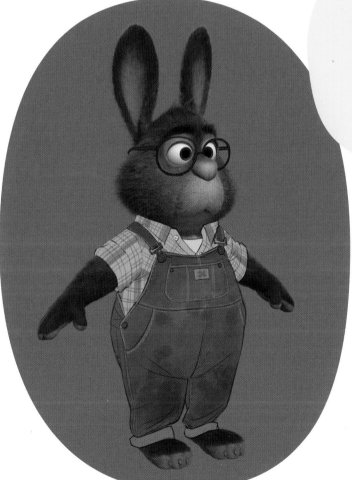

Cory Loftis / (paint over) digital

Scott Watanabe / digital

Woodlands Elementary School

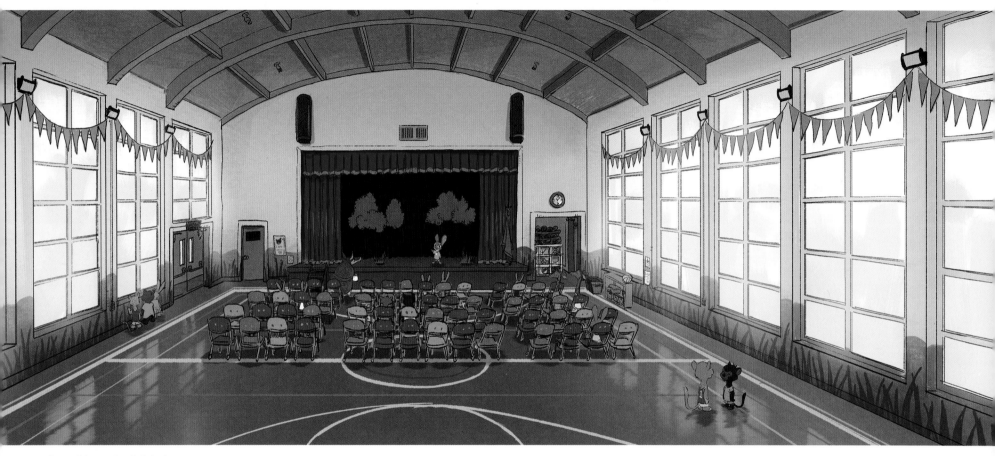

Scott Watanabe / digital

Scott Watanabe / digital

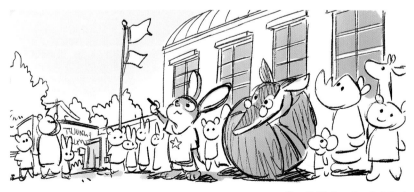

Scott Watanabe / digital

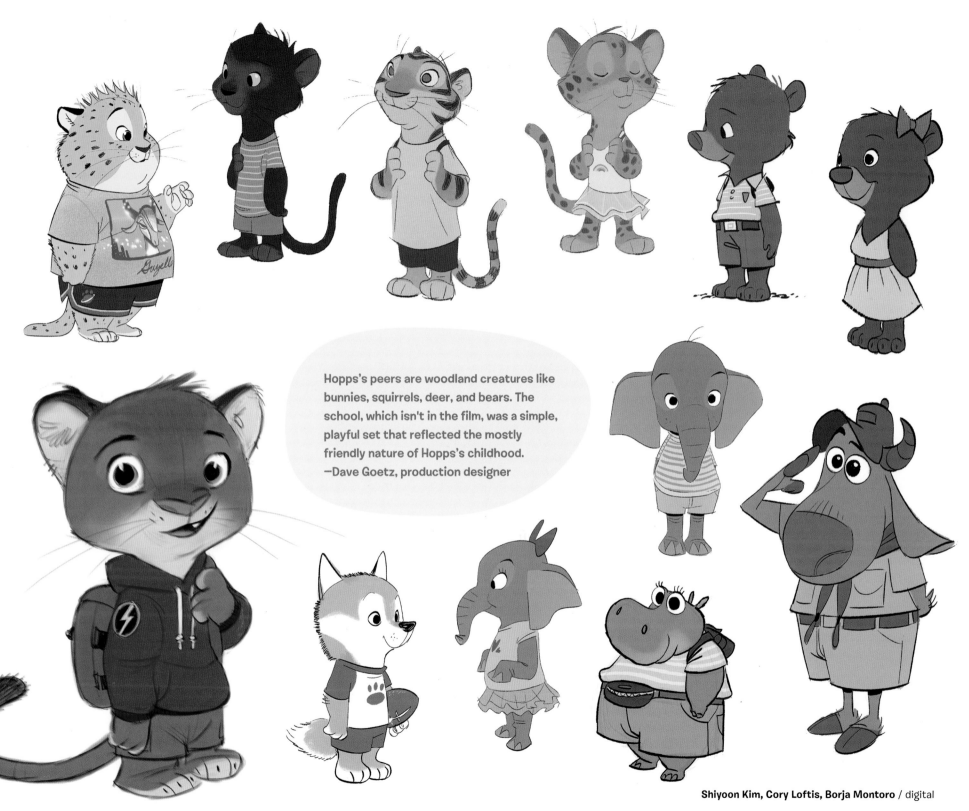

Hopps's peers are woodland creatures like bunnies, squirrels, deer, and bears. The school, which isn't in the film, was a simple, playful set that reflected the mostly friendly nature of Hopps's childhood.
—Dave Goetz, production designer

Shiyoon Kim, Cory Loftis, Borja Montoro / digital

Carrot Days

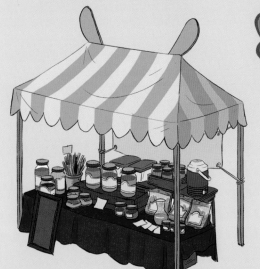

Scott Watanabe / digital

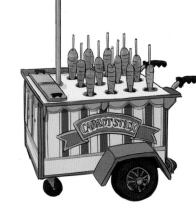

Signage: **Mac George** / digital

Scott Watanabe / digital

The Carrot Days festival is the first scene you see in *Zootopia*. At first, it had rides and fairground attractions, but we stripped it down to simple farmers' market booths to fit more with the Bunnyburrow environment.
—Matthias Lechner,
art director of environments

Scott Watanabe / digital

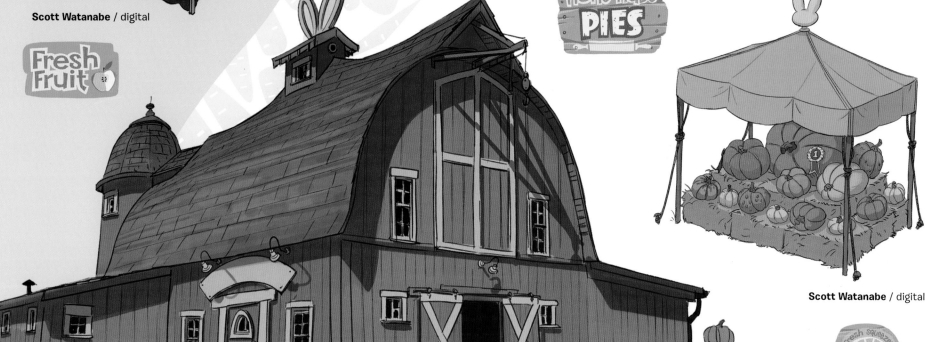

Scott Watanabe / digital

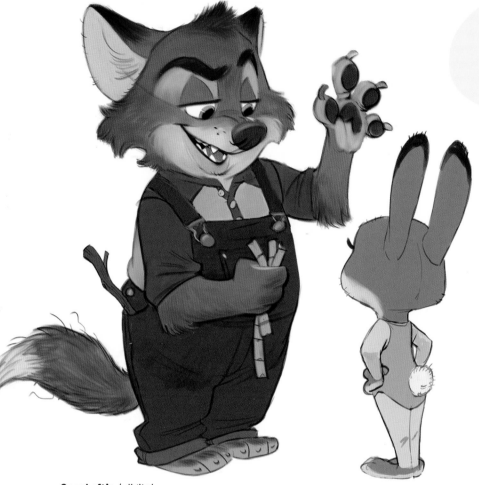

Gideon Grey embodies the worst parts of bad children. He's a bully, probably mean to bugs, and carries around a solid stick for breaking stuff.
—Cory Loftis, art director of characters

Cory Loftis / digital

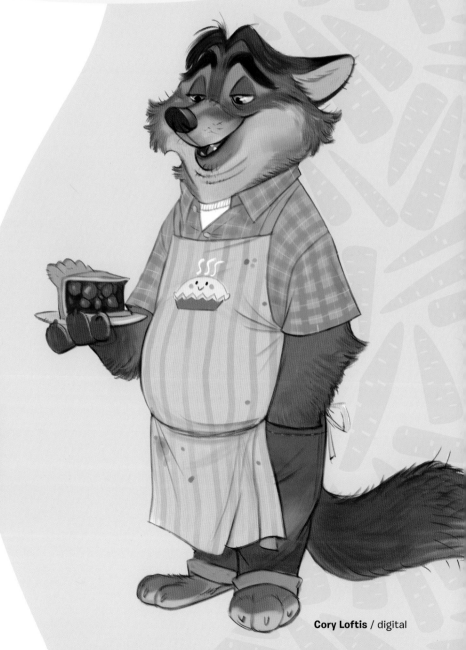

Cory Loftis / digital

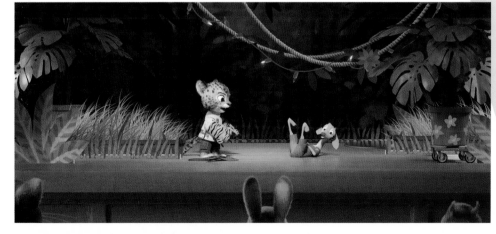

Matthias Lechner / (paint over) digital

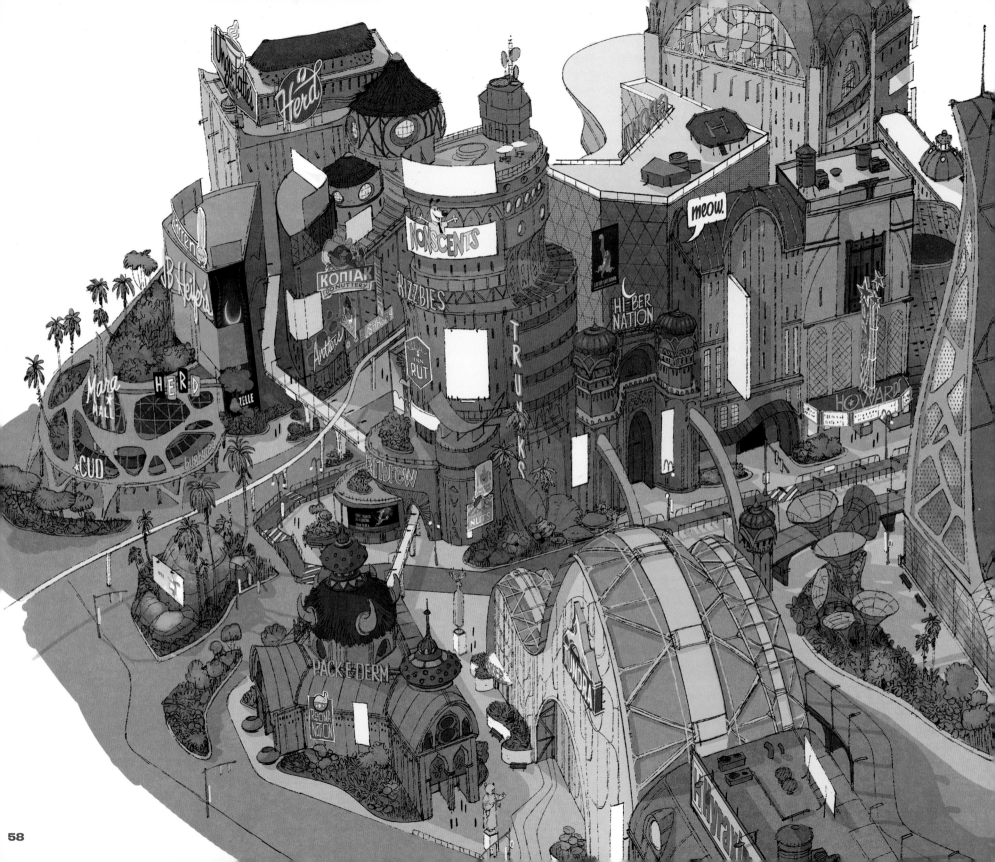

DOWNTOWN ZOOTOPIA

When Hopps leaves Bunnyburrow for the big city, she glimpses different parts of Zootopia from her train. But it's not until she steps into Savanna Central Plaza in Downtown Zootopia that she really gets her first experience of the metropolis. "It's like she's entered Times Square during rush hour. All the research we did—on climate, light, architecture, animal behavior—it all hits you at once in that area," says Howard. "The size, scale, and sheer volume of animals in one place create a very real, overwhelming experience."

Downtown is the crossroads of Zootopia, where Hopps encounters animals of all types and sizes, from the rhinos and lions of ZPD and City Hall, to the elephants and mice in Jumbeaux's Café and Little Rodentia. To add to the feeling of urban chaos, Zootopia's downtown area has buildings from every era and in every style. "When you're creating a whole metropolis like this, you have to include a sense of history to make it feel rich. There are buildings that are twenty, thirty, even one hundred years old," Goetz points out. "City Hall is ultra modern. The train station has a classic European feel. The police station is a minimalist structure with an almost soviet look to it. That can make designing everything harder, but it ends up feeling more like a real place."

Cory Loftis / digital

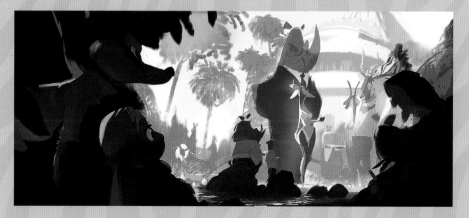

Nick Orsi / digital

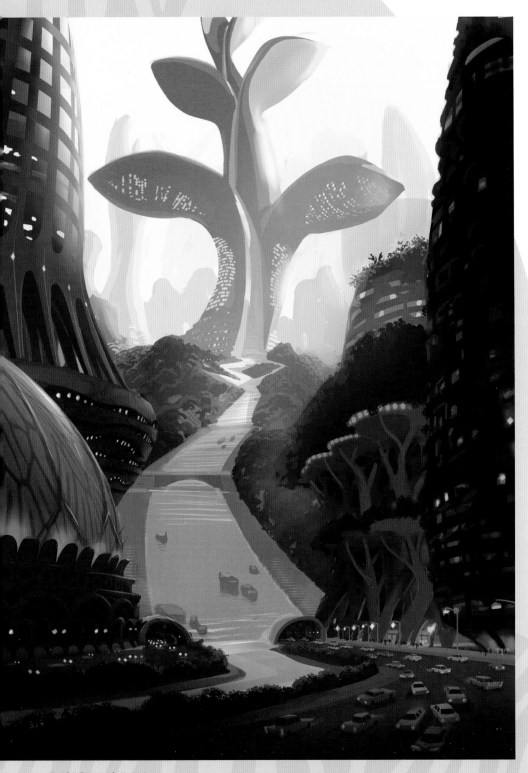

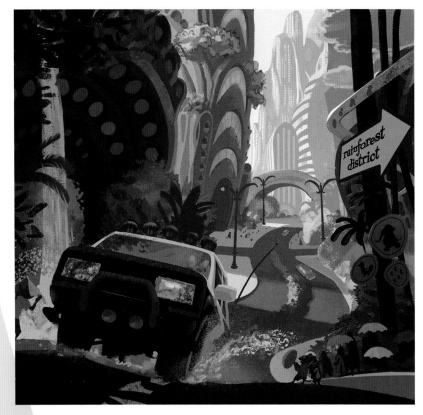

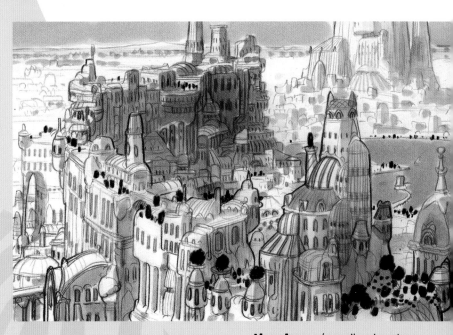

David Goetz / digital

David Goetz / digital

Manu Arenas / pencil and marker

Matthias Lechner / digital

The Plaza is framed by the biggest buildings. The train station is across from the ZPD, with City Hall on the left, all facing each other. The daily migrations occur in the middle of all of this.
—Dave Goetz, production designer

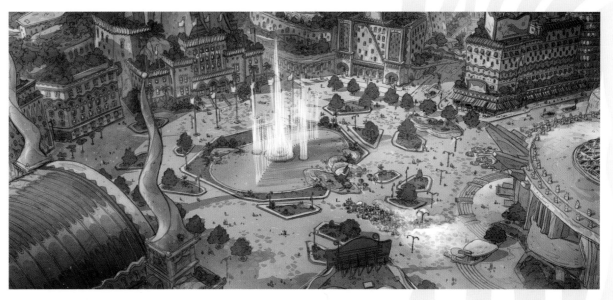

Matthias Lechner / digital

Savanna Central Station

Savanna Central Plaza is one of my favorite environments because everything is mixed together. It's the best combination of Europe and North America, of animals and humans.
—Byron Howard, director

Matthias Lechner / digital

Matthias Lechner / digital

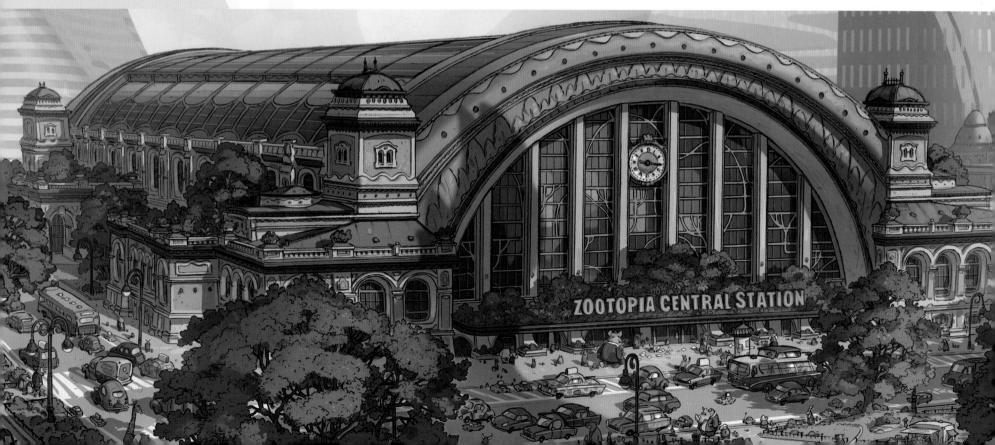

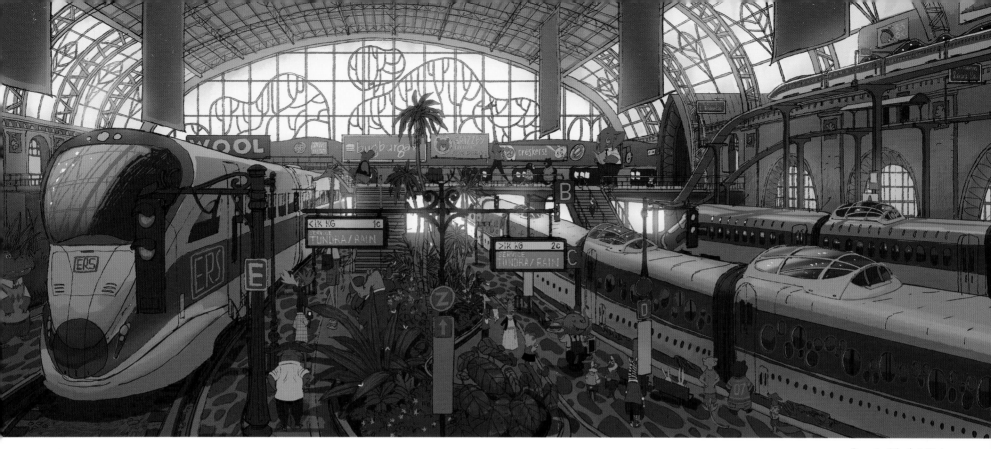

Cory Loftis / digital

Jim Martin / digital

Savanna Central Station's interior is meant to evoke a forest, with pillars and foliage. We used smaller patterns of zigzags and wavy, grass-inspired lines throughout, particularly in the stained glass on the front.
—Matthias Lechner, art director of environments

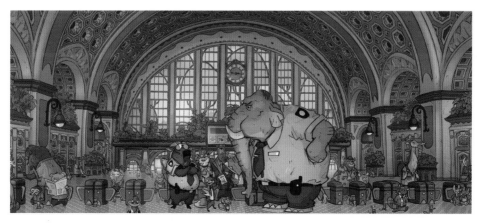

Matthias Lechner / digital

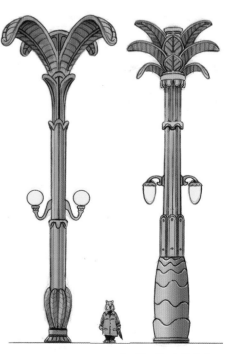

Jim Martin / digital

Nick Orsi / digital

Cory Loftis / digital

Shiyoon Kim / digital

Herd animals have a natural way of moving together—sixty of the same animal doing the same thing. We put that into the Plaza, with fifteen giraffes walking in a group, one hundred wildebeests getting off a tram together. It evokes our human world, but their behavior makes them animals.
—Jared Bush, screenwriter and co-director

Nick Orsi / digital

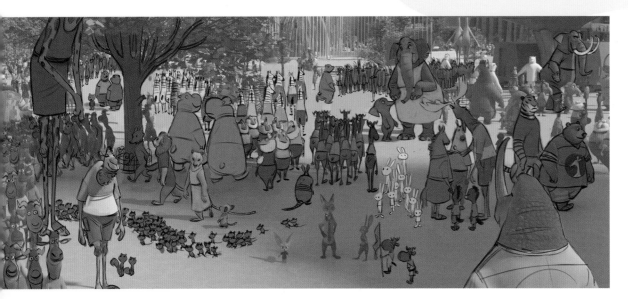

Cory Loftis / digital

Cory Loftis / (draw over) digital

Cory Loftis / digital

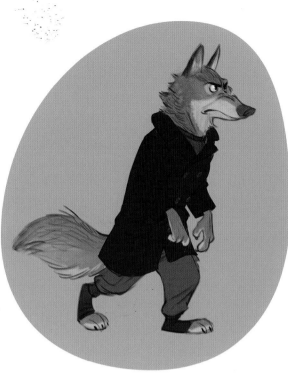

Cory Loftis / digital

Cory Loftis / digital

Cory Loftis / digital

You can't apply the same locomotion mechanics to a zebra as a giraffe or a bunny. Each character's rhythm is affected by the way a head moves and flows, by the weight of the animal, by its posture.
—Renato dos Anjos,
　　co-head of animation

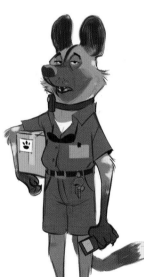

Cory Loftis / digital

Jim Finn / digital

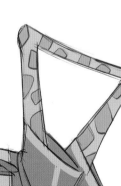

Borja Montoro / digital

Gazelle

Gazelle's mission is to spread a message of unity among animals of all types. She is an international pop star, so she has sophisticated design details—her horns have an almost seashell iridescence and are chiseled into a cool swoop. She has color on her eyelids, and almost human-like proportions.

—Jim Finn, visual development artist

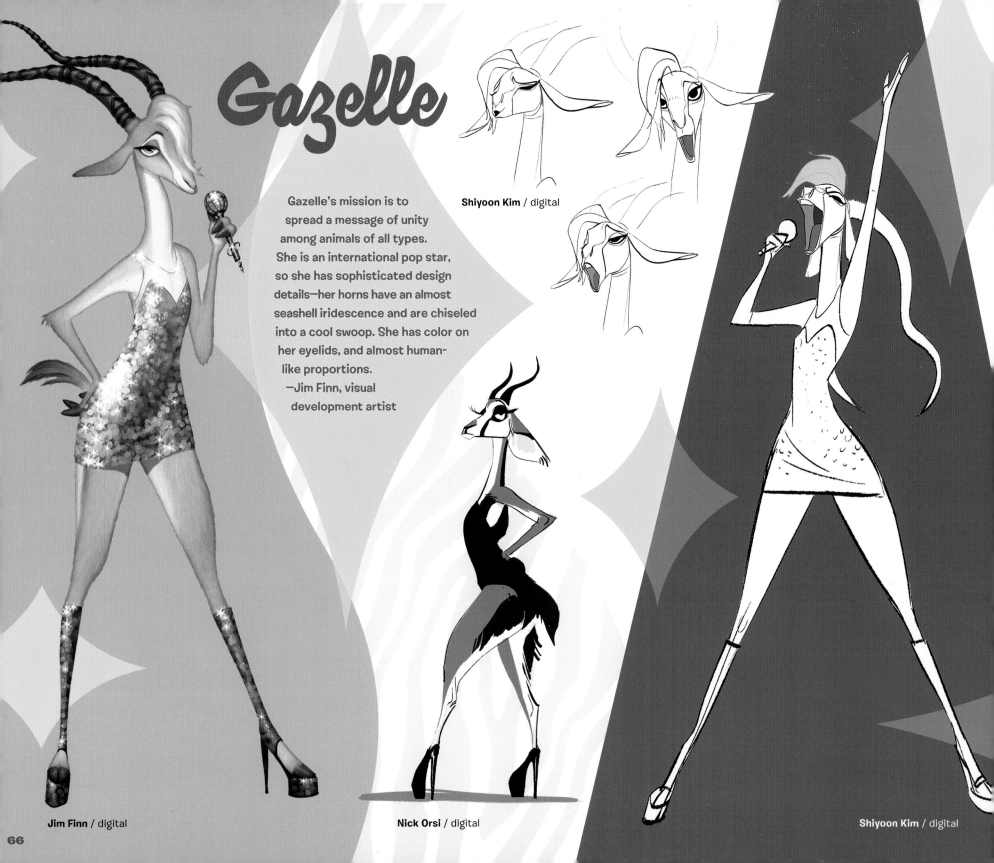

Shiyoon Kim / digital

Jim Finn / digital

Nick Orsi / digital

Shiyoon Kim / digital

Shiyoon Kim / digital

Shiyoon Kim / digital

David Goetz / digital

Shiyoon Kim / digital

In order to have Gazelle walk upright we had to cheat the natural anatomy of her leg. What looks like the knee on the animal is actually the heel, and the heel-to-toe length is much longer than a human's. We tapered it into a graceful shape, and had her stand on her toes as if she's wearing high heels to get the fluidity you see with a real gazelle.
—Shiyoon Kim, visual development artist

Nick Orsi / digital

ZPD

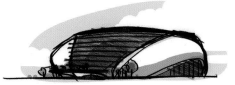

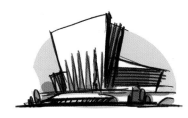

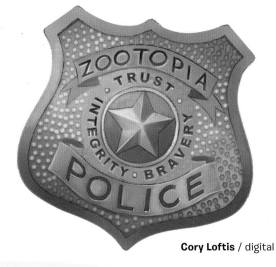

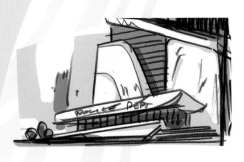

Matthias Lechner / digital

Cory Loftis / digital

The ZPD is an architectural mix between the crown's rays on the Statue of Liberty and the rock slabs of Stonehenge, representing power and strength in one building. The interior is very utilitarian, and designed for animals much bigger than Hopps.
—Matthias Lechner, art director of environments

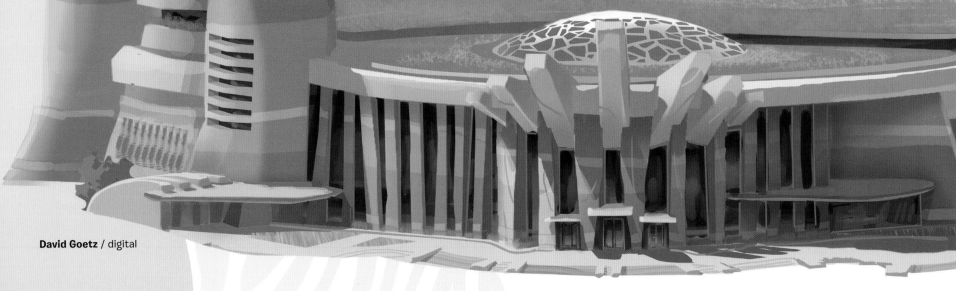

David Goetz / digital

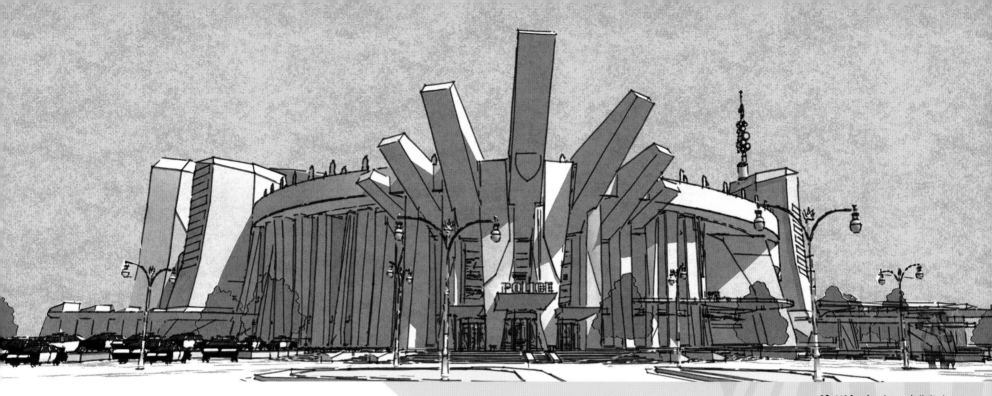

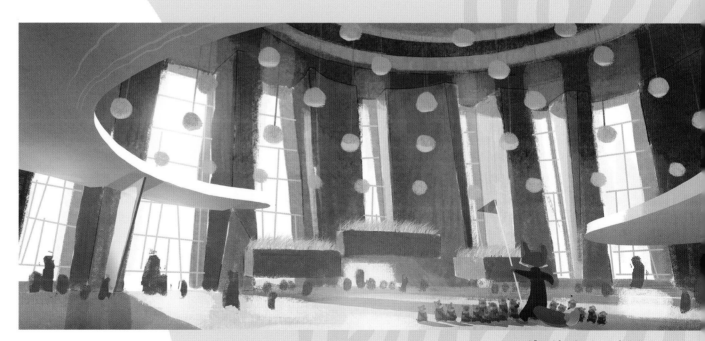

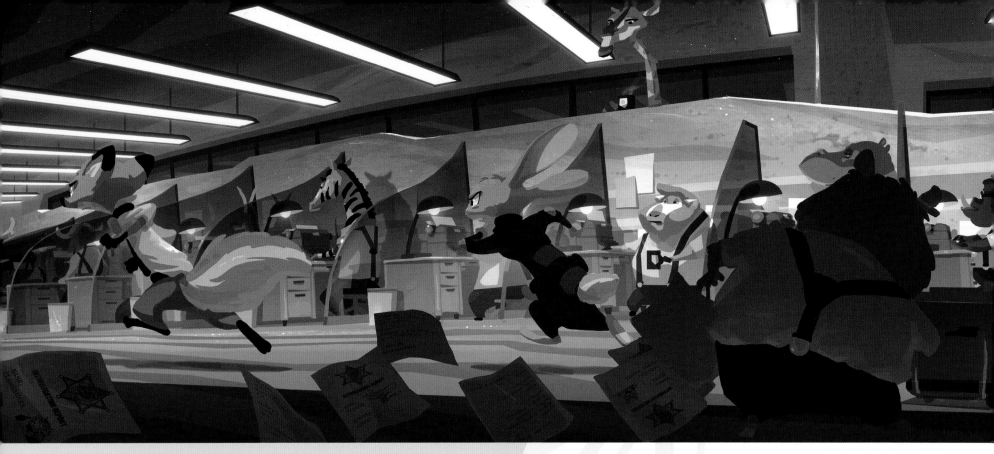

Matthias Lechner / digital

In an early version of the story, bunnies were phone operators routing calls for the ZPD. They sent messages in containers pushed by mice through pneumatic tubes. It was like a bunny internet.
—Dave Goetz, production designer

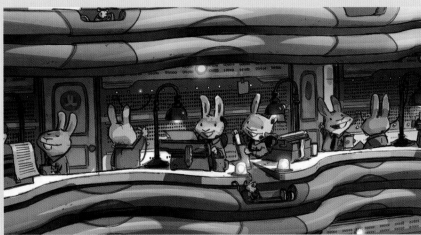

Matthias Lechner / digital

Matthias Lechner / digital

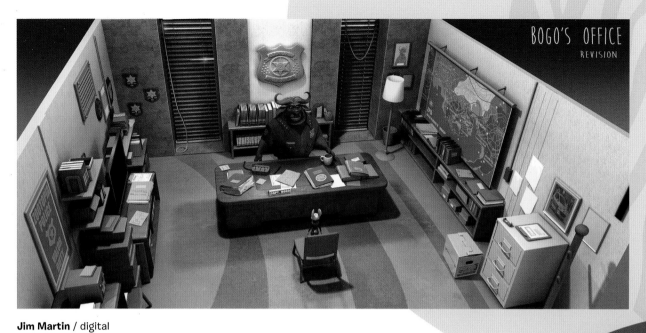

BOGO'S OFFICE
REVISION

Jim Martin / digital

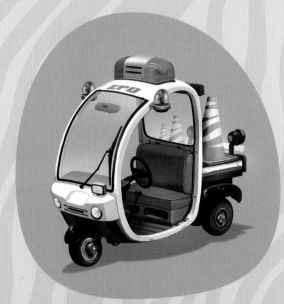

Jim Martin / digital

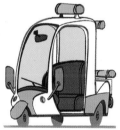

Justin Cram / digital

Jim Martin / digital

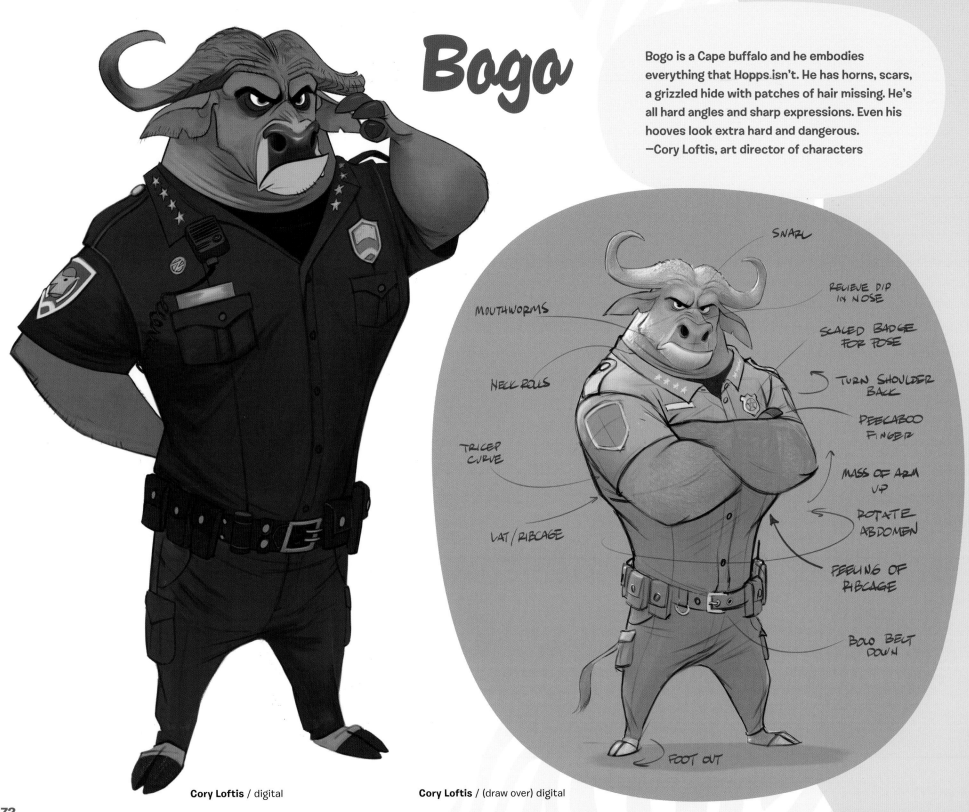

Bogo

Bogo is a Cape buffalo and he embodies everything that Hopps isn't. He has horns, scars, a grizzled hide with patches of hair missing. He's all hard angles and sharp expressions. Even his hooves look extra hard and dangerous.
—Cory Loftis, art director of characters

SNARL

RELIEVE DIP IN NOSE

SCALED BADGE FOR POSE

TURN SHOULDER BACK

PEEKABOO FINGER

MASS OF ARM UP

ROTATE ABDOMEN

FEELING OF RIBCAGE

BOLO BELT DOWN

MOUTHWORMS

NECK ROLLS

TRICEP CURVE

LAT / RIBCAGE

FOOT OUT

Cory Loftis / digital

Cory Loftis / (draw over) digital

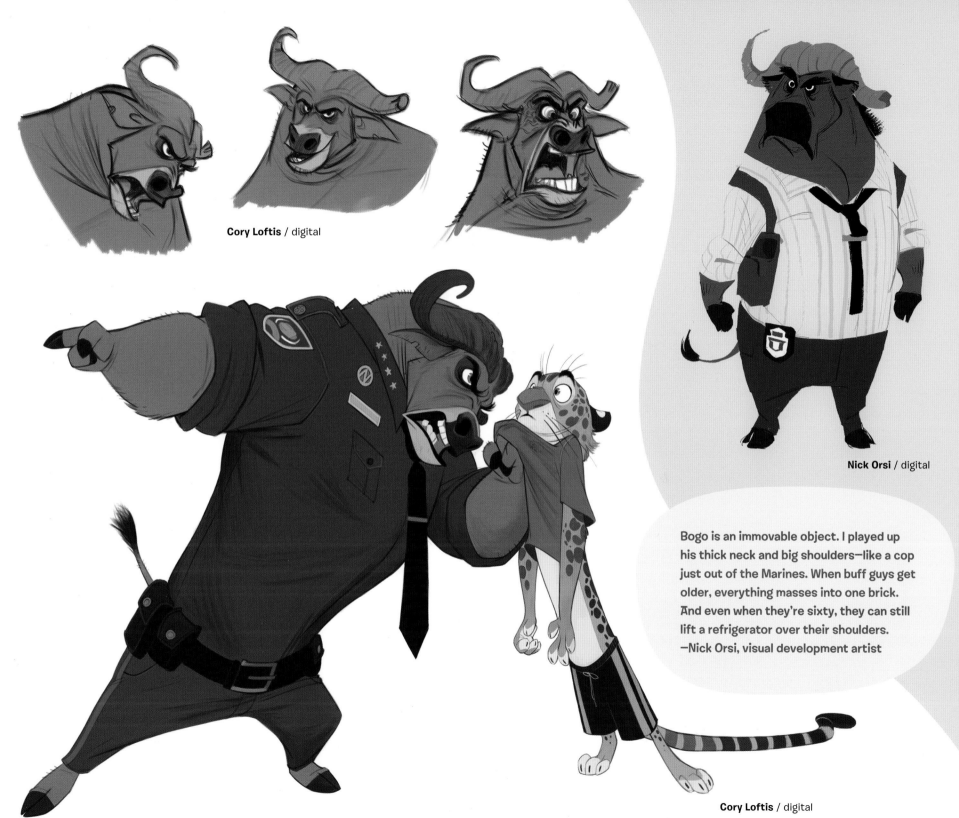

Cory Loftis / digital

Nick Orsi / digital

Bogo is an immovable object. I played up his thick neck and big shoulders—like a cop just out of the Marines. When buff guys get older, everything masses into one brick. And even when they're sixty, they can still lift a refrigerator over their shoulders.
—Nick Orsi, visual development artist

Cory Loftis / digital

Clawhauser

Clawhauser's spots are not random. They are crisper than naturally-occurring spots, the yellows punchier, the division between colors more purposeful. He even has a hidden Mickey in his cheek.
—Cory Loftis, art director of characters

Borja Montoro / digital

Cory Loftis / digital

Cory Loftis / digital

Cory Loftis / digital

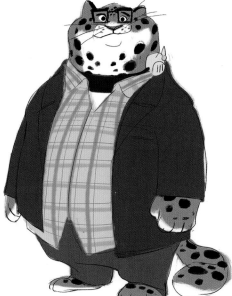

Nick Orsi / digital

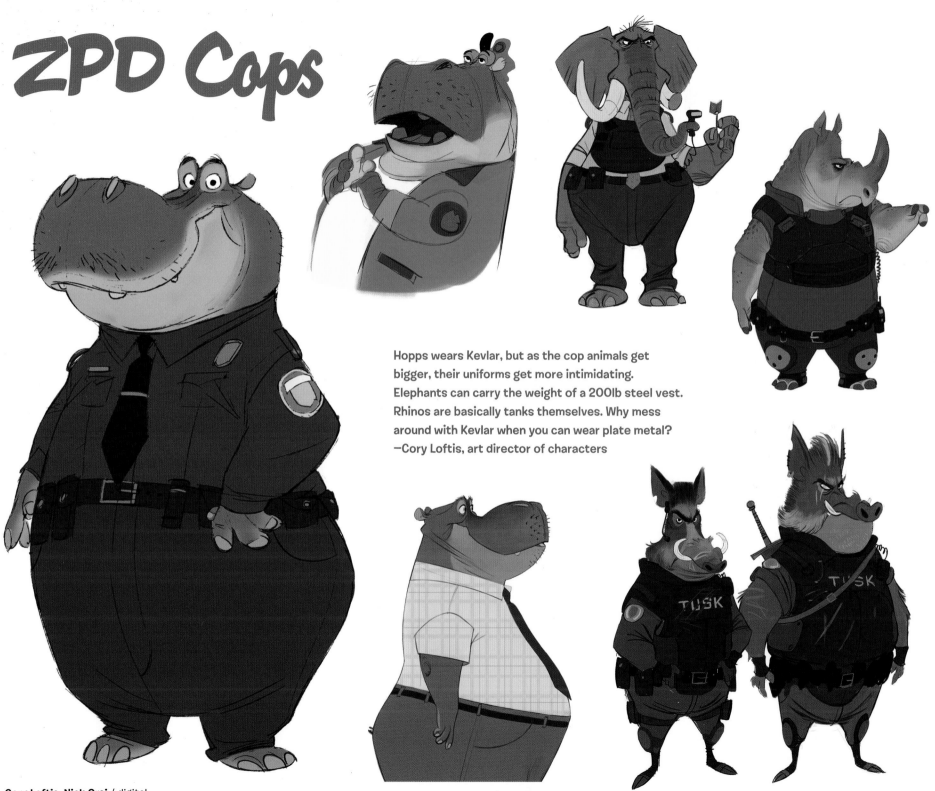

ZPD Cops

Hopps wears Kevlar, but as the cop animals get bigger, their uniforms get more intimidating. Elephants can carry the weight of a 200lb steel vest. Rhinos are basically tanks themselves. Why mess around with Kevlar when you can wear plate metal?
—Cory Loftis, art director of characters

Cory Loftis, Nick Orsi / digital

City Hall

The waterfall on City Hall originally was a symbol of unity between two pinnacles—predators and prey.
—Matthias Lechner, art director of environments

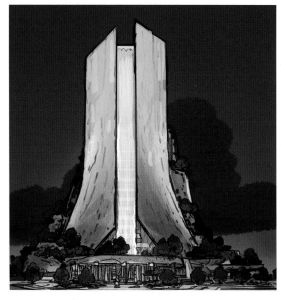

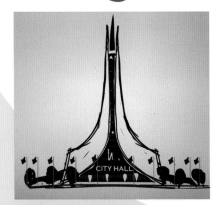

Matthias Lechner / digital

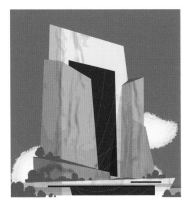

Matthias Lechner / digital

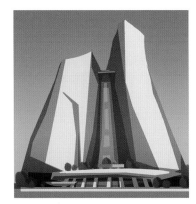

Matthias Lechner / digital

Matthias Lechner / digital

Matthias Lechner / digital

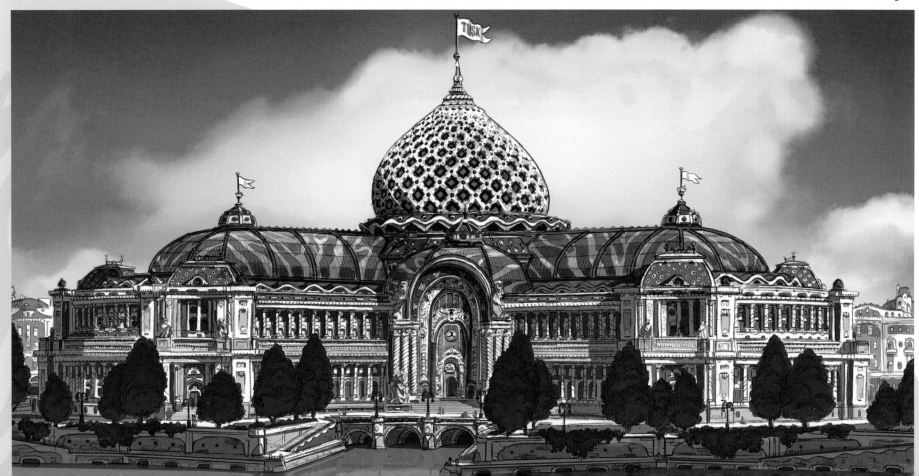

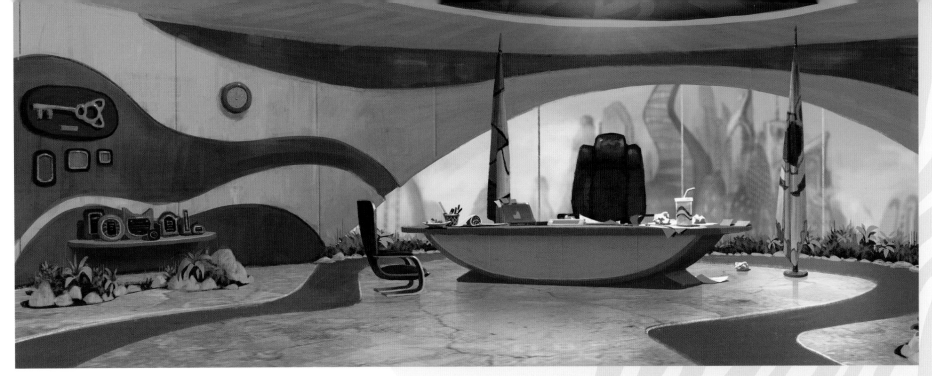

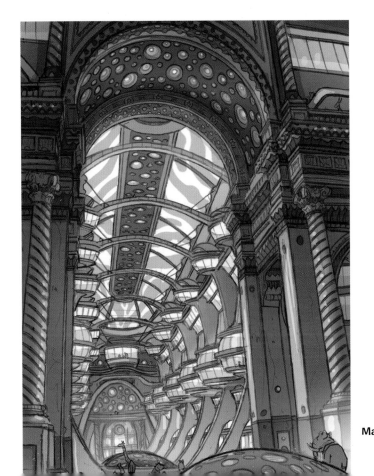

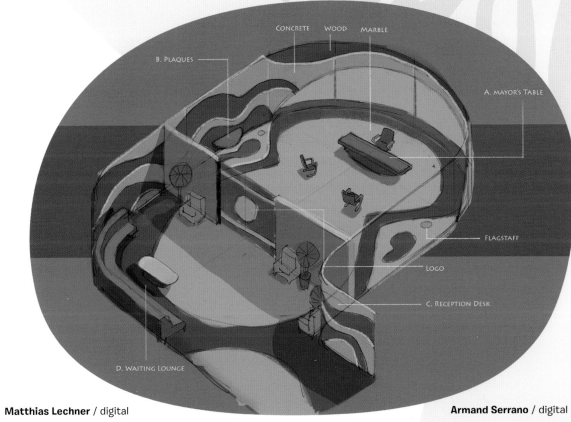

CONCRETE WOOD MARBLE

B. PLAQUES

A. MAYOR'S TABLE

FLAGSTAFF

LOGO

C. RECEPTION DESK

D. WAITING LOUNGE

Lionheart

Lionheart's big mane covers up his tie and collar, so in early designs he looked like he was wearing a fabric leotard or onesie. It's difficult to design a mane that looks natural since long hair can look crazy. It's styled, but not too combed or slick; it still looks like a lion's mane.
—Cory Loftis, art director of characters

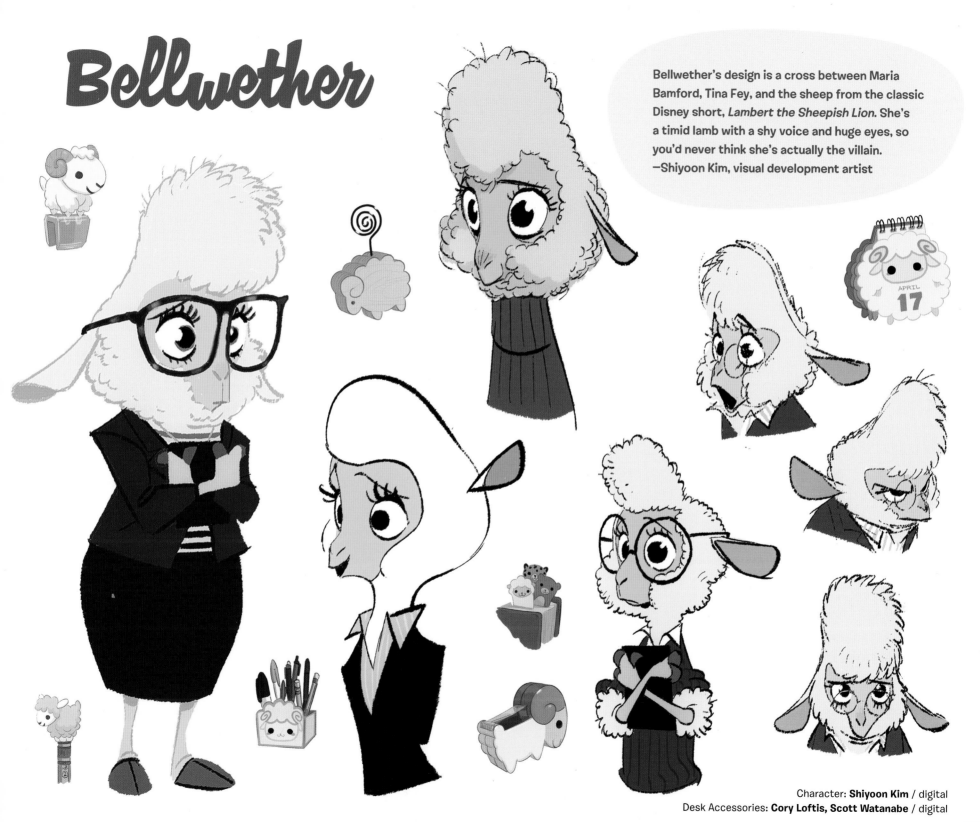

Bellwether

Bellwether's design is a cross between Maria Bamford, Tina Fey, and the sheep from the classic Disney short, *Lambert the Sheepish Lion*. She's a timid lamb with a shy voice and huge eyes, so you'd never think she's actually the villain.
—Shiyoon Kim, visual development artist

APRIL 17

Character: **Shiyoon Kim** / digital
Desk Accessories: **Cory Loftis, Scott Watanabe** / digital

Jumbeaux's Café

Jumbeaux's Café is set up to cater primarily to elephants. Everything is jumbo-sized. It's an 1890s-style ice cream shop with pachyderm motifs, from the Egyptian-style frieze outside, to the elephant faces, ears, and trunks in the décor.
—Matthias Lechner, art director of environments

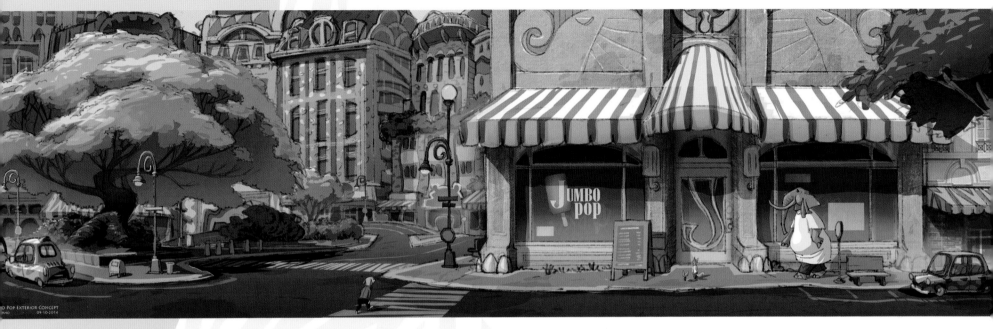

Armand Serrano / digital

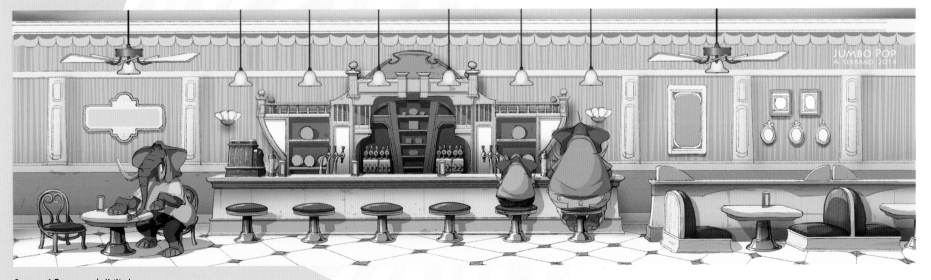

Armand Serrano / digital

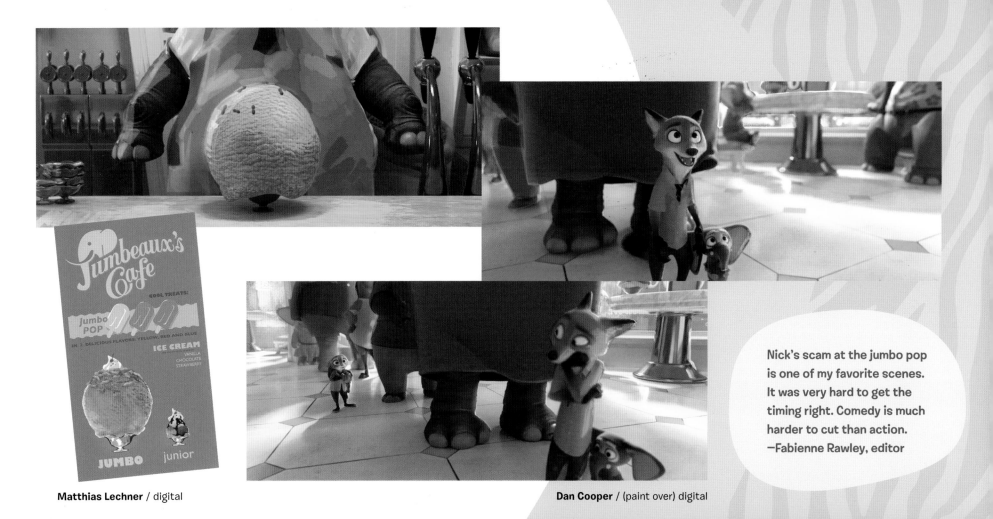

Matthias Lechner / digital

Dan Cooper / (paint over) digital

Nick's scam at the jumbo pop is one of my favorite scenes. It was very hard to get the timing right. Comedy is much harder to cut than action.
—Fabienne Rawley, editor

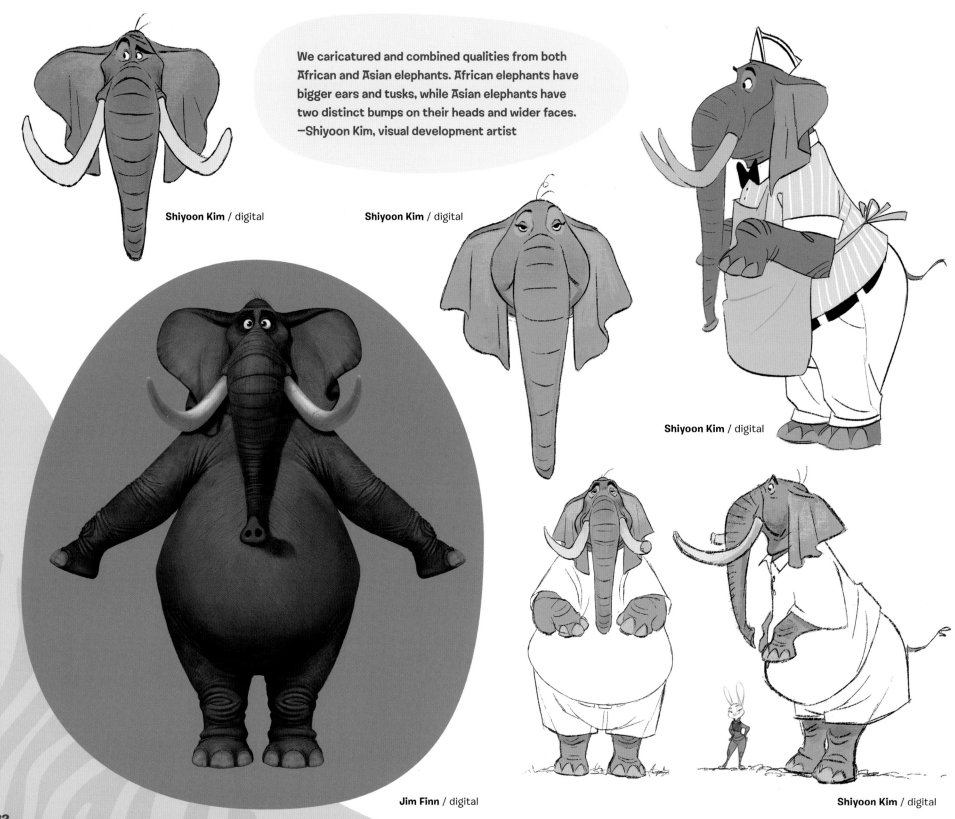

We caricatured and combined qualities from both African and Asian elephants. African elephants have bigger ears and tusks, while Asian elephants have two distinct bumps on their heads and wider faces.
—Shiyoon Kim, visual development artist

Shiyoon Kim / digital

Shiyoon Kim / digital

Shiyoon Kim / digital

Jim Finn / digital

Shiyoon Kim / digital

Finnick

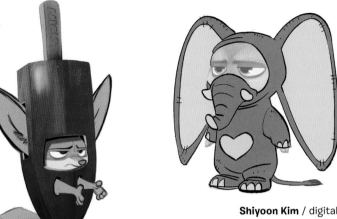

Borja Montoro / digital

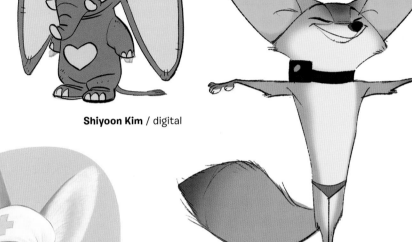

Shiyoon Kim / digital

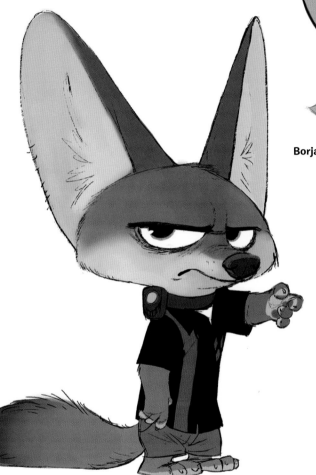

Cory Loftis / digital

Cory Loftis / digital

Cory Loftis / digital

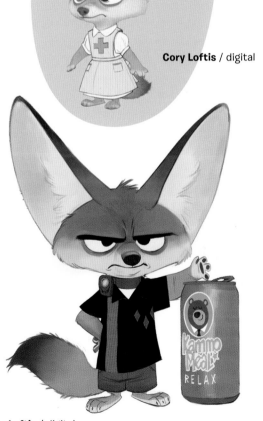

Cory Loftis / digital

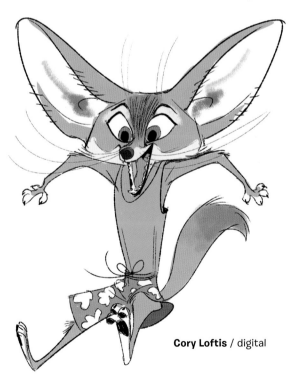

Cory Loftis / digital

There is a comedic aspect to Finnick's personality that comes from the way he speaks. We made a choice to match that temperament in his animation, instead of the dispositions of real fennec foxes who are very erratic and nervous creatures, constantly moving around.
—Renato dos Anjos, head of animation

Little Rodentia

Little Rodentia is a tiny mammal-only residential park in the center of Downtown Zootopia, surrounded by large buildings. It's a gated community so bigger animals can't accidentally walk in and destroy the place. There's even a sign that says, "You have to be this small to enter."
—Dave Goetz, production designer

David Goetz / digital

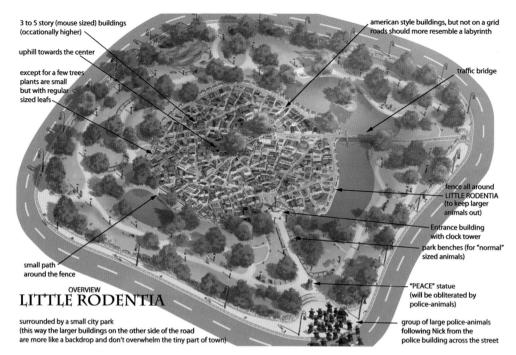

3 to 5 story (mouse sized) buildings (occasionally higher)

american style buildings, but not on a grid roads should more resemble a labyrinth

uphill towards the center

traffic bridge

except for a few trees plants are small but with regular sized leafs

fence all around LITTLE RODENTIA (to keep larger animals out)

Entrance building with clock tower

park benches (for "normal" sized animals)

small path around the fence

"PEACE" statue (will be obliterated by police-animals)

OVERVIEW
LITTLE RODENTIA

surrounded by a small city park
(this way the larger buildings on the other side of the road are more like a backdrop and don't overwhelm the tiny part of town)

group of large police-animals following Nick from the police building across the street

Matthias Lechner / digital

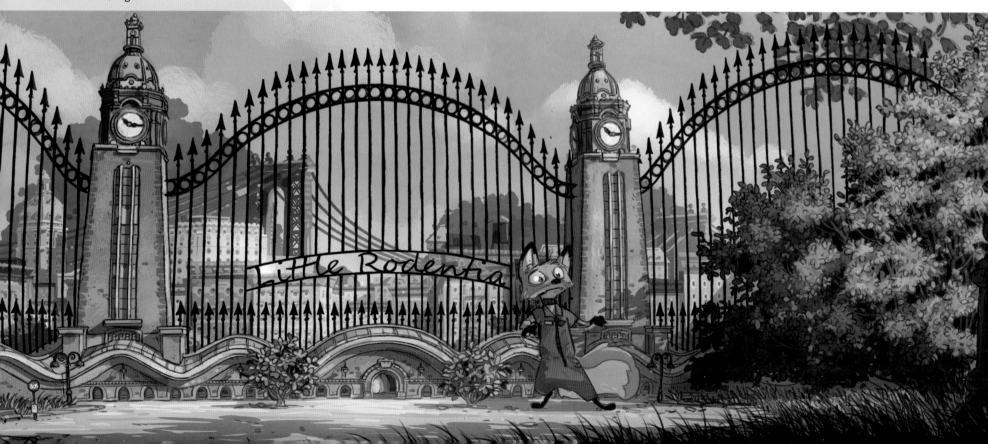

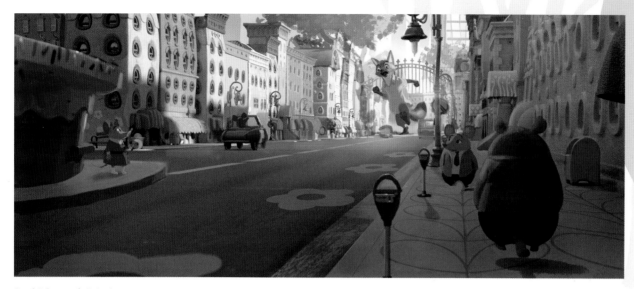

David Goetz / digital

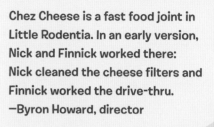

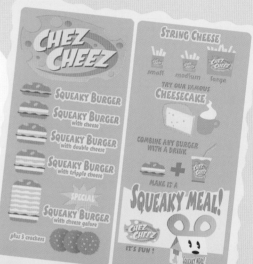

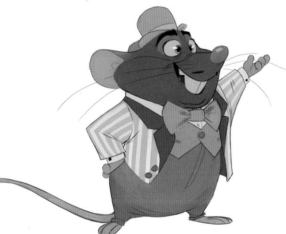

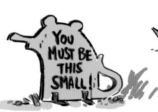

Matthias Lechner / digital

Matthias Lechner / digital

Cory Loftis / digital

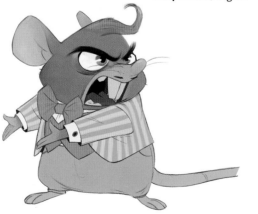

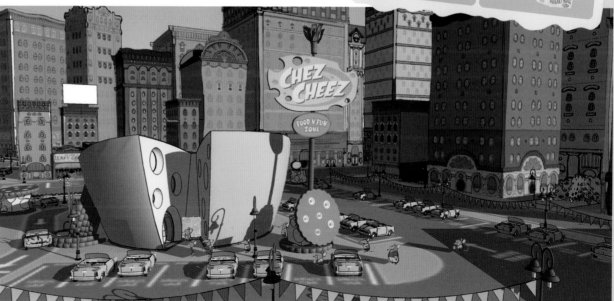

Matthias Lechner / digital

Andy Harkness / digital

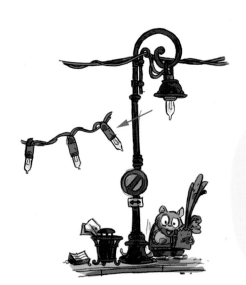

Matthias Lechner / digital

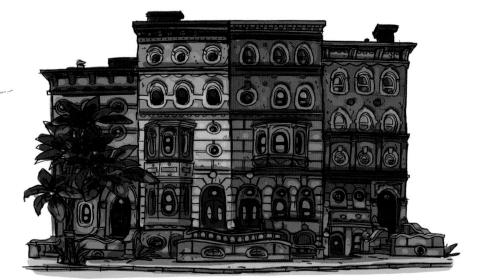

Matthias Lechner / digital

Little Rodentia is a tiny, tidy mini-city. Everything has a bit less detail. Streetlights are made from a single Christmas lightbulb. Stoves only have one dial.
—Matthias Lechner,
 art director of environments

Mice: **Shiyoon Kim** / digital

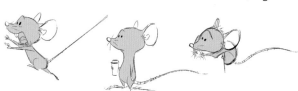

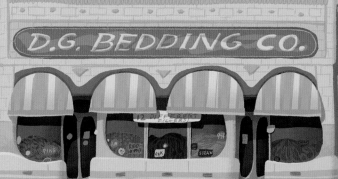

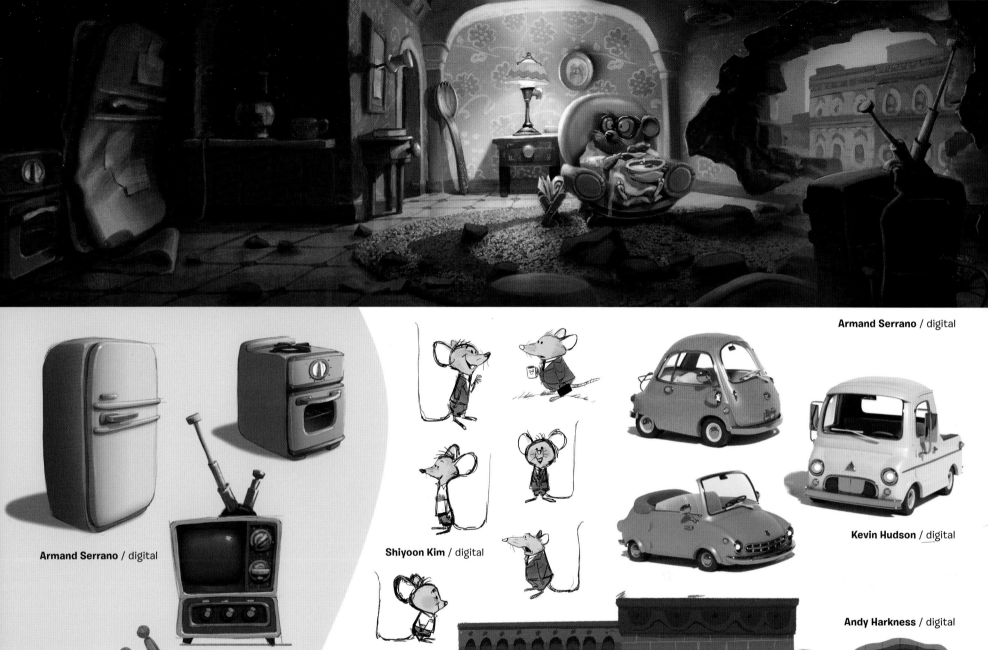

Armand Serrano / digital

Armand Serrano / digital

Shiyoon Kim / digital

Kevin Hudson / digital

Andy Harkness / digital

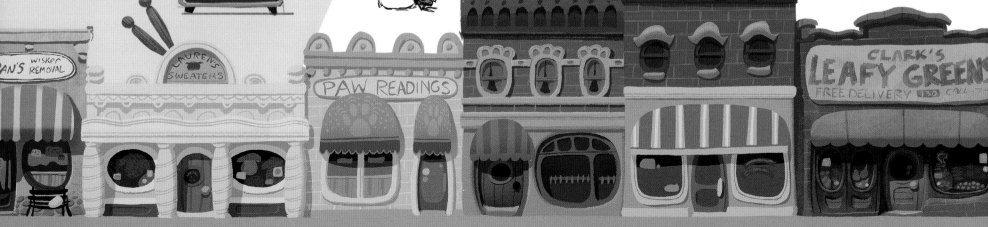

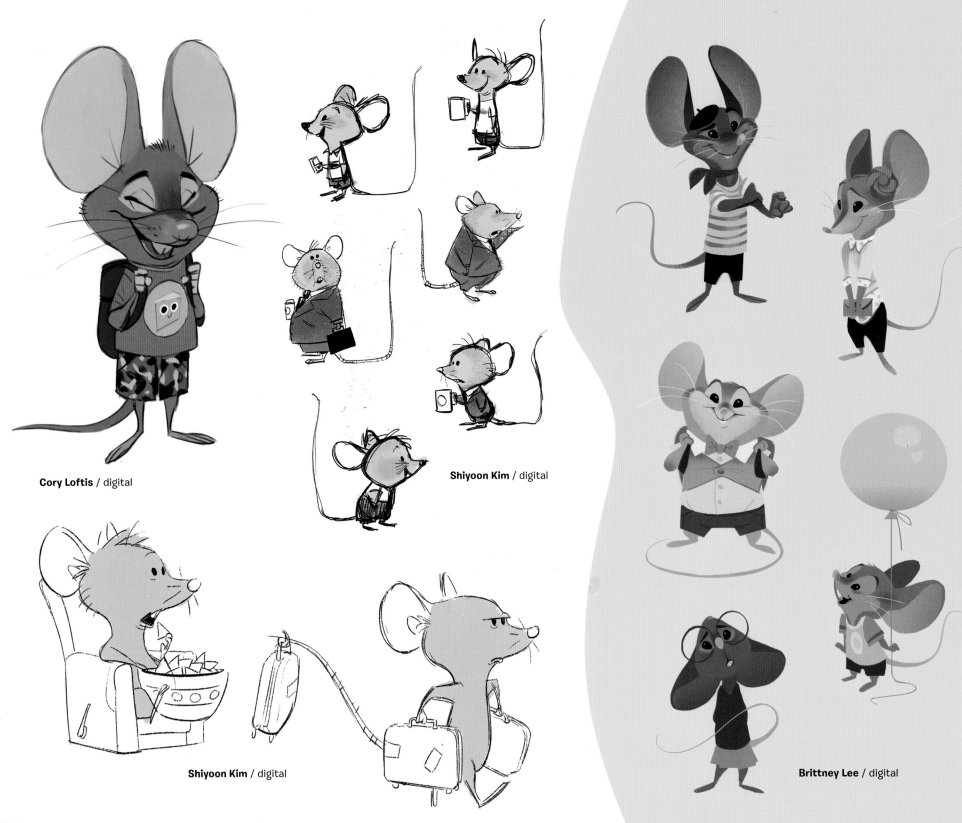

Cory Loftis / digital

Shiyoon Kim / digital

Shiyoon Kim / digital

Brittney Lee / digital

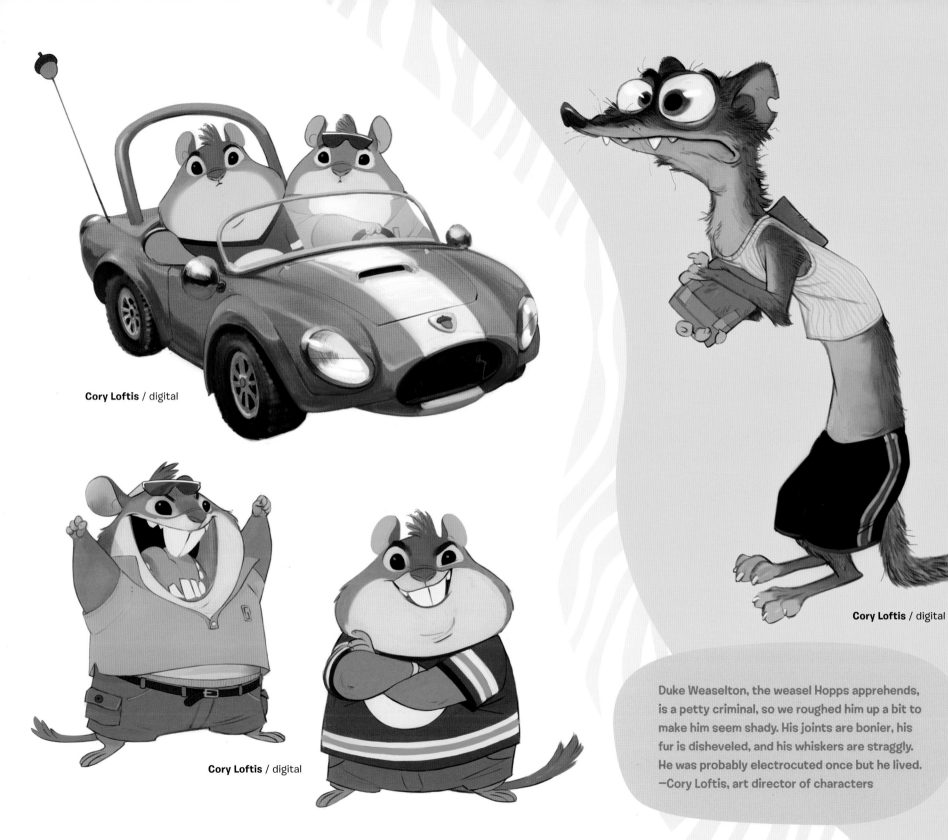

Cory Loftis / digital

Cory Loftis / digital

Cory Loftis / digital

Cory Loftis / digital

Duke Weaselton, the weasel Hopps apprehends, is a petty criminal, so we roughed him up a bit to make him seem shady. His joints are bonier, his fur is disheveled, and his whiskers are straggly. He was probably electrocuted once but he lived. —Cory Loftis, art director of characters

DMV

We worried the DMV [Department of Motor Vehicles] concept might be too American a concept, but our international friends said they have offices just like that in their countries. Red tape and bureaucracy are universal.
—Rich Moore, director

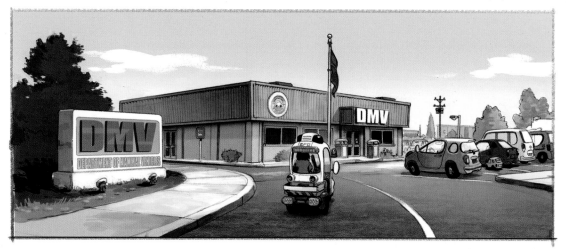

Jim Martin / digital

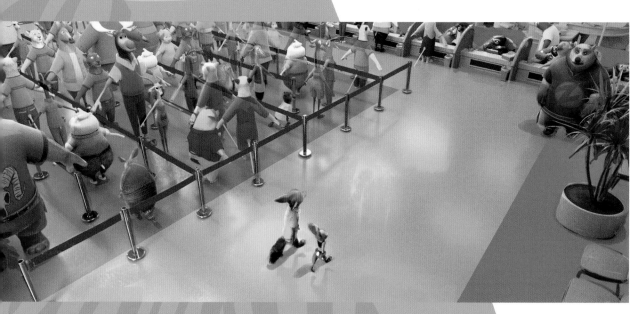

Dan Cooper / (paint over) digital

Jim Martin / digital

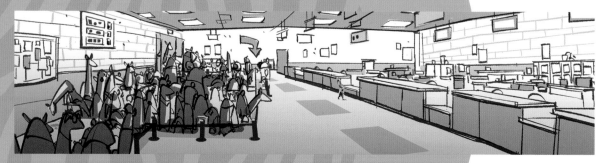

Justin Cram / digital

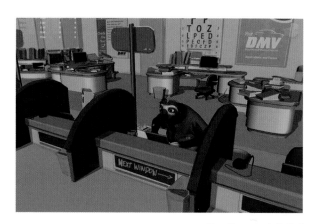

Dan Cooper / digital

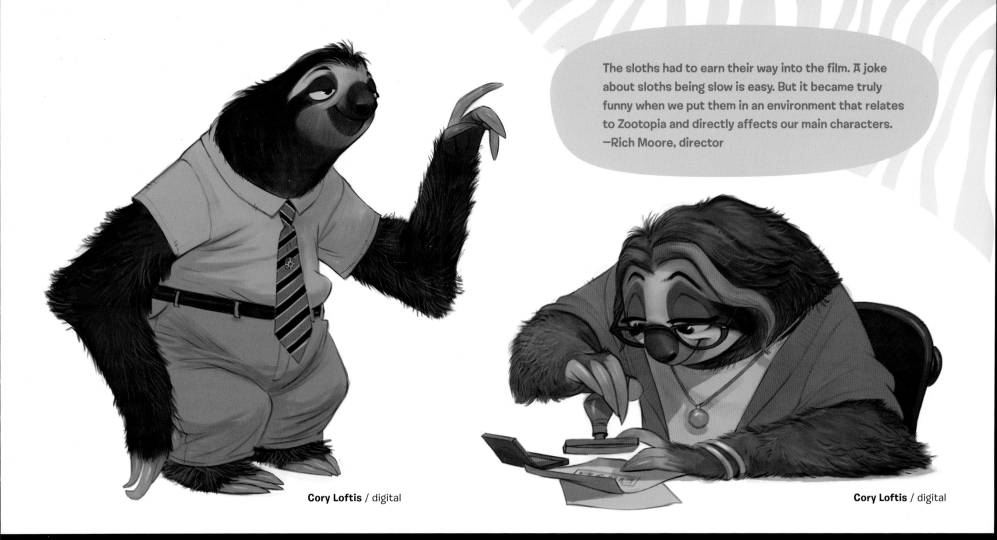

The sloths had to earn their way into the film. A joke about sloths being slow is easy. But it became truly funny when we put them in an environment that relates to Zootopia and directly affects our main characters.
—Rich Moore, director

Cory Loftis / digital

Cory Loftis / digital

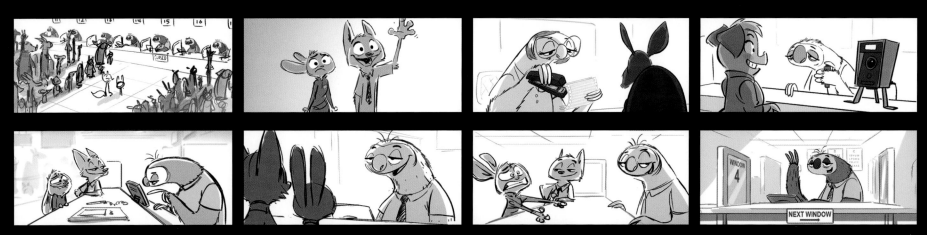

Storyboards: **Jason Hand, Josie Trinidad** / digital

Natural History Museum

Armand Serrano / digital

The Natural History Museum's exhibits show the evolution of Zootopia's animals. One diorama shows a black panther in its natural, naked state. Another is a sculpture of a huge woolly mammoth in a loincloth, carrying a spear.
—Dave Goetz, production designer

Cory Loftis / digital

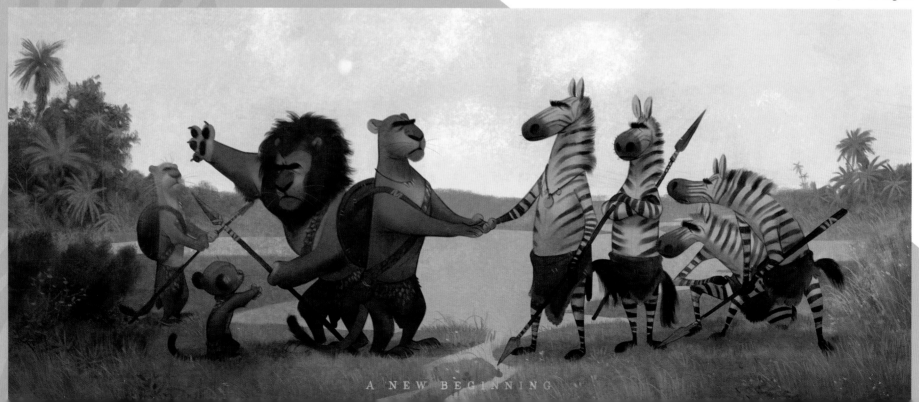

A NEW BEGINNING

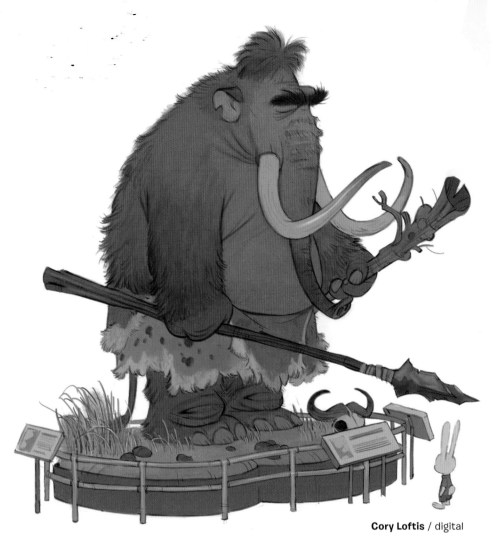

Cory Loftis / digital

Cory Loftis / digital

Armand Serrano / digital

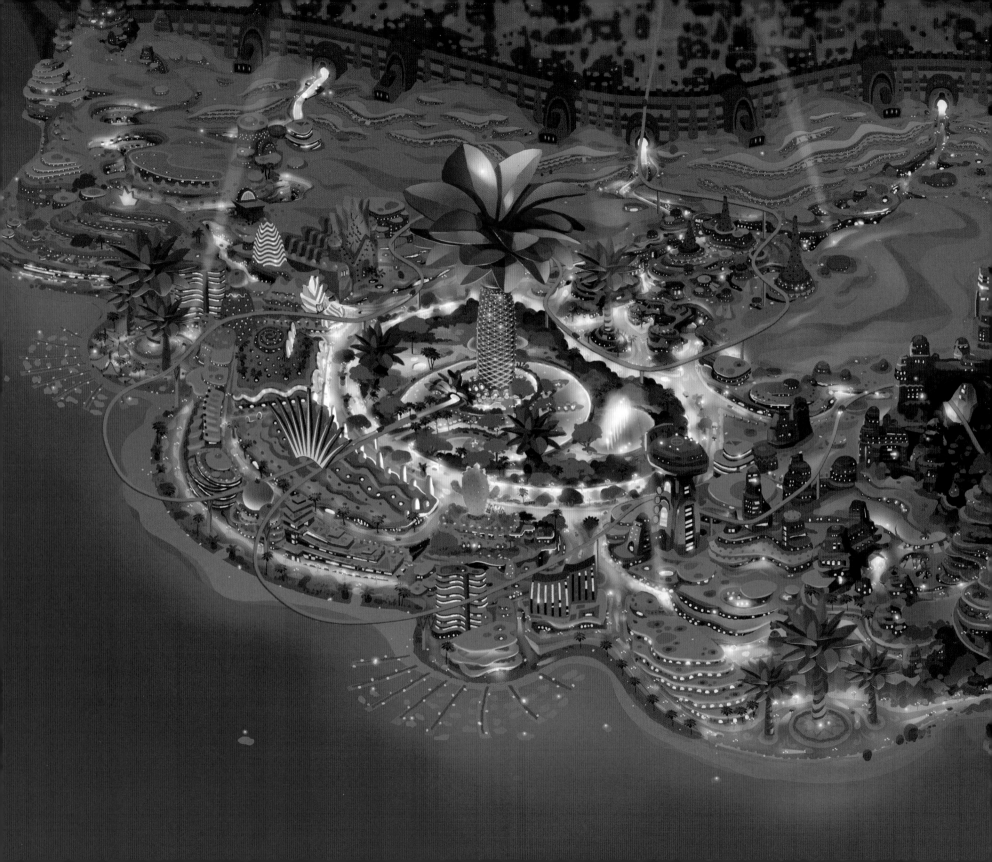

SAHARA SQUARE

After Hopps secures Nick's help in solving the case of the missing Mr. Otterton, they head to Sahara Square. The neighborhood is home to the Mystic Spring Oasis naturalist club, where Nick knows Otterton liked to relax, as well as the Palm Hotel and Casino. It's a desert environment, with large expanses of open space, rolling dunes, and rock cliffs, surrounding a shimmering oasis. "Think Palm Springs meets Dubai," says Matthias Lechner, art director of environments. Director Byron Howard loved that idea. "As soon as Matthias said it's not just a barren desert, it's a swanky, glitzy place, I got it," he says. "It's layering the human equivalent on top of an animal habitat. The buildings are high-end and well-designed. It's a desirable place to live in Zootopia."

Mirage patterns appear throughout Sahara Square, and dust often fills the air. But since many desert animals are nocturnal, the fun and sun district really comes alive at night. "It's like the Las Vegas strip," says production designer Dave Goetz. "But beyond the strip, there are slot canyons that are more historic, with smaller buildings, residences, and a marketplace."

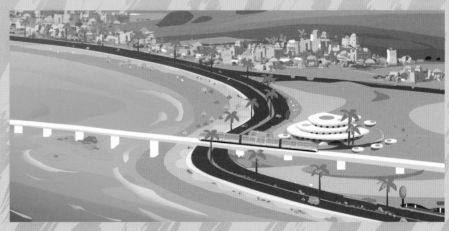

Matthias Lechner / digital

Matthias Lechner / digital

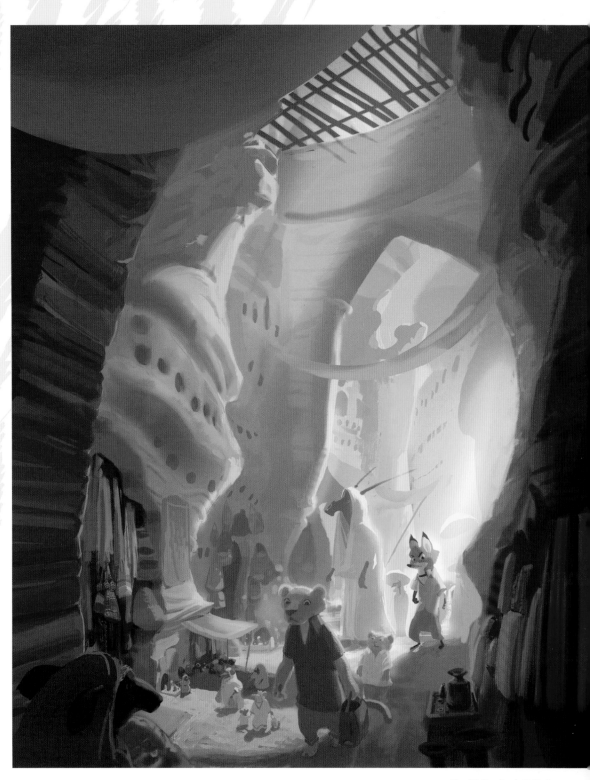

Matthias Lechner / digital

David Goetz / digital

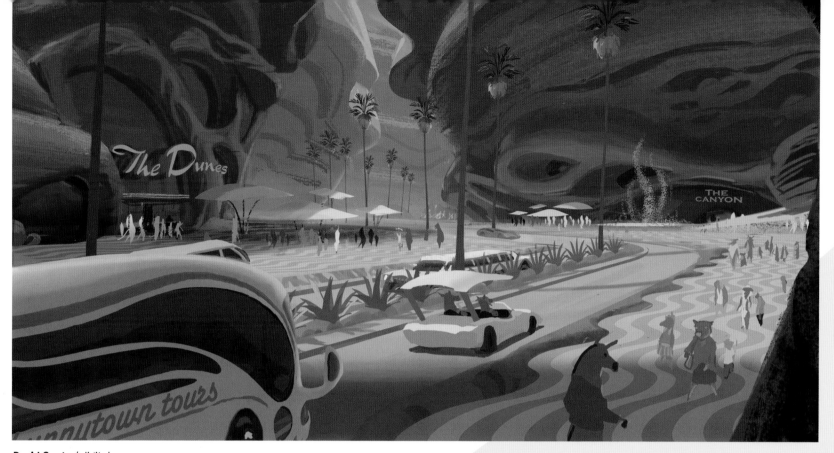

David Goetz / digital

The mix of architecture, motifs, and patterns comes from the way all these animals live together. Sahara Square is a semi-arid desert with Arabian, African, and American elements in it.
—Dave Goetz, production designer

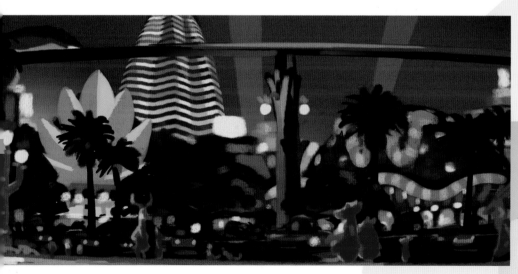

Matthias Lechner / digital

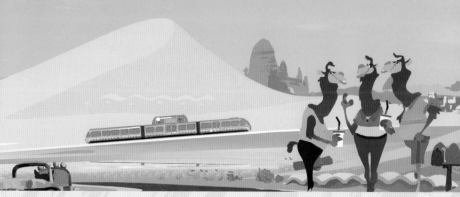

Matthias Lechner / digital

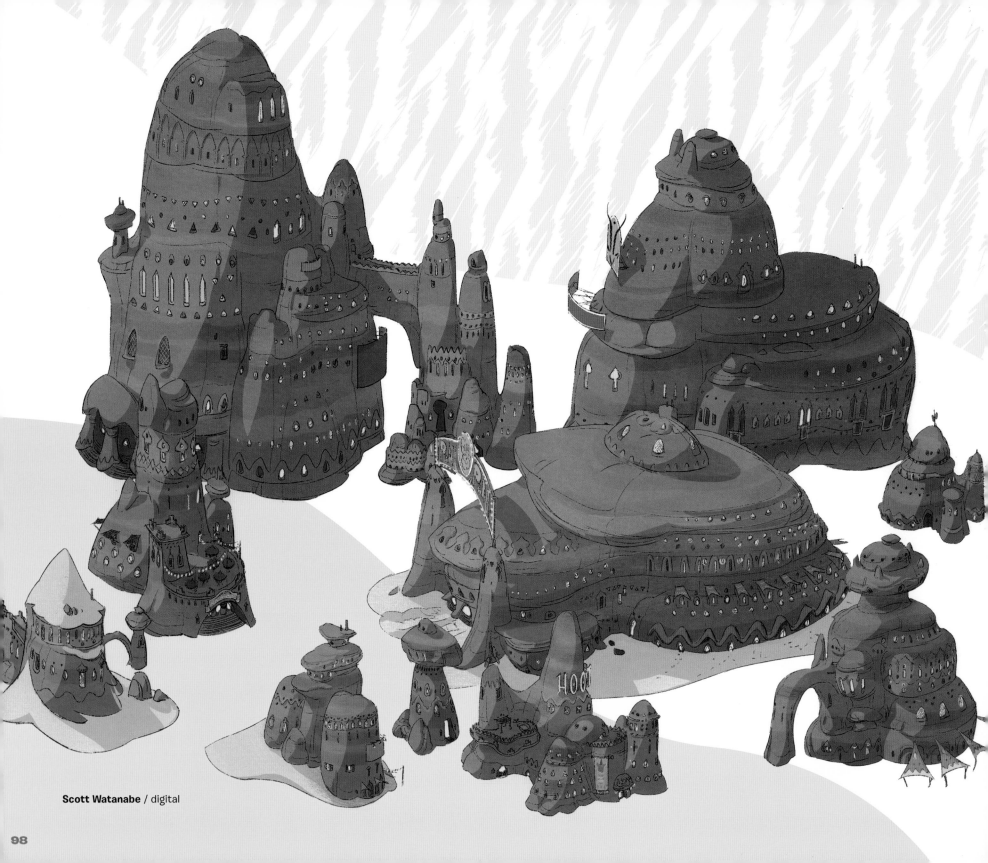

Scott Watanabe / digital

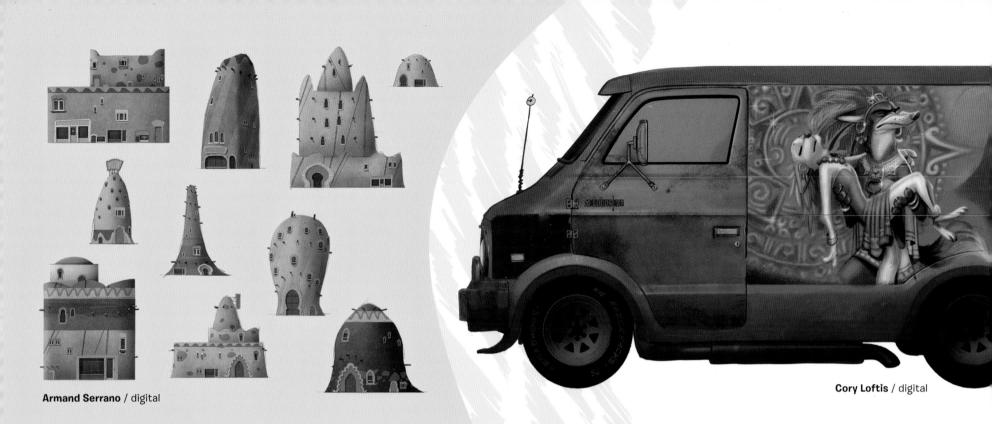

Armand Serrano / digital

Cory Loftis / digital

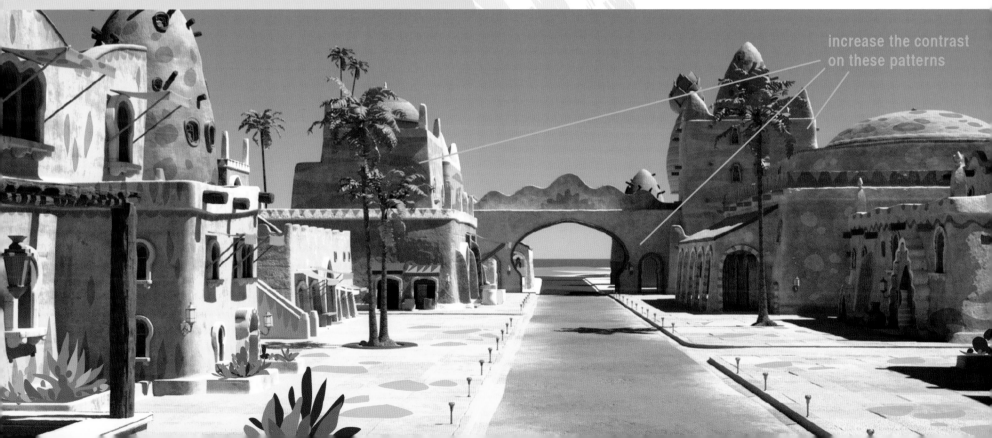

increase the contrast
on these patterns

Palm Hotel & Casino

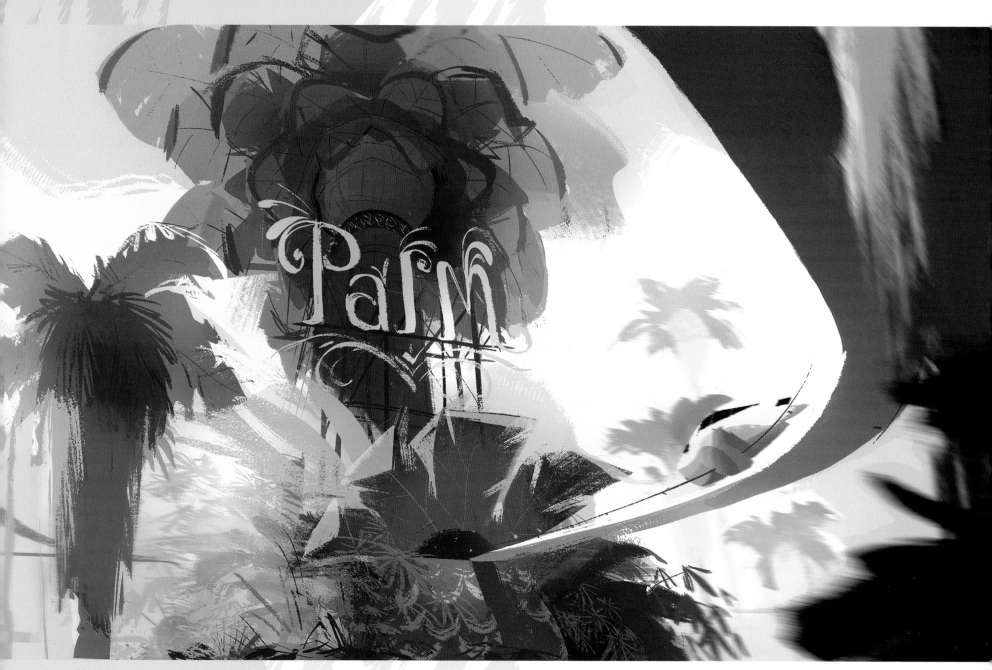

Nick Orsi / digital

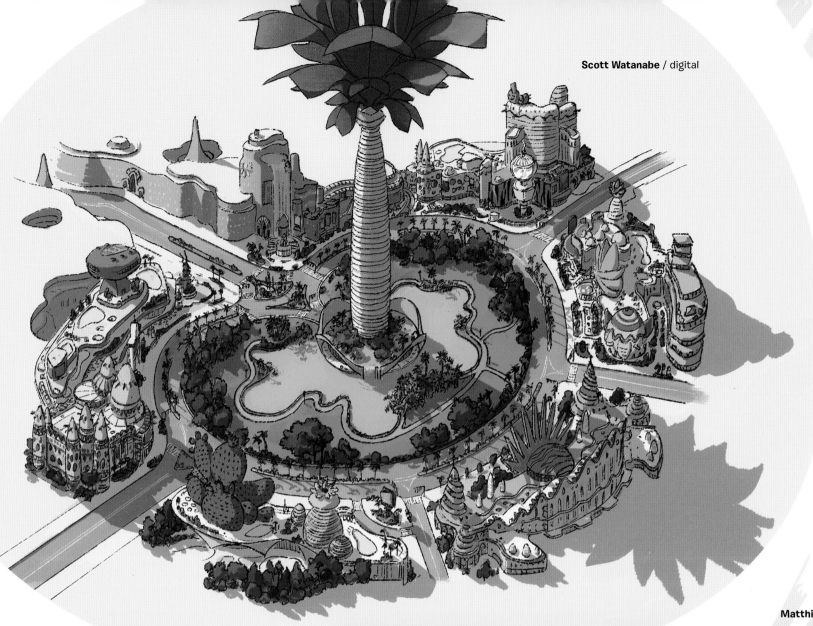

Scott Watanabe / digital

Matthias Lechner / digital

The Palm Hotel is very classy. It has water features, and a strip around it with all the things a Vegas hotel would have—shopping, casinos, entertainment.
—Matthias Lechner,
 art director of environments

[Visual development artist] Brett Albert was our architectural ace in the hole. He designs using multi-sized, organic motifs. Brett took all the palm tree research and turned it into a luxury hotel. The interior is based on how ripples look in the sand. —Dave Goetz, production designer

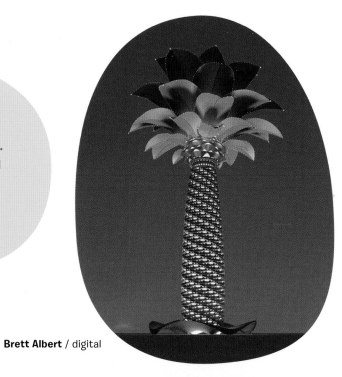

Brett Albert / digital

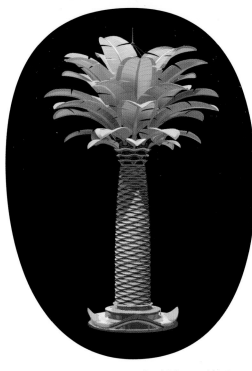

David Goetz / (paint over) digital

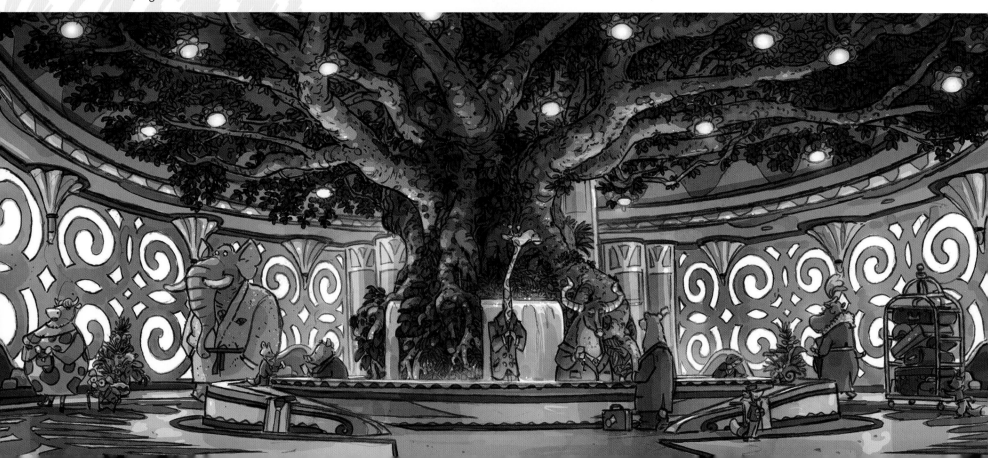

Matthias Lechner / digital

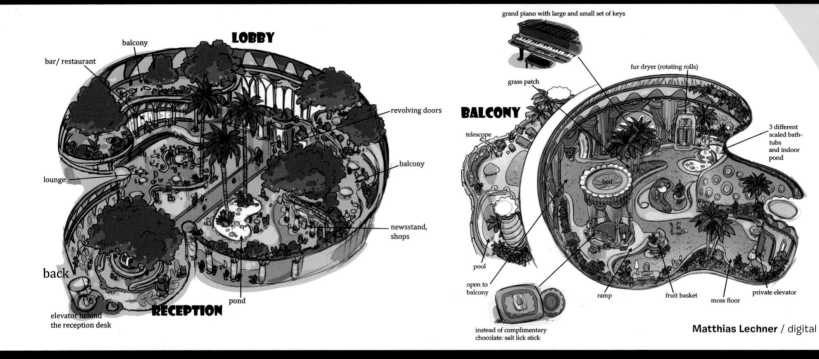

LOBBY

balcony

bar/ restaurant

revolving doors

lounge

balcony

back

newsstand, shops

pond

RECEPTION

elevator behind the reception desk

grand piano with large and small set of keys

BALCONY

grass patch

fur dryer (rotating rolls)

telescope

3 different scaled bath-tubs and indoor pond

bed

pool

open to balcony

ramp

fruit basket

moss floor

private elevator

instead of complimentary chocolate: salt lick stick

Matthias Lechner / digital

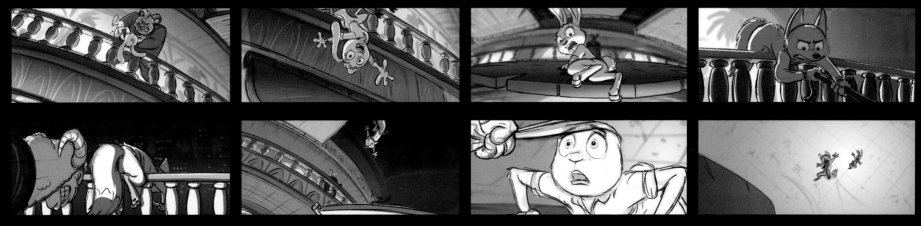

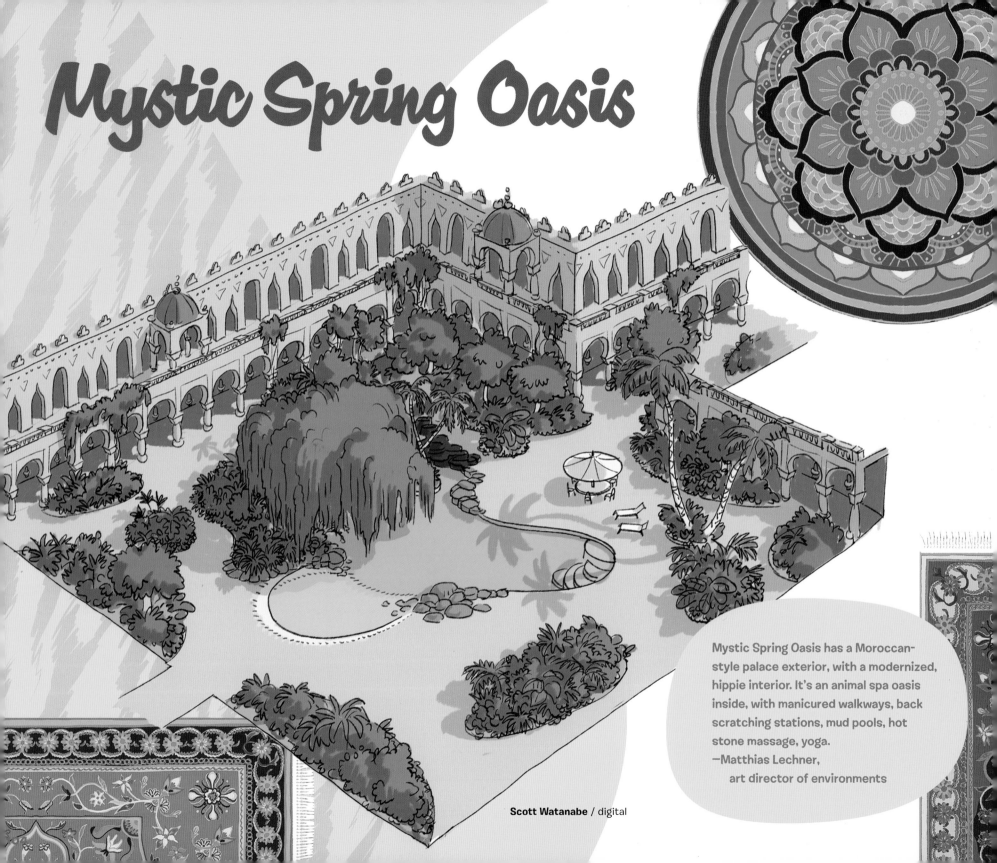

Mystic Spring Oasis

Mystic Spring Oasis has a Moroccan-style palace exterior, with a modernized, hippie interior. It's an animal spa oasis inside, with manicured walkways, back scratching stations, mud pools, hot stone massage, yoga.
—Matthias Lechner,
 art director of environments

Scott Watanabe / digital

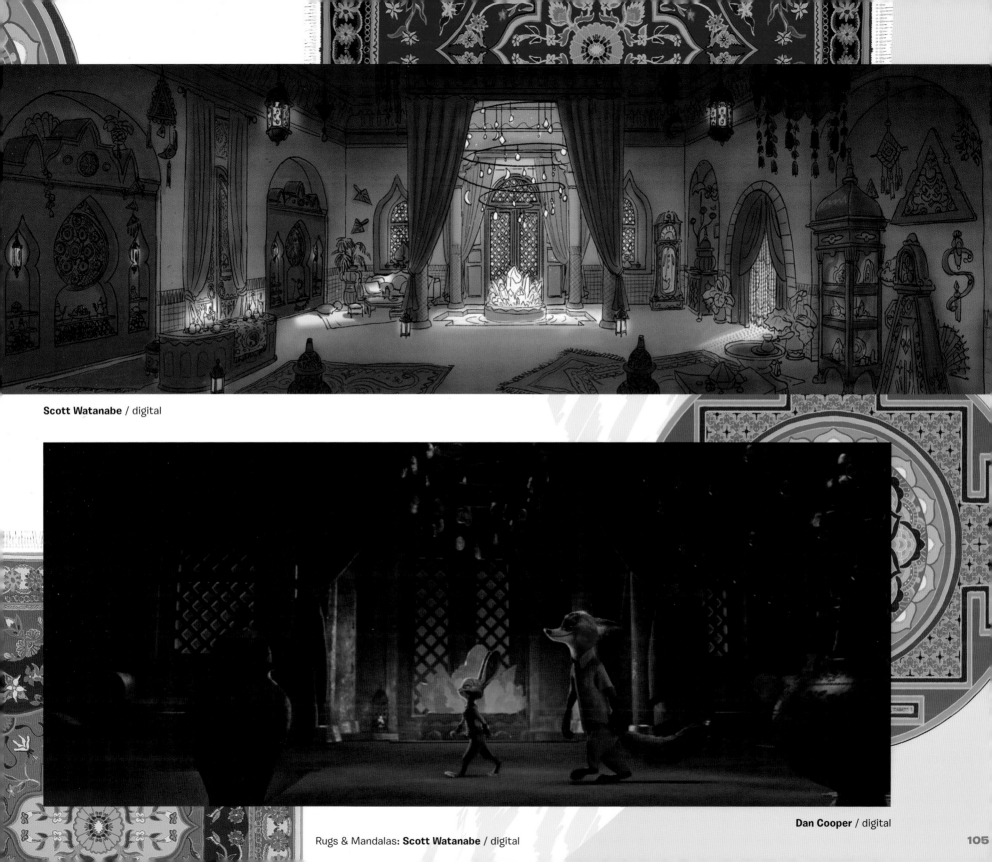

Scott Watanabe / digital

Rugs & Mandalas: **Scott Watanabe** / digital

Dan Cooper / digital

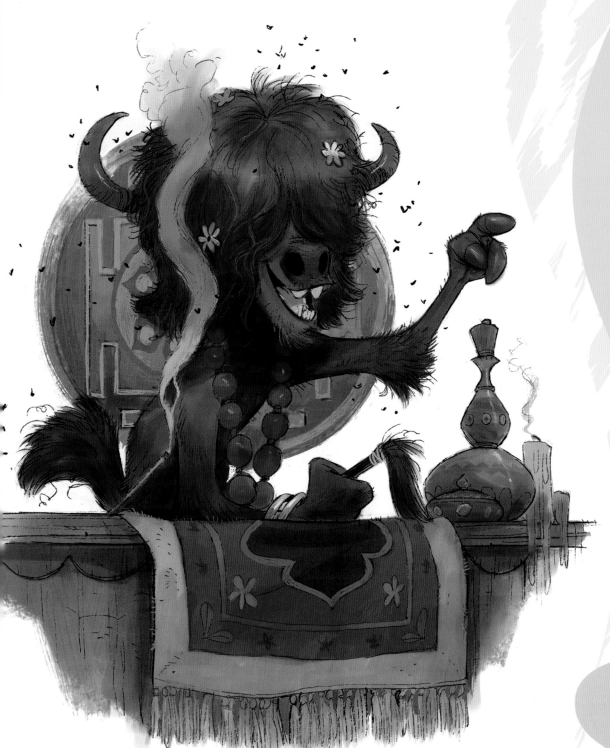

Cory Loftis / digital

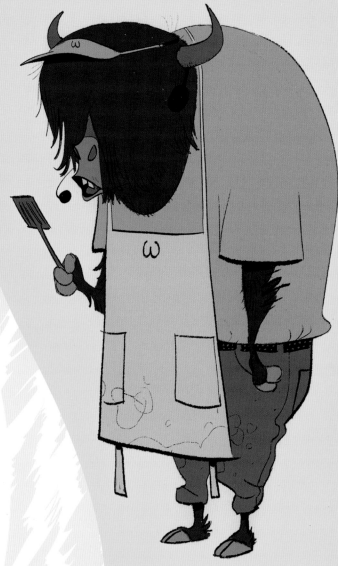

Shiyoon Kim / digital

I initially designed Yax as a hairy, millennial dude,
inspired by skate punks I see around Burbank.
—Shiyoon Kim, visual development artist

Otters are bulkier than weasels, and tough, like one big muscle. But Mrs. Otterton needed to seem frail enough to ask a bunny for help, so we gave her a thinner wrist and neck.
—Cory Loftis, art director of characters

Cory Loftis / digital

Cory Loftis / digital

Cory Loftis / digital

Cory Loftis / (draw over) digital

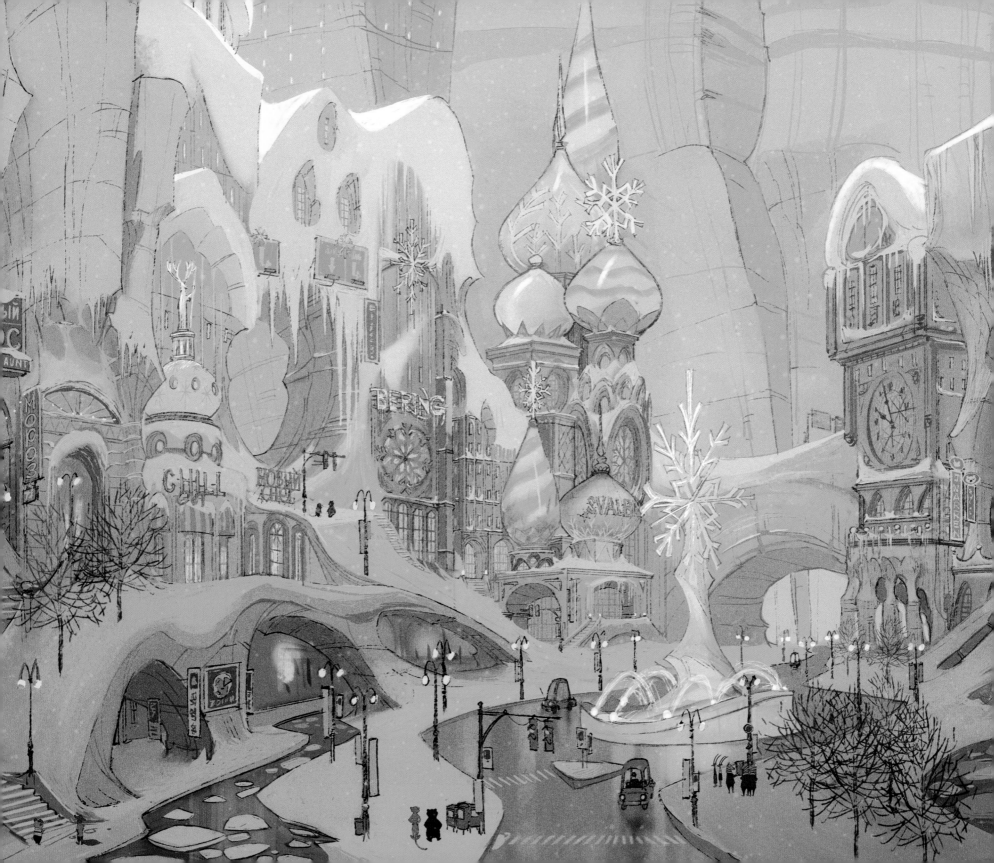

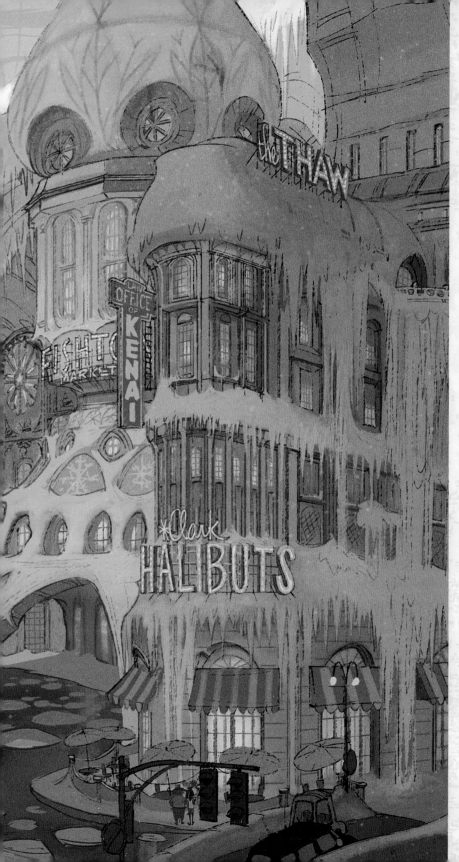

Cory Loftis / digital

TUNDRA TOWN

Hopps and Nick's next clue takes them to Tundratown, where they encounter the fearsome crime lord, Mr. Big. This neighborhood of Zootopia is made entirely out of snow and ice. Air conditioners and snow blowers run constantly, and everything always has a thick layer of snow on it to keep the reindeer, arctic shrews, polar bears, and moose that live there comfortable. Even the fountain in the plaza spouts snow instead of water. But what would an icy part of the city built by those animals look like?

"Snow and ice present particular challenges," says production designer Dave Goetz. "We were inspired to try Russian architecture, but once buildings are covered with snow, even an onion dome just looks like a normal structure." Eventually the team decided to use the snow itself in the district's construction. "Roofs feel like pieces of glacier that broke off. Streets look like crevasses in a sheet of snow. But structural foundations, like window frames, are made of wood and set into the snow. There's still some Russian influence, as well as Italian flavor inspired by Mr. Big's character, but it's more a decorative touch.

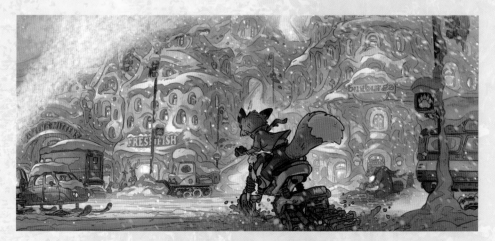

Matthias Lechner / digital

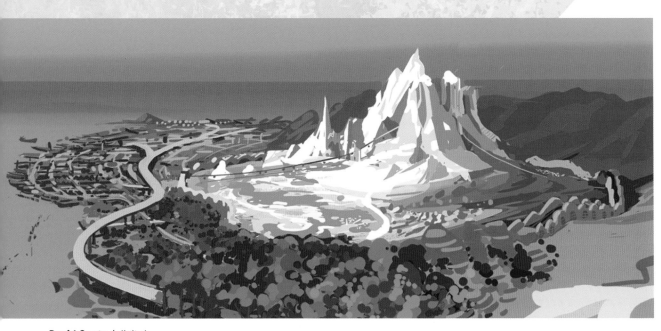

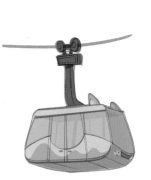

Justin Cram / digital

David Goetz / digital

Much of Tundratown was built directly into big mountains. The gondolas help smaller animals move around the area more easily.
—Nick Orsi, visual development artist

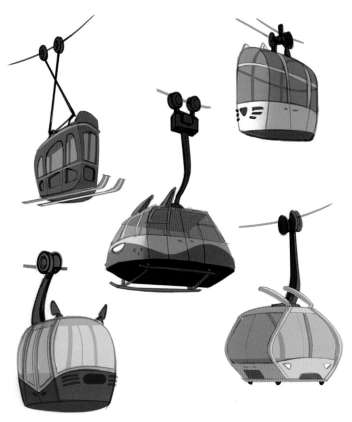

Justin Cram / digital

Andy Harkness / digital

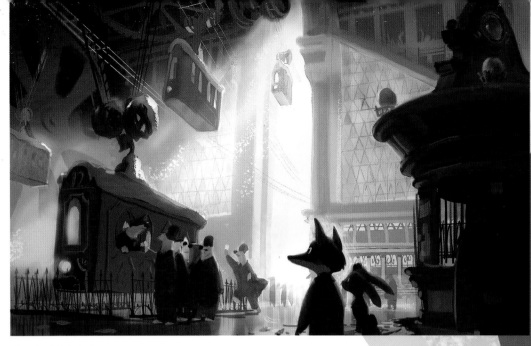

Nick Orsi / digital

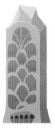

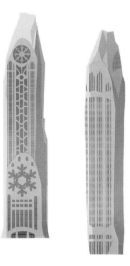

Nick Orsi / digital

Scott Watanabe / digital

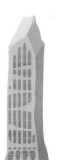

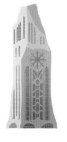

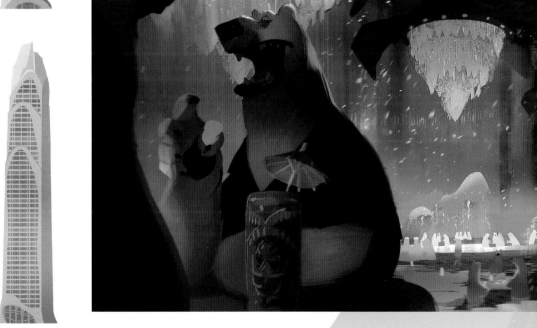

Mr. Big & Fru Fru

Mr Big is a homage to *The Godfather*. He's like Marlon Brando as an arctic shrew.
—Cory Loftis, art director of characters

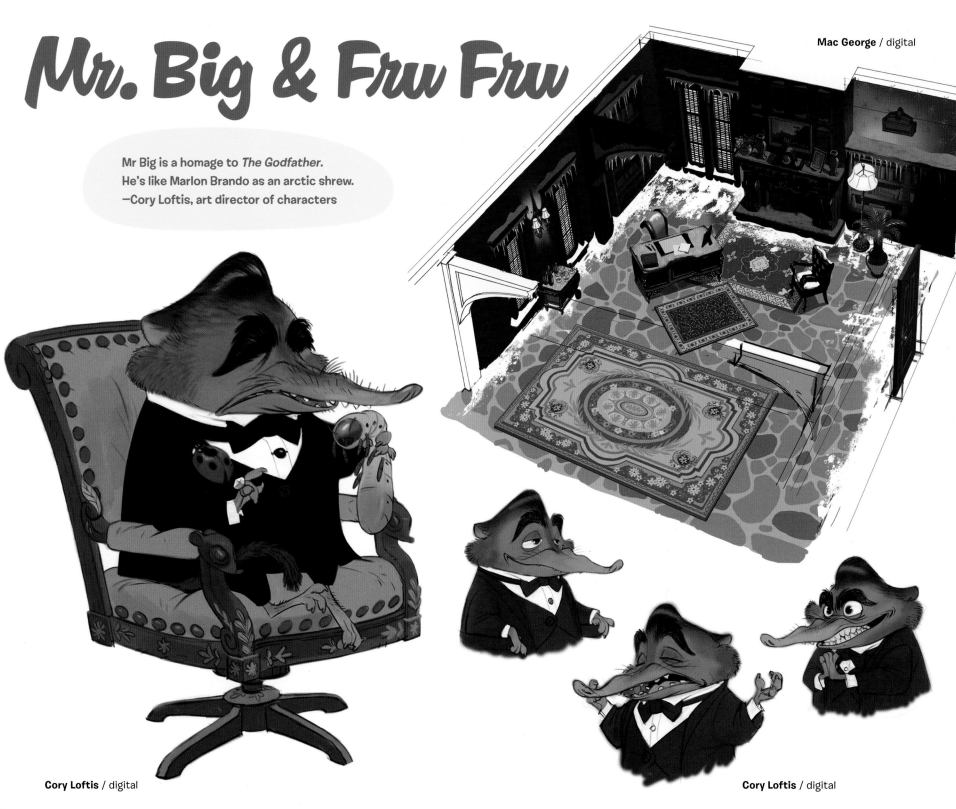

Cory Loftis / digital

Mac George / digital

Fru Fru is supposed to be aesthetically pleasing but her individual elements are so bizarre—the long nose, scraggly teeth, bouffant hairdo. It amazes me when elements can add up to something cute and appealing.
—Rich Moore, director

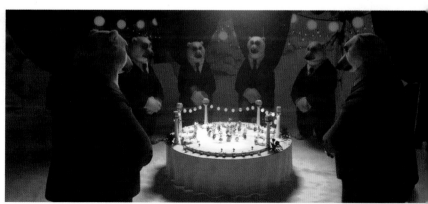

Cory Loftis / digital

Dan Cooper / digital

Koslov's Palace

Koslov started as a Russian gangster who owned a restaurant that was a front for his criminal activity. Koslov's Palace is a polar bear cave with a Russian-style interior. The tile is made of ice that flashes red, purple, pink, and blue when light flickers through it. —Matthias Lechner, art director of environments

Matthias Lechner / digital

Matthias Lechner / digital

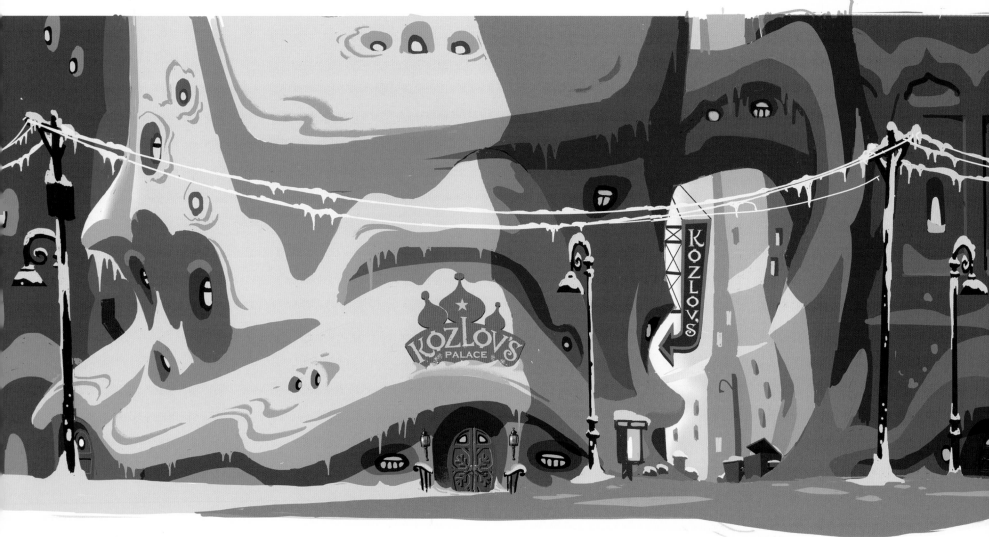

Mac George / digital

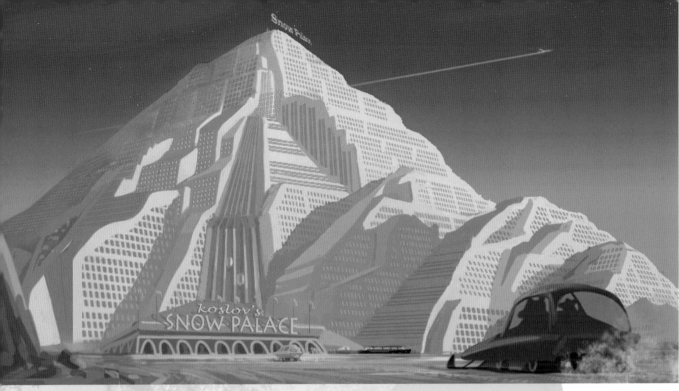

Matthias Lechner / digital

David Goetz / digital

Matthias Lechner / digital

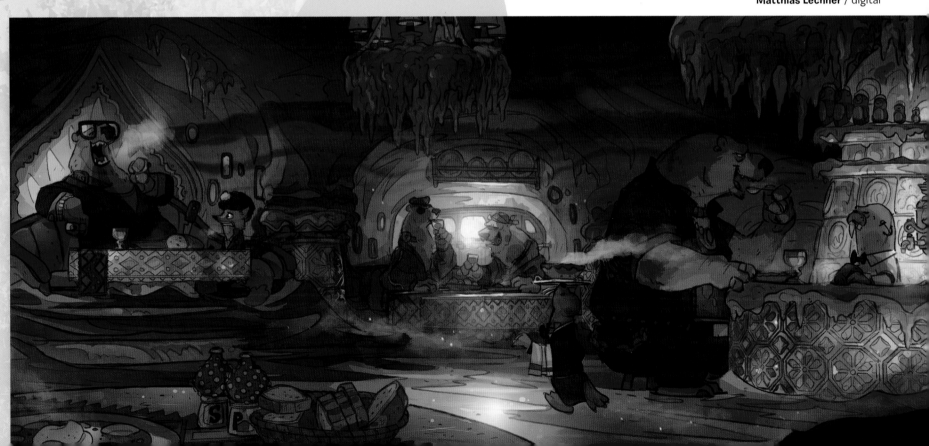

Koslov & Morris

Polar bears are one of the few animals that do stand up on two feet at times, so we used that for reference in Koslov's animation. He is a character who knows what he wants, is very certain and to the point, so his movement reflects that.
—Renato dos Anjos,
 co-head of animation

Cory Loftis / digital

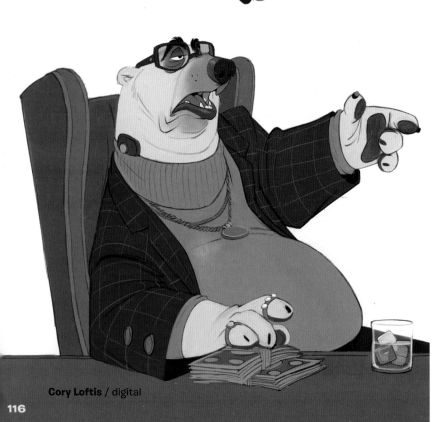

Cory Loftis / digital

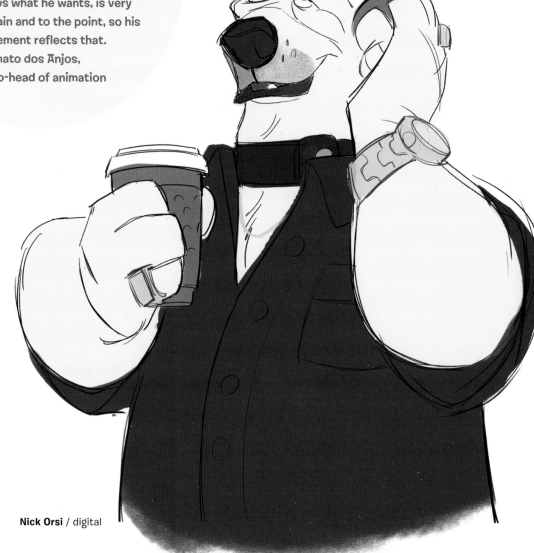

Nick Orsi / digital

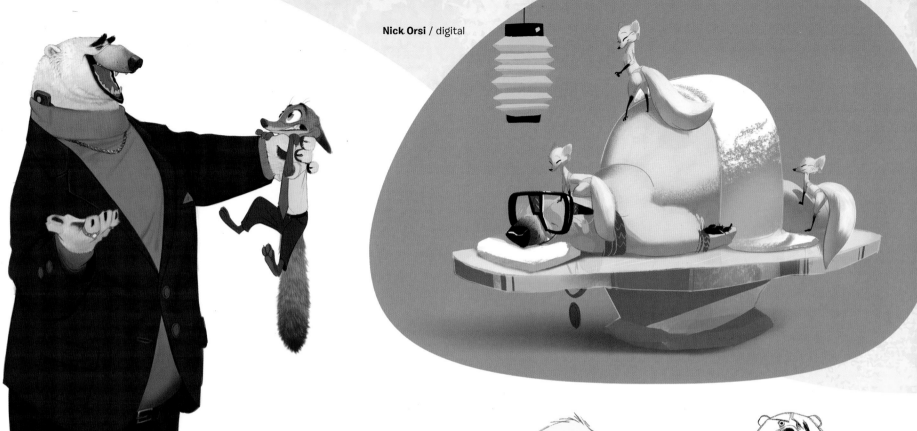

Nick Orsi / digital

Cory Loftis / digital

Of all the characters that are no longer in the movie, I miss Morris most. He was Koslov's son and it was tough to make him feel soft and cute. Morris's fur is cleaner than Koslov's—the filth of the world hadn't gotten to him yet. His claws look like pearls because he hasn't had to use them.
—Cory Loftis, art director of characters

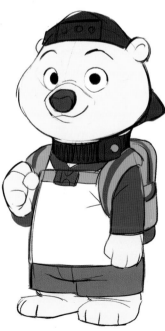

Nick Orsi / digital

Cory Loftis / digital

Nick Orsi / digital

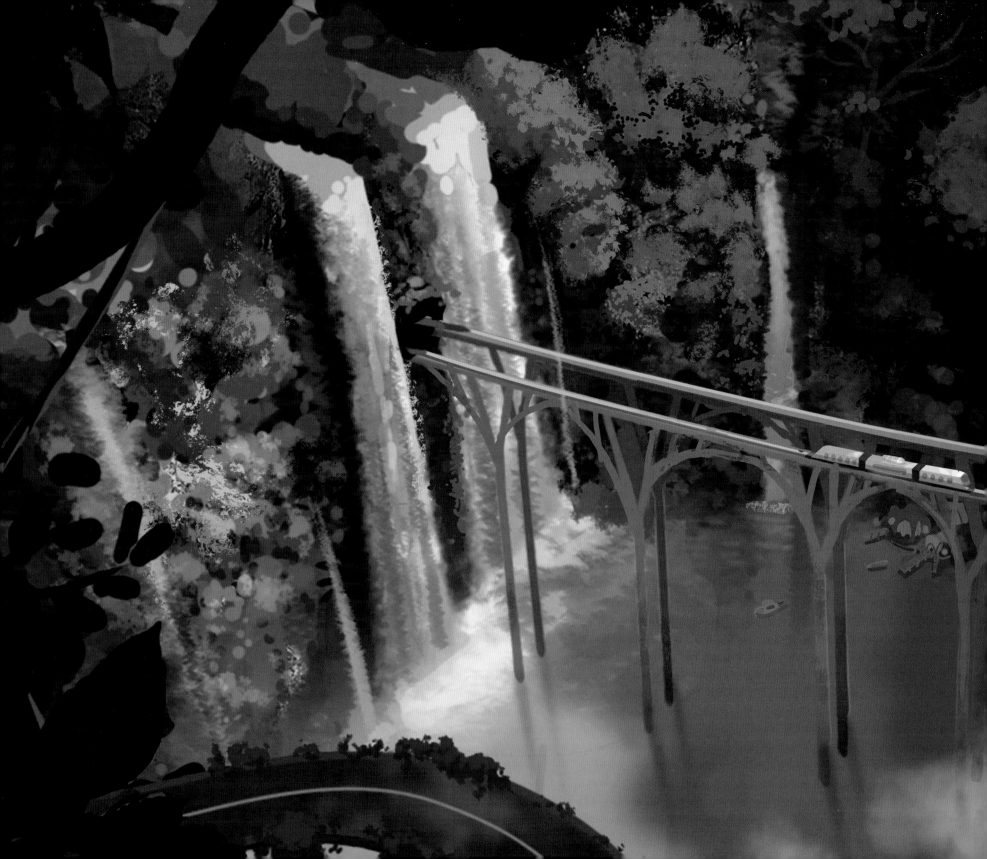

RAINFOREST DISTRICT

Following a tip from Mr. Big, Hopps and Nick venture into the Rainforest District in search of Manchas, the last animal to see Mr. Otterton alive and a witness to his sudden savagery. The Rainforest District is one of the most complex environments in Zootopia, with artificial structures made to look like real vegetation and a pervasive wetness permeating the atmosphere. It's also the only habitat built on a vertical axis, with a sheer drop from the treetop canopy to the river at the bottom, which adds to the sense of mystery and foreboding.

To make the environment functional for its animal inhabitants, art director of environments Matthias Lechner designed huge tree-like structures built around pipes inspired by tree roots. "They suck water from the river and transport it up the tree to sprinklers in the canopy, so there is a constant cloud of steam in the air." Roads are a combination of real trees and artificial branches. Homes are made of wood, with leafy roofs to shed rain, and become nicer the higher up one resides. "Nearer the bottom, it's hot, it's rainy, and stuff is constantly falling down from above," says Lechner.

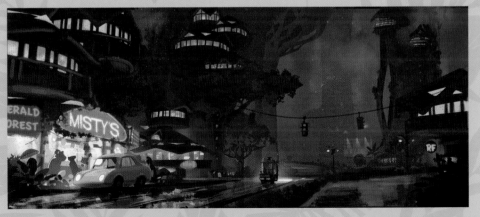

David Goetz / digital

David Goetz / digital

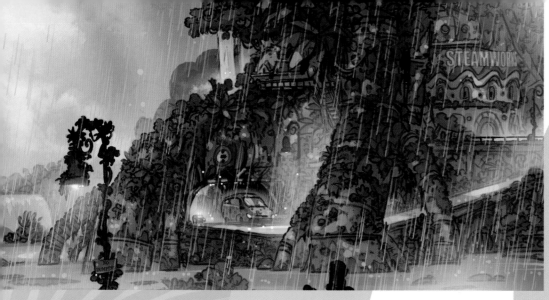

Matthias Lechner / digital

The colors are tropical and South American inspired—vibrant, so they pop out against green.
—Dave Goetz, production designer

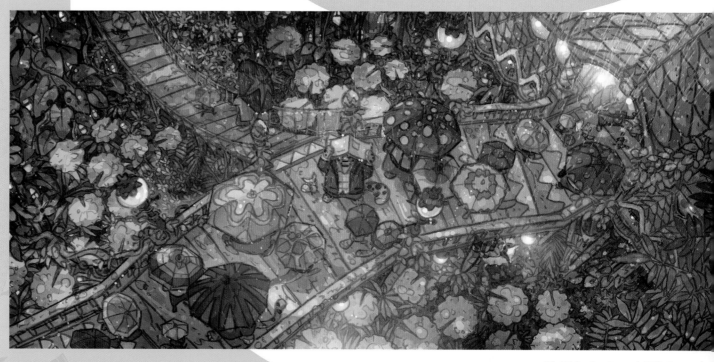

Armand Serrano / digital

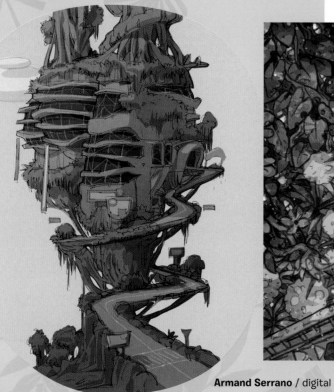

Armand Serrano / digital

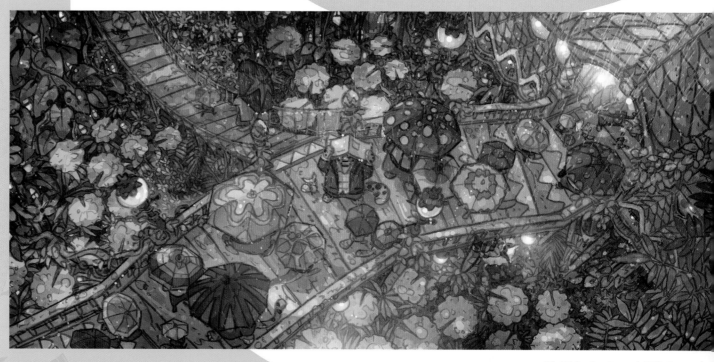

Matthias Lechner / digital

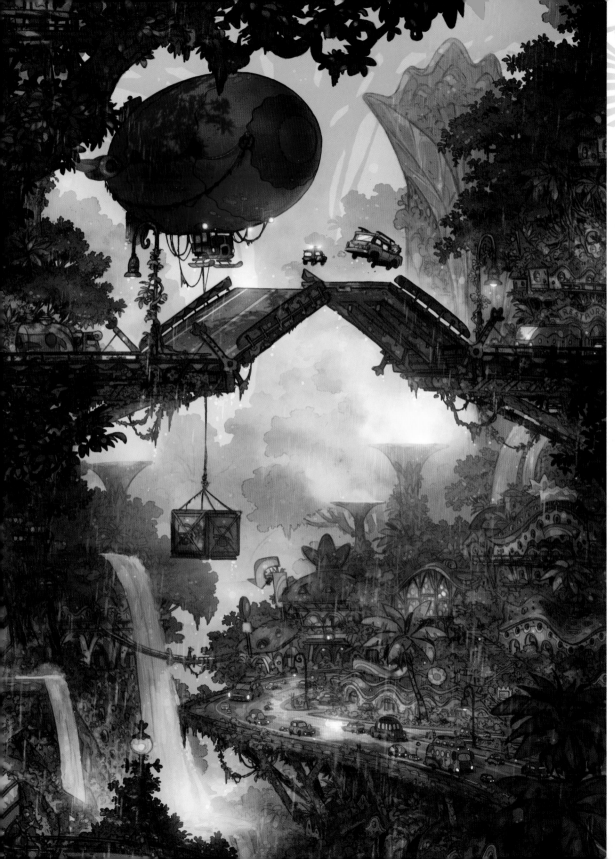

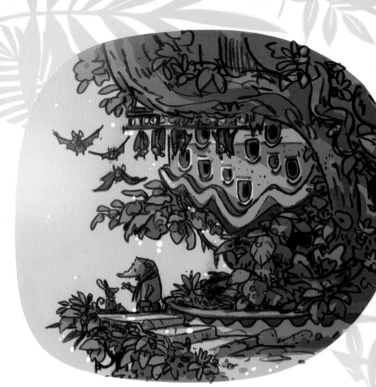

Matthias Lechner / digital

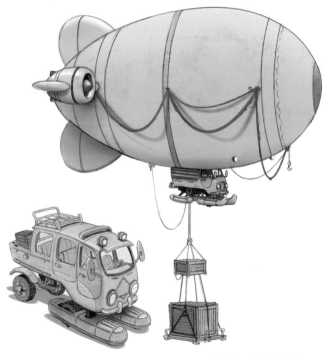

Jim Martin / digital

Matthias Lechner / digital

121

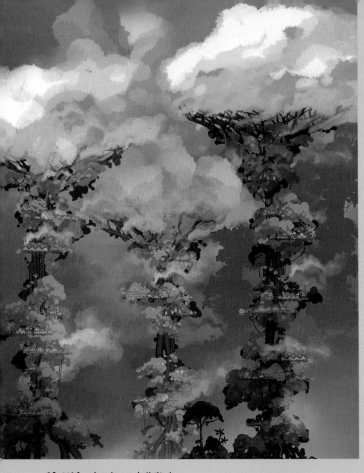

Matthias Lechner / digital

An environment with lots of vegetation is technologically difficult because a forest isn't still. Air moves through the trees and each tree moves differently. To make it feel believable, we had to find clever ways to get unique motion, such as working in layers or grouping branches.
—Ernie Petti,
 technical supervisor

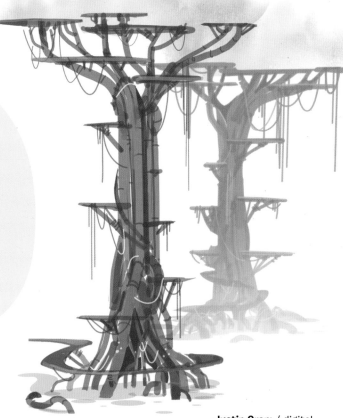

Justin Cram / digital

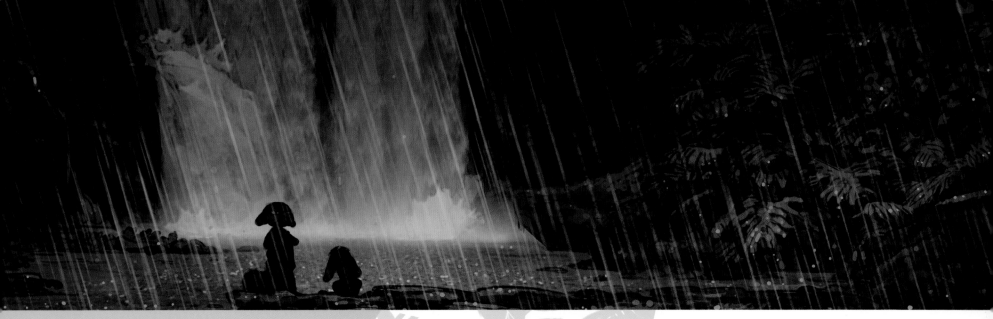

Matthias Lechner / digital

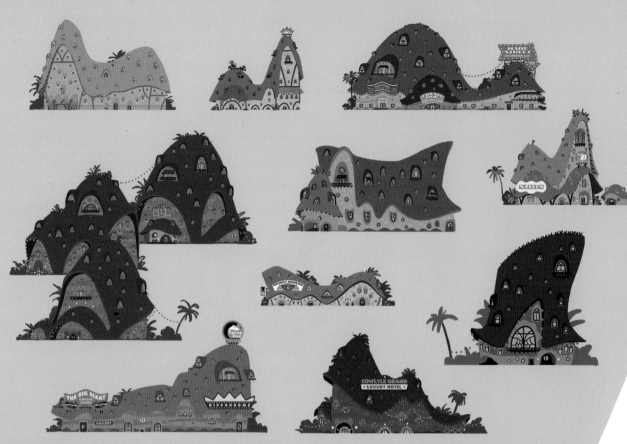

Scott Watanabe / digital

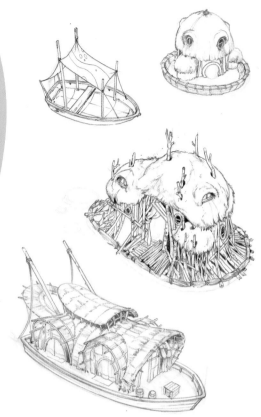

Jim Martin / digital

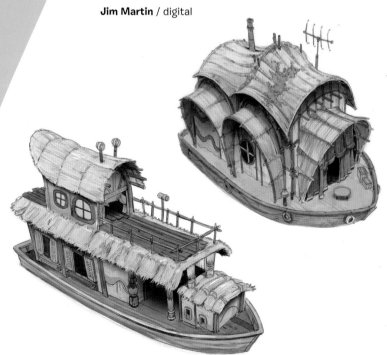

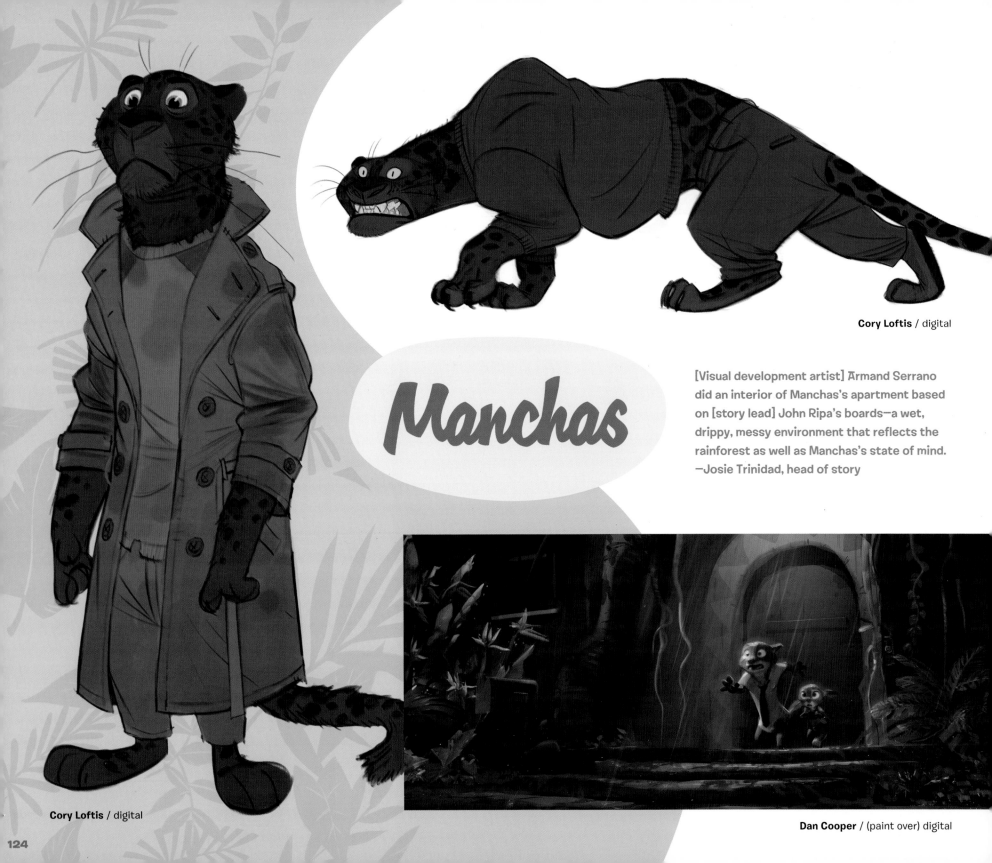

Cory Loftis / digital

Manchas

[Visual development artist] Armand Serrano did an interior of Manchas's apartment based on [story lead] John Ripa's boards—a wet, drippy, messy environment that reflects the rainforest as well as Manchas's state of mind.
—Josie Trinidad, head of story

Cory Loftis / digital

Dan Cooper / (paint over) digital

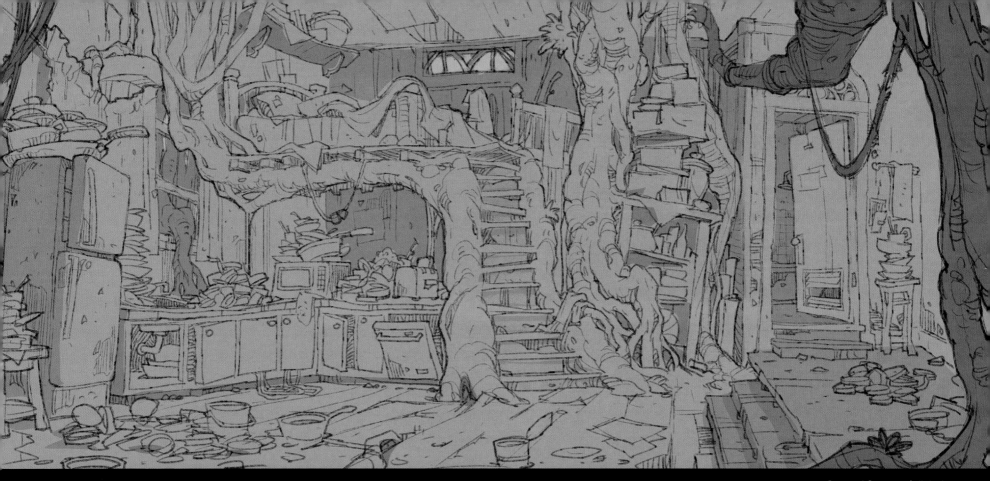

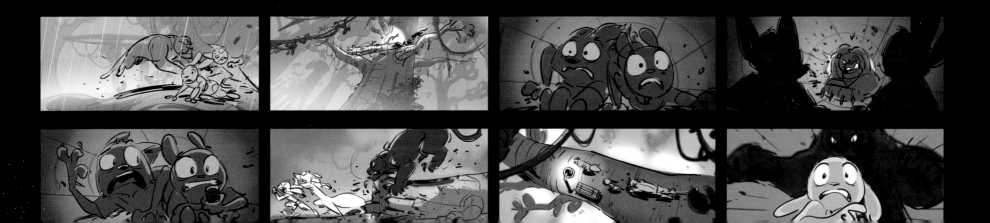

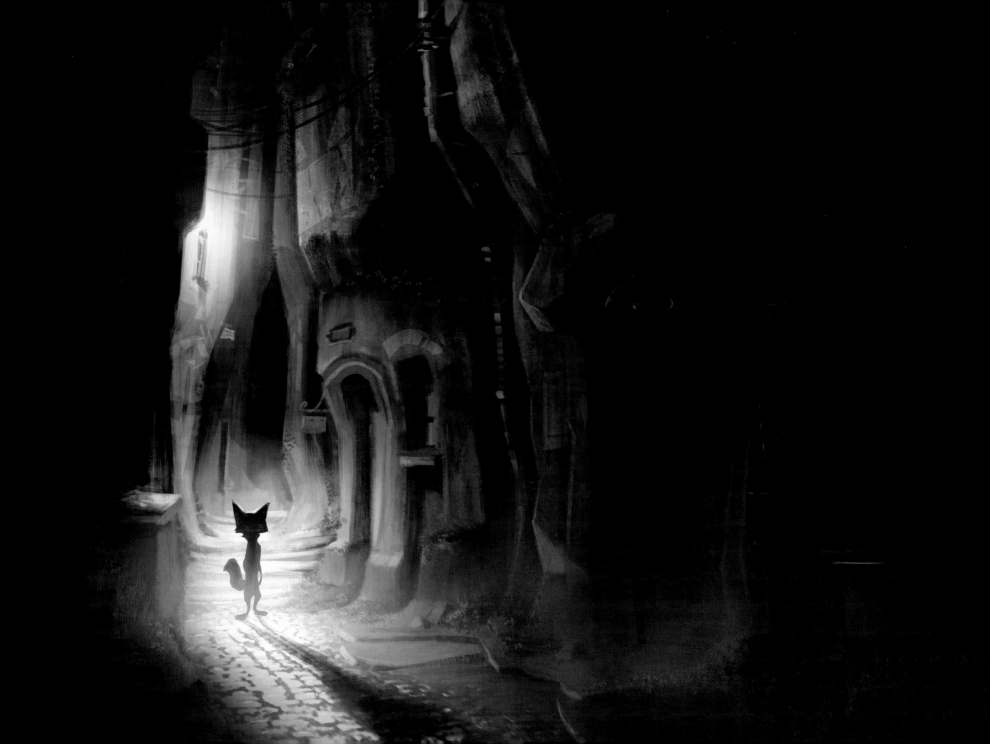

MEADOWLANDS

Zootopia is an enormous metropolis, with more places in it than can possibly be visited in one movie. As the story evolved, many locations that were created ultimately did not make it into the final film. But as much care and thought were put into their designs as all of the others.

One example is the Meadowlands, an expansive grassland that is home to sheep and other grazing animals. In an early version of the movie, when predators were the minority and prey ran the world, there was a grand conspiracy involving sheep wearing wolf suits trying to make predators seem dangerous. "It was overly complicated and utterly silly," says screenwriter and co-director Jared Bush, "and ultimately the story shifted enough that we had to lose that plot. But the sheep still needed a place to live."

Hopps and Nick do briefly encounter the Meadowlands when they discover Cliffside Asylum, where Mayor Lionheart quarantines the animals going savage. "It's a creepy old hospital, all by itself on the edge of the Meadowlands," says Matthias Lechner, art director of environments. "It's a dark contrast to the rest of the area around it."

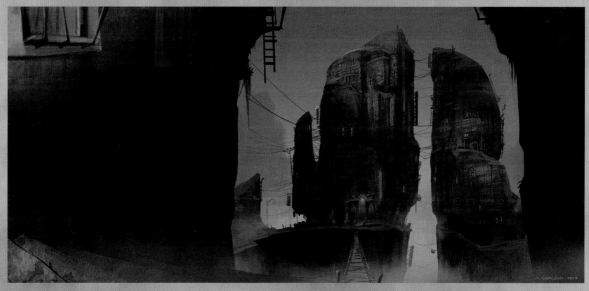

Armand Serrano / digital

Armand Serrano / digital

Cliffside Asylum

Cliffside Asylum is a gloomy, creepy, desolate place. We added rock striations and textures, so it feels like a structure that's partially made out the rocky cliff it's built on.
—Jim Martin, visual development artist

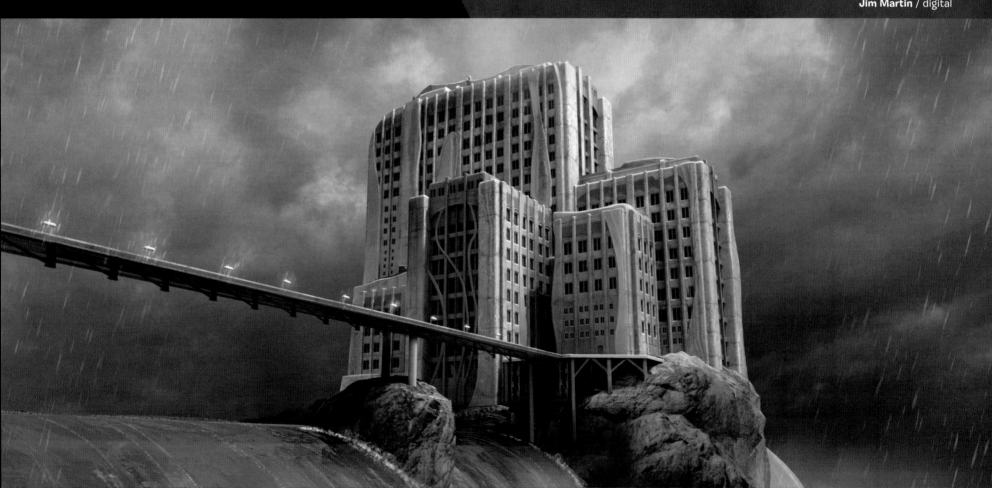

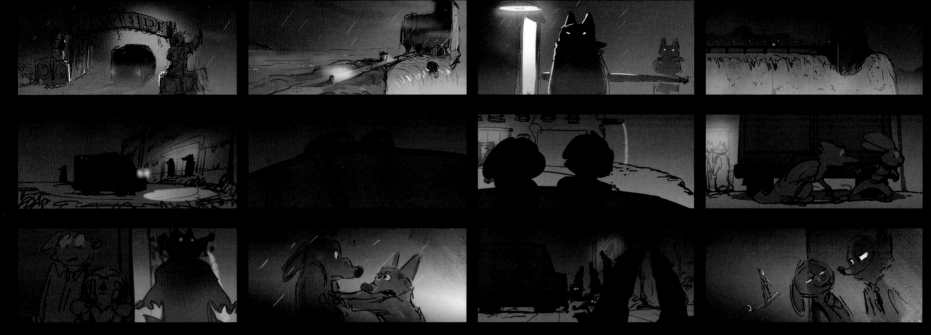

Shiyoon Kim / digital

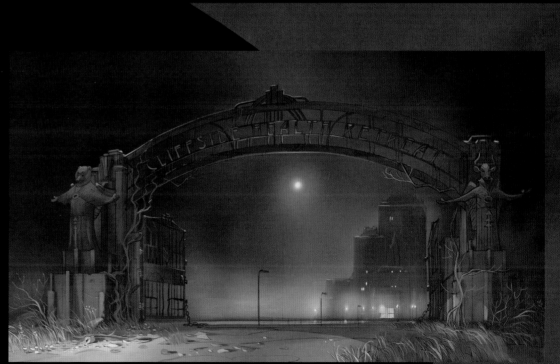

Cory Loftis / digital

129

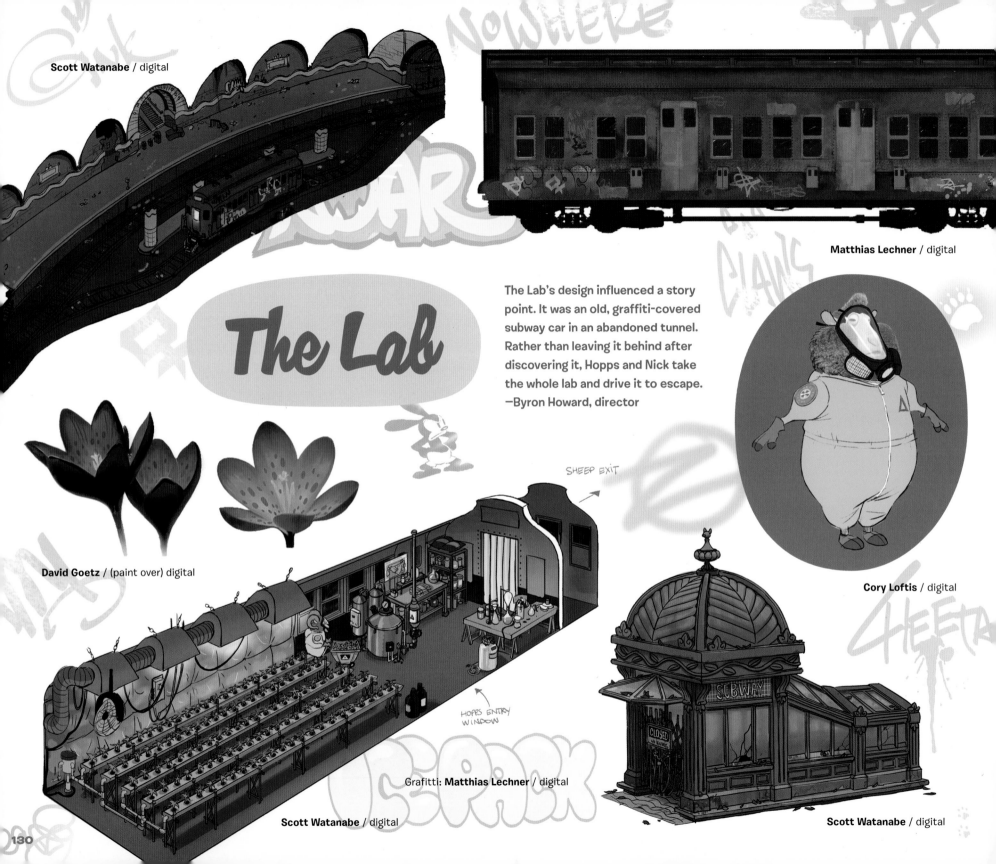

Scott Watanabe / digital

Matthias Lechner / digital

The Lab

The Lab's design influenced a story point. It was an old, graffiti-covered subway car in an abandoned tunnel. Rather than leaving it behind after discovering it, Hopps and Nick take the whole lab and drive it to escape.
—Byron Howard, director

David Goetz / (paint over) digital

SHEEP EXIT

HOPPS ENTRY WINDOW

Cory Loftis / digital

Grafitti: Matthias Lechner / digital

Scott Watanabe / digital

Scott Watanabe / digital

Wooly

Wooly started out as the mayor's henchman, doing the dirty work. At first he seemed to be this bumbling, funny character, always eating paper out of cans. Later you'd find out he was shredding important documents.
—Nick Orsi, visual development artist

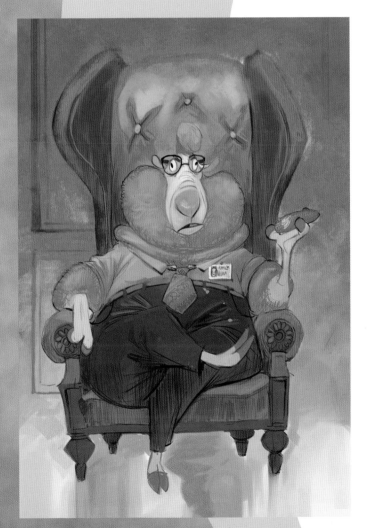

Cory Loftis / digital

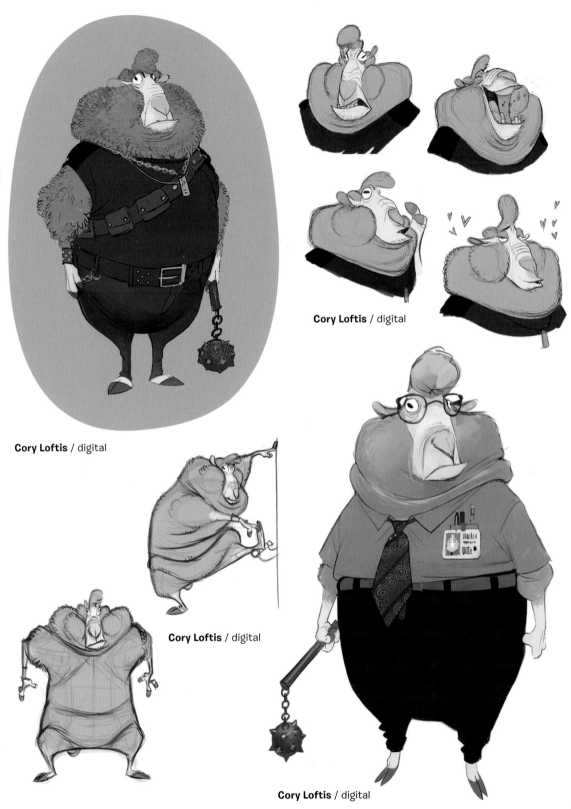

Cory Loftis / digital

Cory Loftis / digital

Cory Loftis / digital

Cory Loftis / digital

Cloven
Hoof

HERd

CLOVEN

THE
HERD

BORN
FERAL

Cory Loftis / digital

Jim Martin / pencil

Cory Loftis / digital

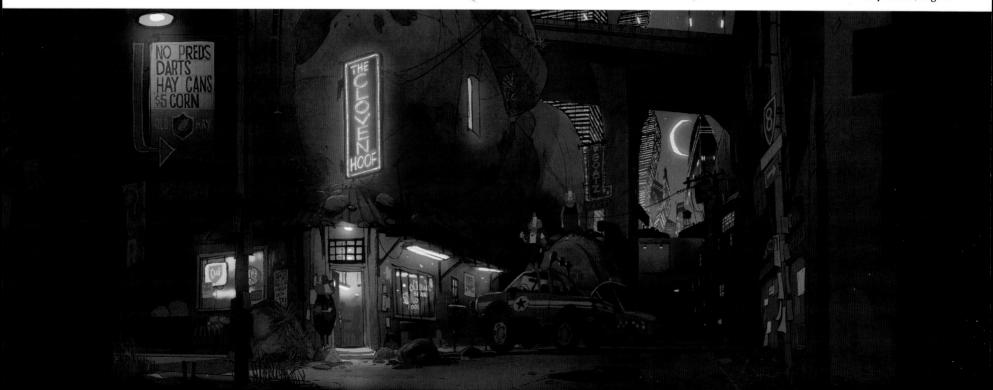

NO PREDS
DARTS
HAY CANS
$5 CORN

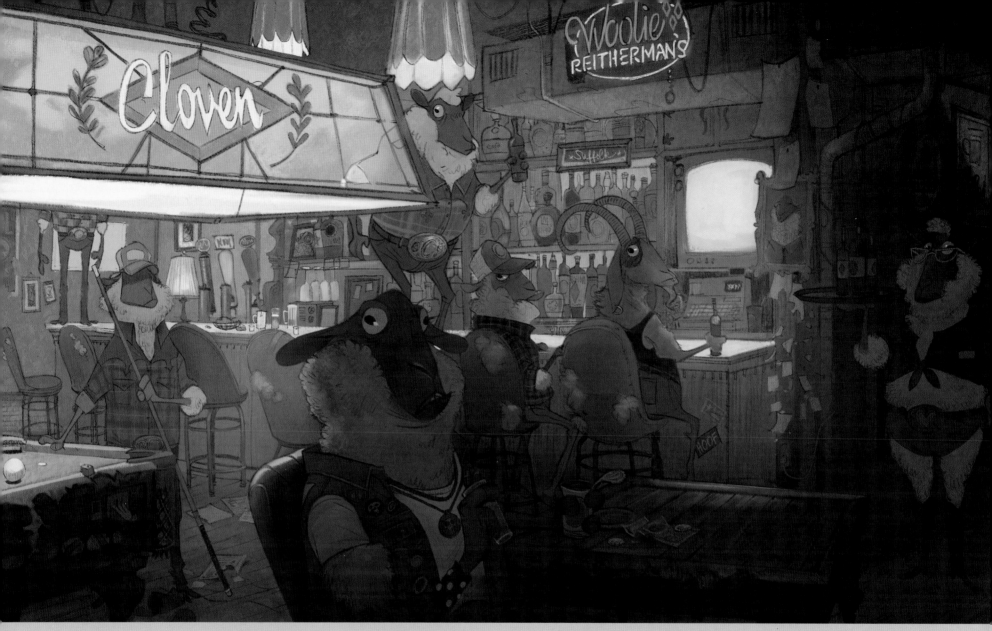

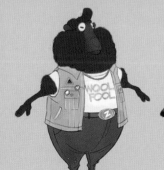

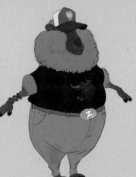

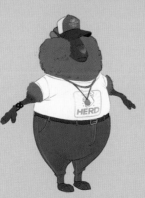

Cory Loftis / digital

The Cloven Hoof was like a biker bar where the sheep hung out, in the seedy part of town. There are so many fun details in it.
—Jared Bush,
 screenwriter and co-director

Cory Loftis / digital

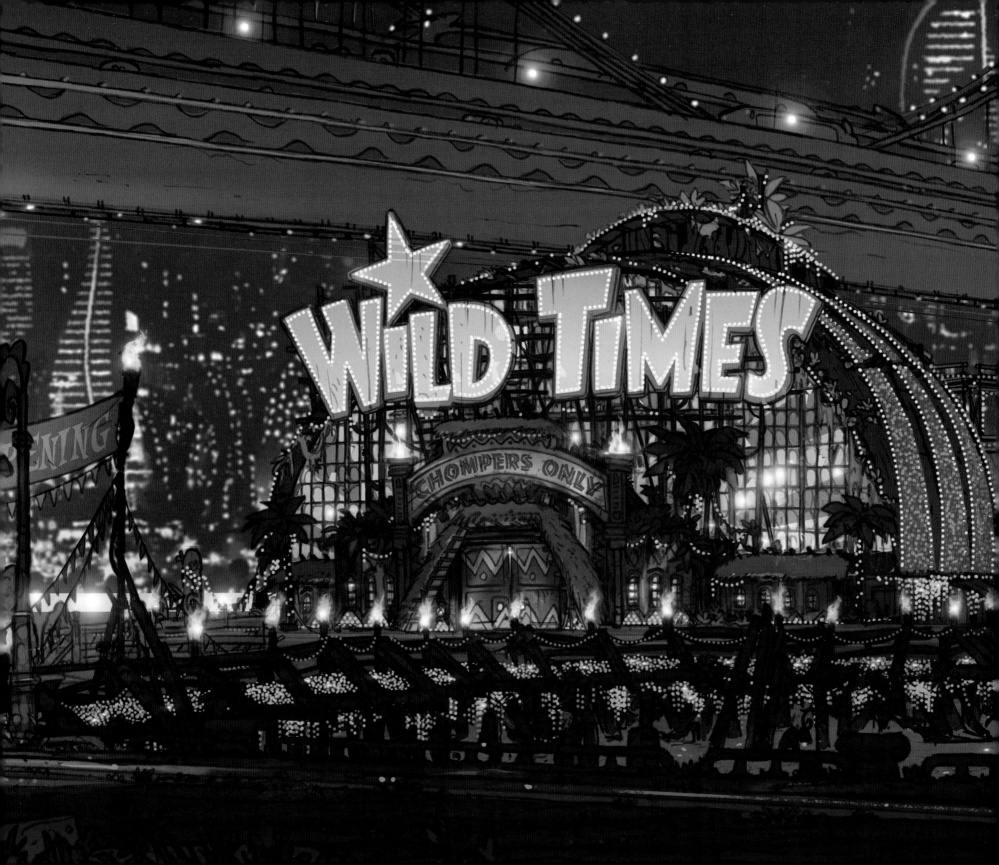

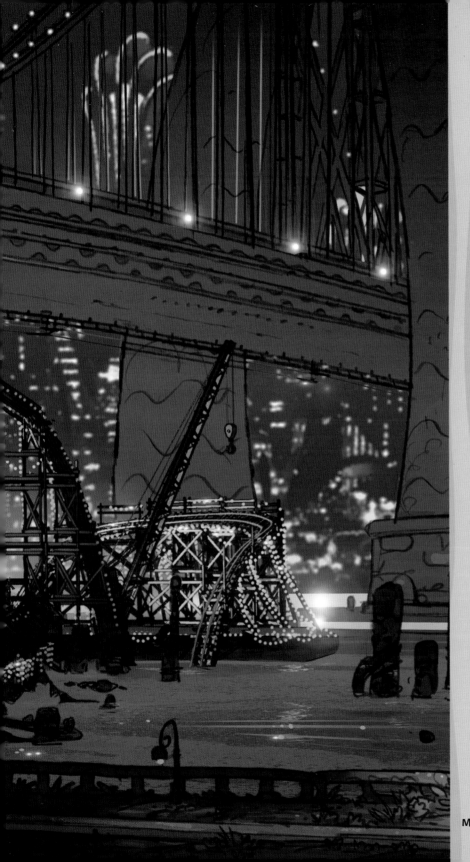

FUN AND GAMES

Two entertainment venues for *Zootopia* were designed but did not make it into the final film—Wild Times and Zootennial Stadium. Both were integral to an earlier version of the story, when predators and prey were sharply divided from the outset. Though the story evolved, the concept inspired one of the filmmakers' favorite unused environments—Wild Times, a clandestine playground refuge for predators, run by Nick. "It was an arcade where predators could indulge their animal natures," says production designer Dave Goetz.

Zootennial Stadium featured in the climax of that earlier version of the film. In an elaborate show meant to demonstrate unity and equality among predators and prey, pop superstar Gazelle, a prey animal, performed fearlessly alongside her tiger backup dancers. Titled *Animalia*, the show conveyed the history and evolution of the film's animals and their universe.

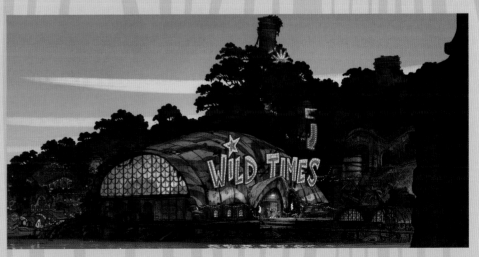

Matthias Lechner / digital

Matthias Lechner / digital

Wild Times

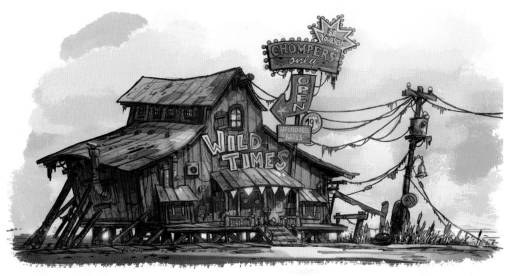

Mac George / digital

Matthias Lechner / digital

Matthias Lechner / digital

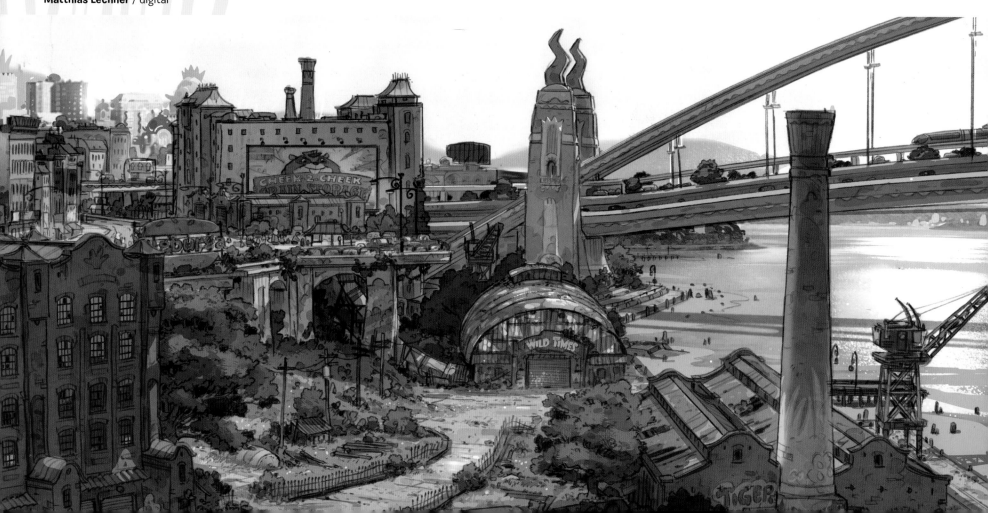

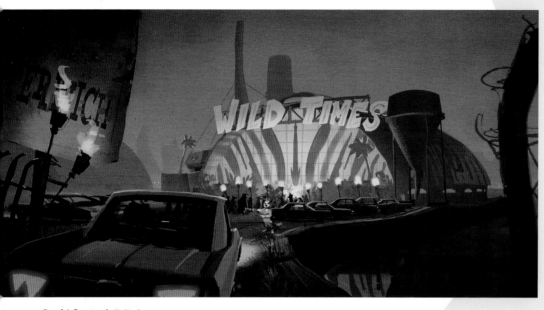

David Goetz / digital

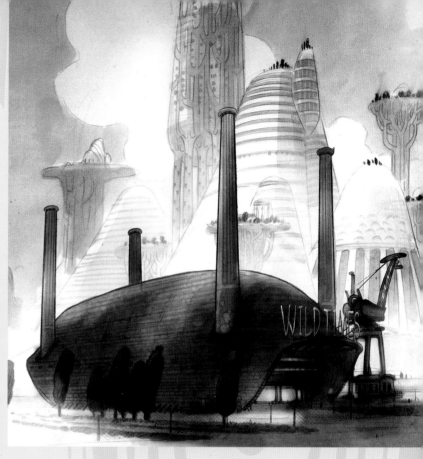

Manu Arenas / pencil and marker

Wild Times was initially decrepit—at one point there was a tree growing through a hole in the roof; later it had a ramshackle blues club feeling with a bunch of materials patched together. At different times it was located under a bridge, or next to an old factory, or behind the front of a doctor's office.
—Dave Goetz, production designer

Dan Cooper / digital

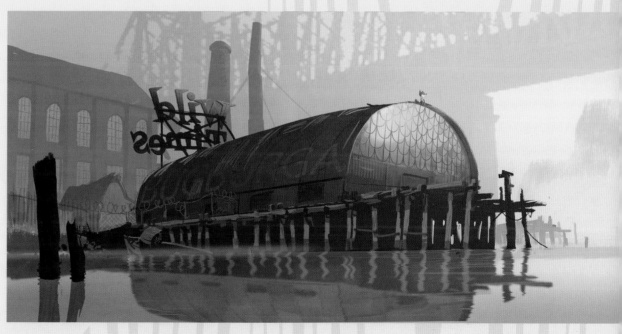

David Goetz / digital

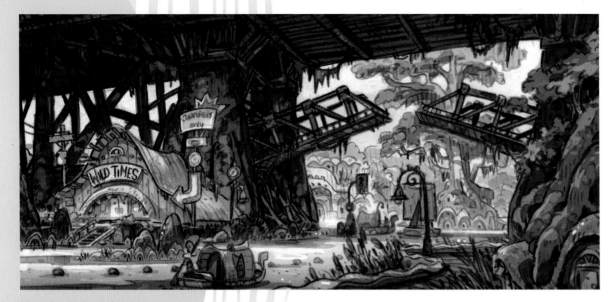

Matthias Lechner / digital

We invented games that predators might enjoy playing. There was laser tag for cats. A Roar-A-Coaster. There was Log Rolling, where a bear balanced on a plank that rotated in the water, causing plastic salmon to shoot up to him to catch.
—Matthias Lechner,
 art director of environments

Matthias Lechner / digital

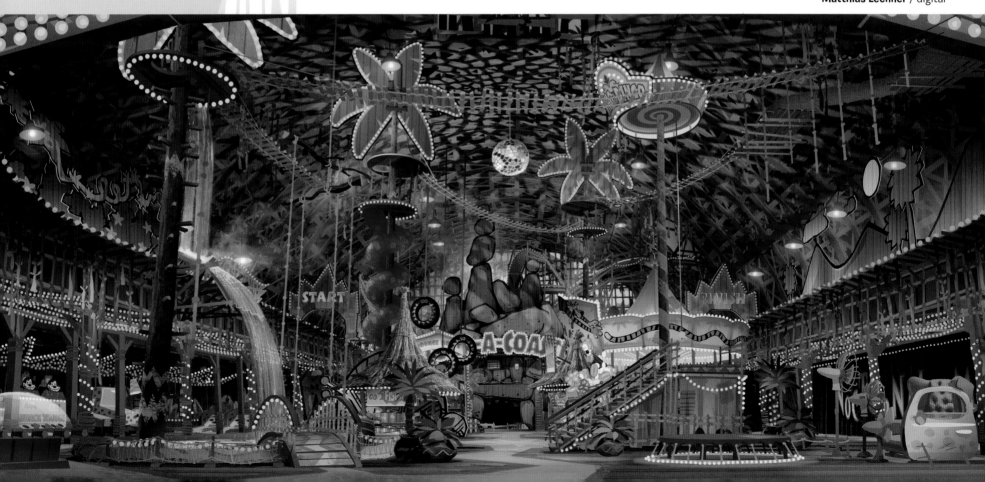

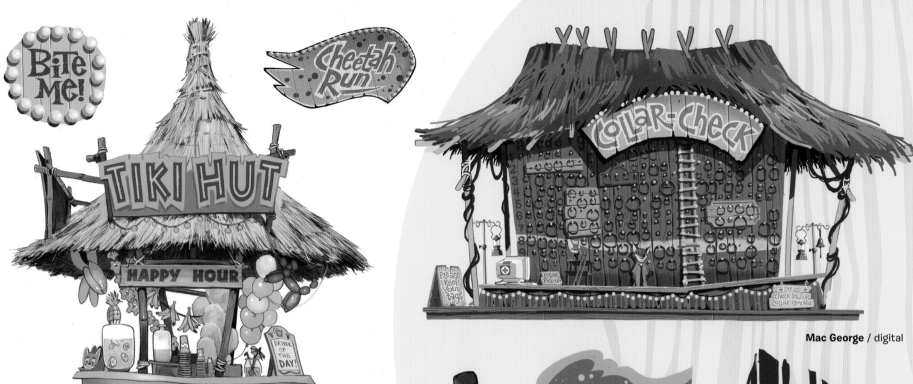

Bite Me!

Cheetah Run

Collar-Check

Please Keep Your tags

Collar Pick-Up

Please check in for Collar Removal

TIKI HUT

HAPPY HOUR

DRINK OF THE DAY!

Mac George / digital

Mac George / digital

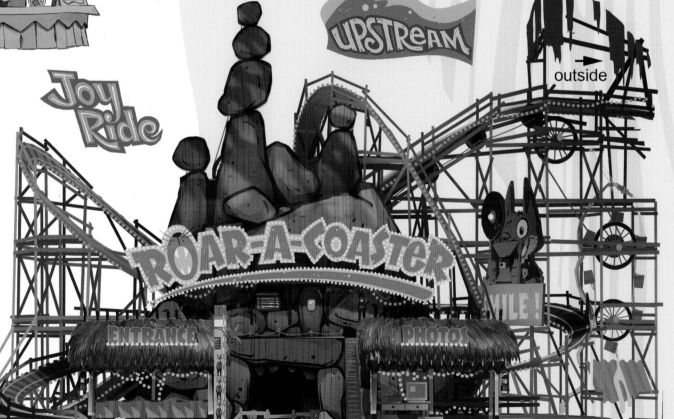

UPSTREAM

outside

Joy Ride

ROAR-A-COASTER

ENTRANCE

PHOTOS

SWINGA DINGO

So You Think You can PRANCE

Signage: **Mac George** / digital

Matthias Lechner / digital

139

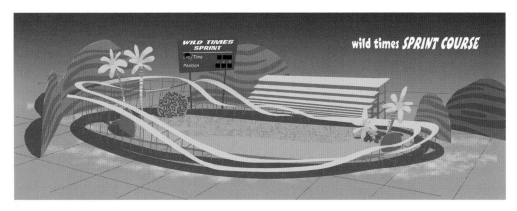

wild times **SPRINT COURSE**

WILD TIMES SPRINT
Lap/Time
Position

David Goetz / digital

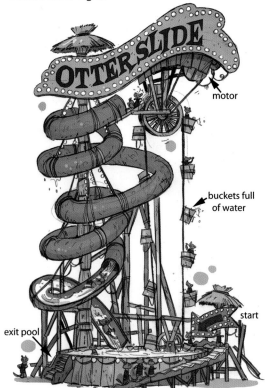

OTTER SLIDE

← motor

← buckets full of water

start →

exit pool →

Matthias Lechner / digital

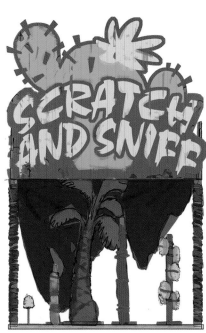

SCRATCH AND SNIFF

Mac George / digital

BUMPER CARS
don't have to be restricted to one area. If they work with pedal power, you can use them all over Wild Times

clothes hanger

← tire-tubing

go cart baloons

Matthias Lechner / digital

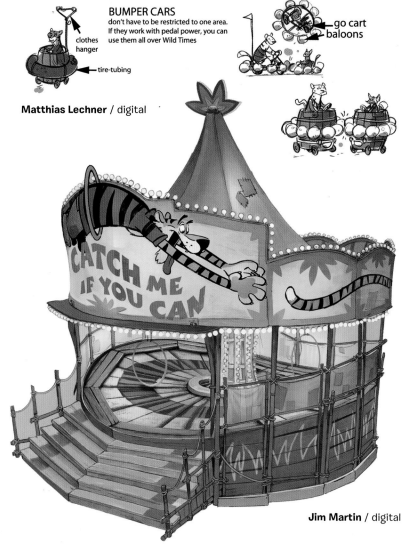

CATCH ME IF YOU CAN

Jim Martin / digital

BALL OF YARN PIT

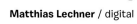

BALL OF YARN PIT

shaped like a basket

jumping board in the middle

BALL OF YARN PIT

stairs →

Matthias Lechner / digital

Matthias Lechner / digital

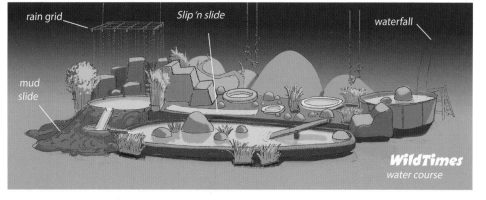

rain grid

Slip 'n slide

waterfall

mud slide

WildTimes
water course

David Goetz / digital

WHACK A MOLE

light →

120 050

WHACK'A'MOLE

Matthias Lechner / digital

BOP-A-BUNNY

Jim Martin / digital

HOWL ALONG

WOOOH / WOOH / WOOOON

WOOOH / WOOH / WOOOON

Matthias Lechner / digital

UPSTREAM

UPSTREAM

moving waterfall backdrop

balancing on log in water while catching plastic fish

net

WATER

Matthias Lechner / digital

MIDDLE LIGHTS INDICATE STRENTH

HAT MOVES UP

BITE ON MOCK-BUGBURGER

wood
soft rubber
wood

MIDDLE LIGHTS INDICATE STRENTH

TAIL MOVES UP WHEN BELL GOES OFF

bugburga

Matthias Lechner / digital

IF TOP IS REACHED LIGHTS BLINK AND BELL RINGS

GEORGE

L WOLF

BADGER

FOX

OTTER

BITE ME!

lights moving to attract players

BURGER AND ARMS CAN BE ADJUSTED FOR HIGHT OF ANIMAL

bugburga

SO U THINK YOU CAN PRANCE

Jim Martin / digital

backlit sign

sign: embroidered on Velcro

incondescent tubes (blue/yellow/red) (on and off alternating)

lightbulbs

painted wood
carpet
protected lights

bucket with guns and glasses

bamboo and rope

red triangle is painted on
red/blue tape

painted wood

Matthias Lechner / digital

JUMP'N'STICK
100
50
10
STICKY FUN

Mac George / digital

VELCRO WALL

JUMP'N'STICK

INFLATABLE BEAR WITH STICKY BIB

VELCRO IS SIMPLY STRETCHED BETWEEN TWO POSTS

Matthias Lechner / digital

Honey Badger

Honey was Nick's friend in an earlier version of the story. Honey badgers are extremely tough, so she was a heavier, stouter character. She was also a conspiracy theorist and a bit nuts. So we put crumbs in her hair, stains on her clothes, made one eye bigger than the other; she's clearly unstable.
—Cory Loftis, art director of characters

FOLLOW THE BLOOD-LINE

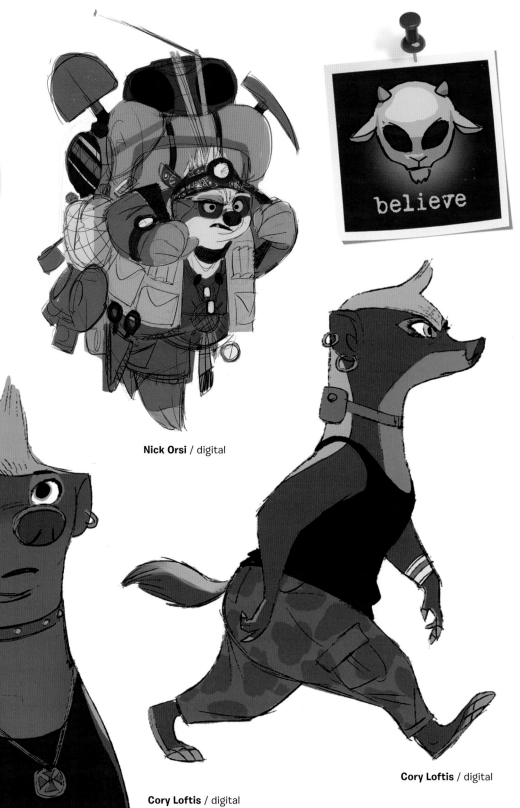

believe

Nick Orsi / digital

Nick Orsi / digital

Cory Loftis / digital

Cory Loftis / digital

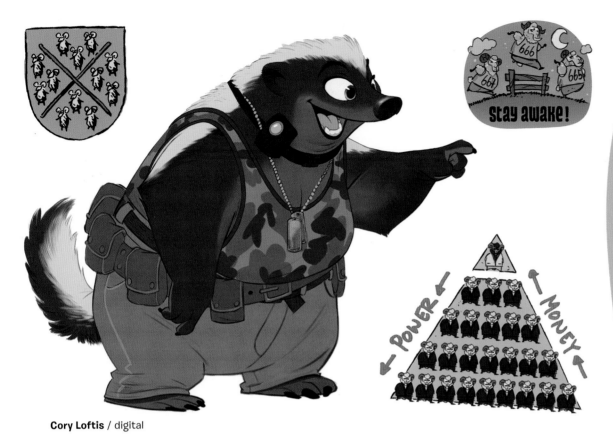

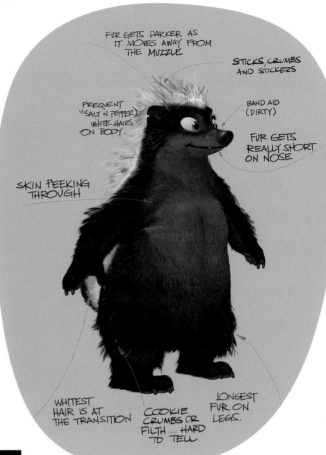

stay awake!

666
667
665½

POWER
MONEY

Cory Loftis / digital

FUR GETS DARKER AS
IT MOVES AWAY FROM
THE MUZZLE

STICKS, CRUMBS
AND STICKERS

FREQUENT
"SALT N PEPPER"
WHITE HAIRS
ON BODY.

BAND AID
(DIRTY)

FUR GETS
REALLY SHORT
ON NOSE

SKIN PEEKING
THROUGH

WHITEST
HAIR IS AT
THE TRANSITION

COOKIE
CRUMBS OR
FILTH ... HARD
TO TELL

LONGEST
FUR ON
LEGS.

Cory Loftis / digital

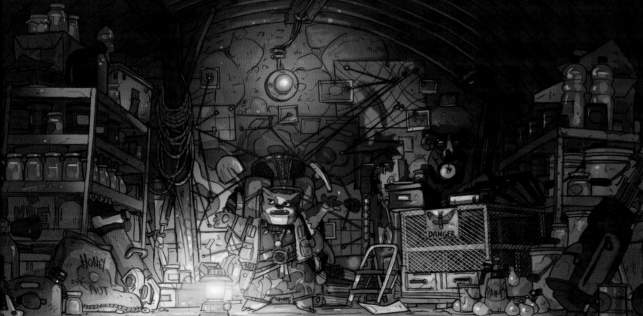

Matthias Lechner / digital

GRAZERS!

Conspiracy Art: **Matthias Lechner** / digital

143

Animalia

The stadium is shaped like a drop of water that bounces back from the bay it's located on.
—Dave Goetz, production designer

David Goetz / digital

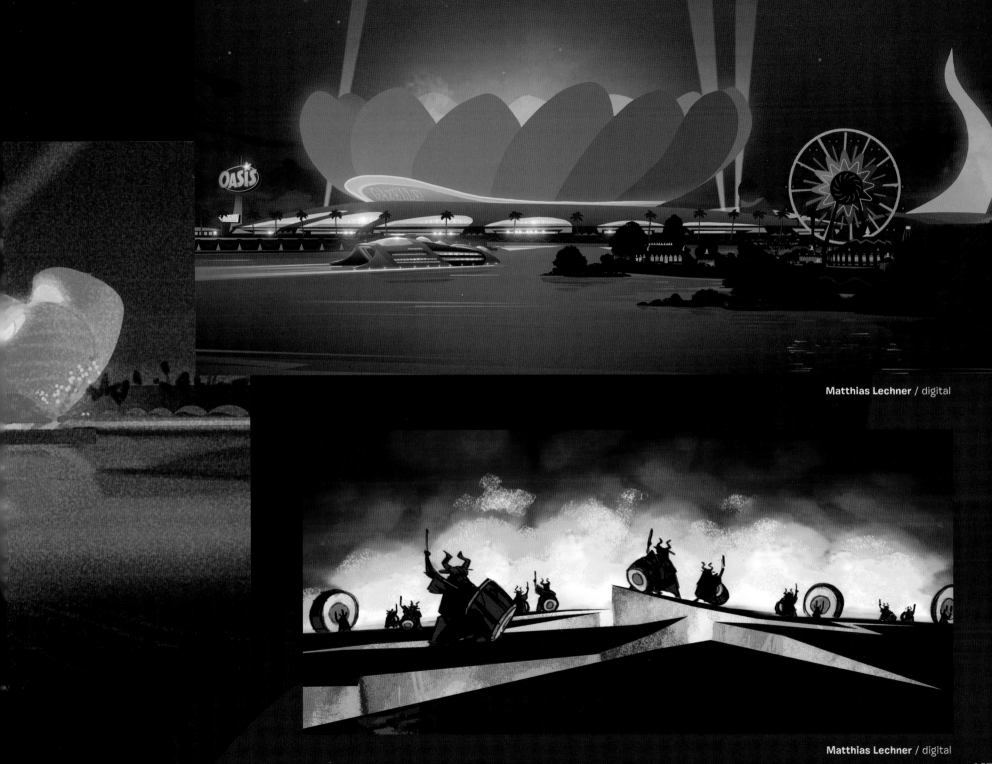

Matthias Lechner / digital

Matthias Lechner / digital

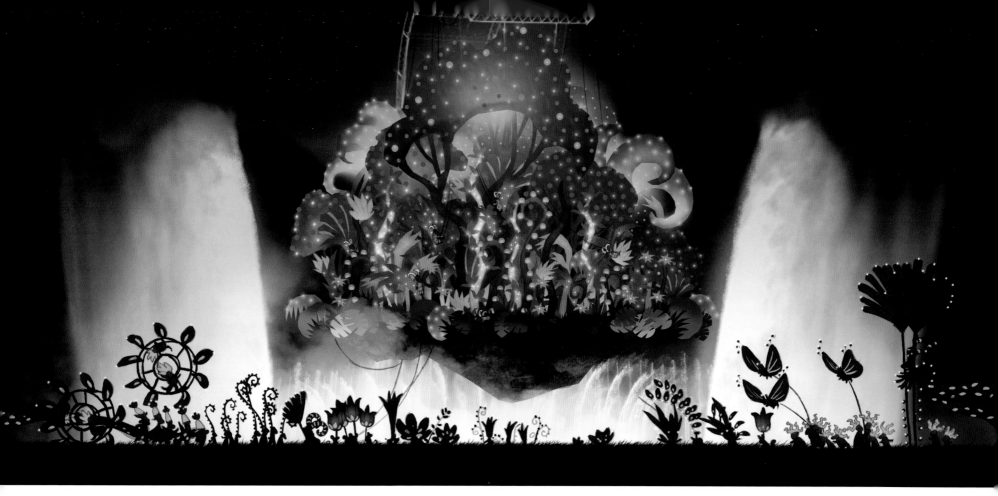

Matthias Lechner / digital

Gazelle's show was an extravaganza. Squirrels were
shot into airstreams and then fell in formation. There
were flying pigs, confetti cannons, and lots of lights.
—Matthias Lechner, art director of environments

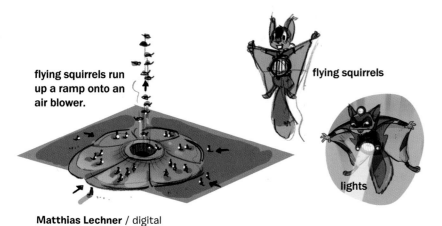

flying squirrels run
up a ramp onto an
air blower.

flying squirrels

lights

Matthias Lechner / digital

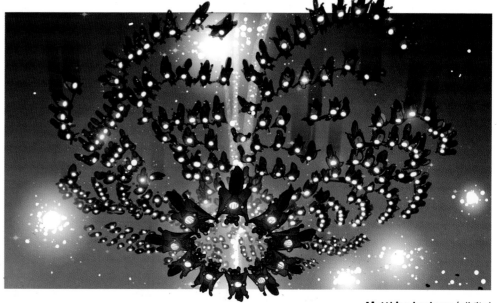

Matthias Lechner / digital

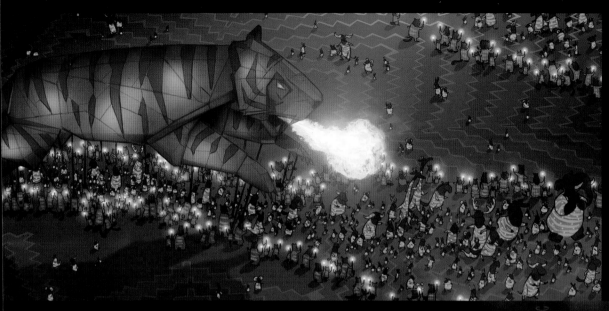

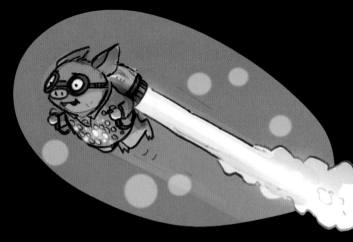

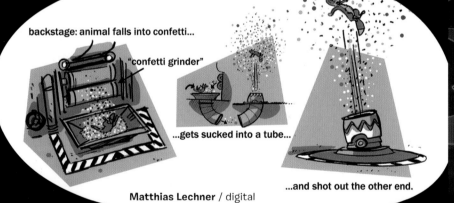

backstage: animal falls into confetti...

"confetti grinder"

...gets sucked into a tube...

...and shot out the other end.

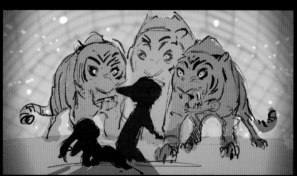

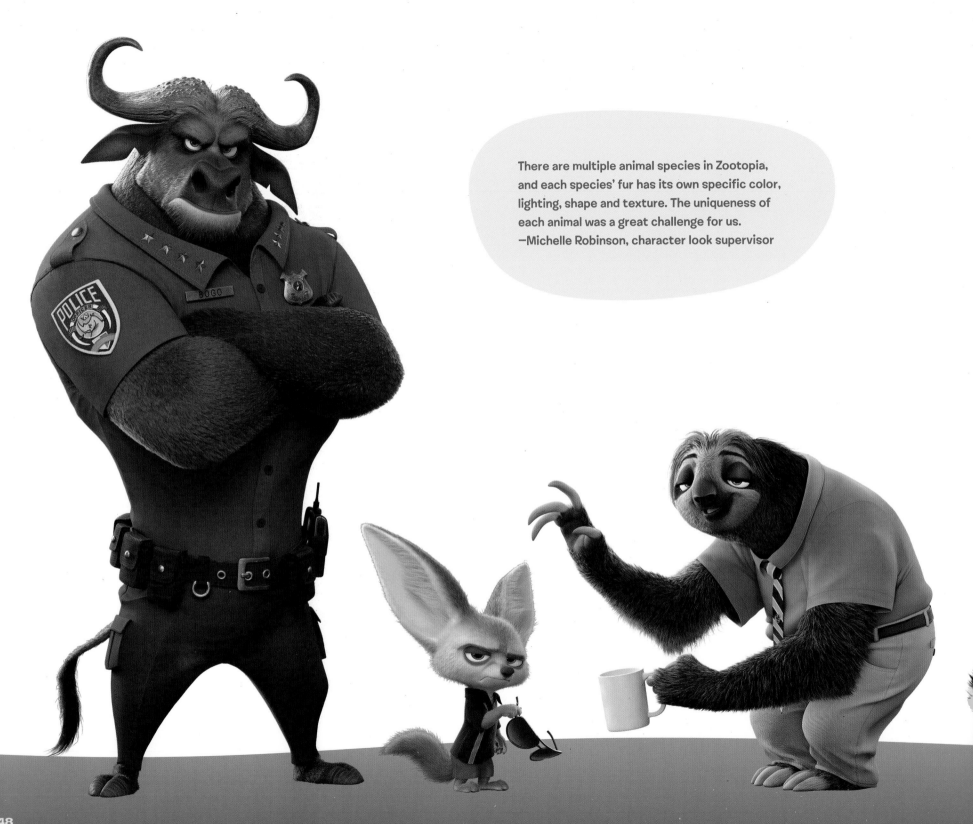

There are multiple animal species in Zootopia, and each species' fur has its own specific color, lighting, shape and texture. The uniqueness of each animal was a great challenge for us.
—Michelle Robinson, character look supervisor

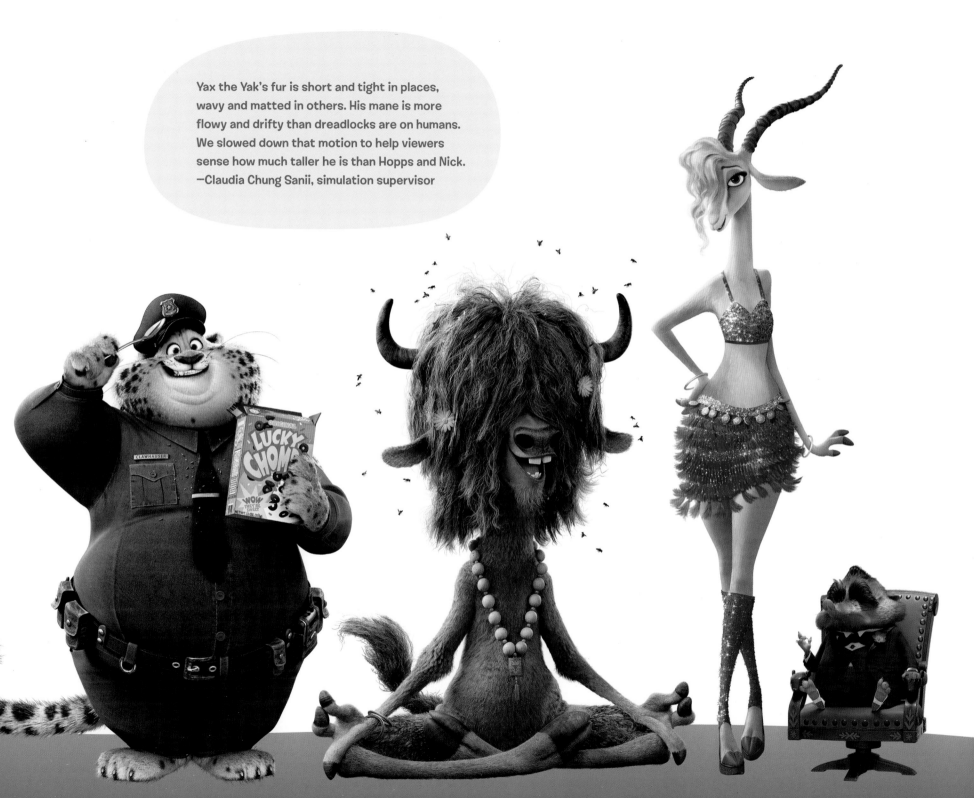

Yax the Yak's fur is short and tight in places, wavy and matted in others. His mane is more flowy and drifty than dreadlocks are on humans. We slowed down that motion to help viewers sense how much taller he is than Hopps and Nick.
—Claudia Chung Sanii, simulation supervisor

FILMING ZOOTOPIA

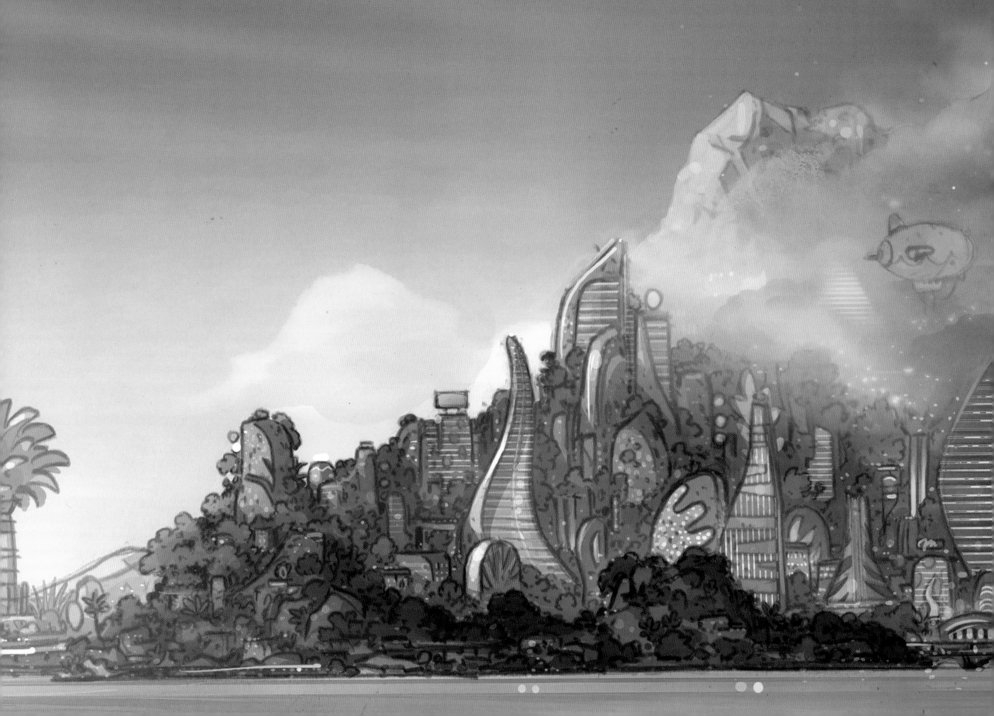

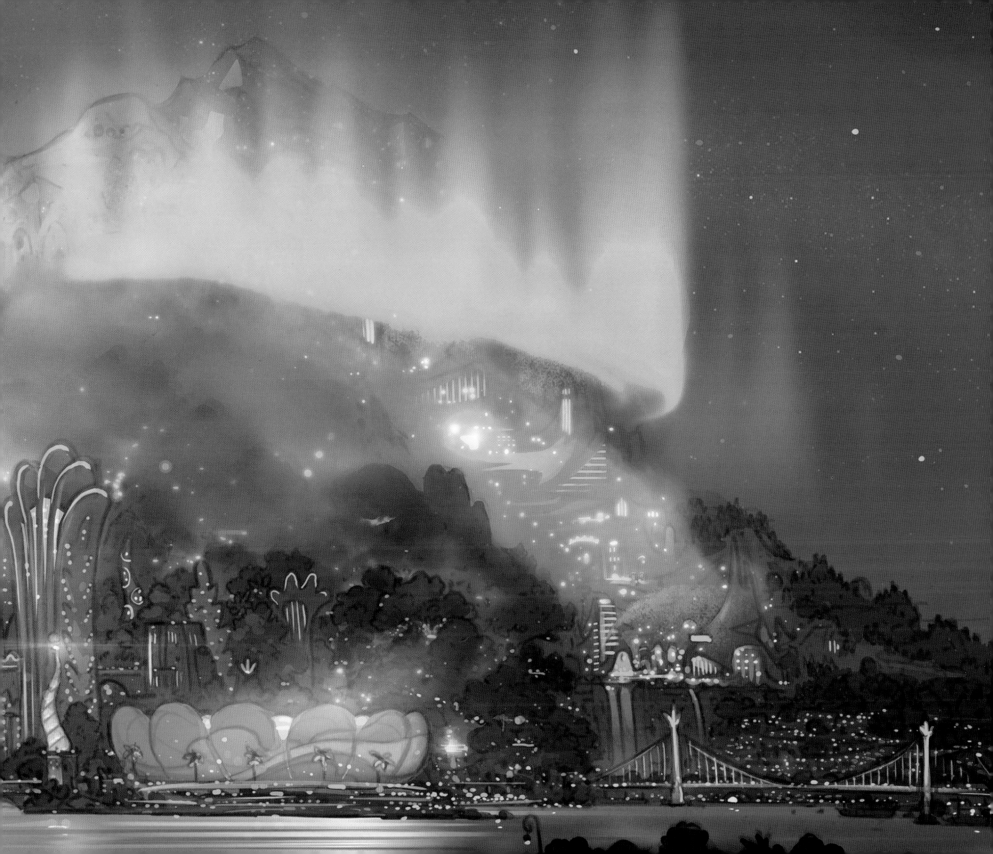

The filmmakers faced several technical challenges during *Zootopia's* production. One of the first and most immediate problems was creating believable fur. "Fur is very different from human hair," says Ernie Petti, the film's technical supervisor. "Its physical structure is different, which affects its movement, its lighting, its grooming.

We had to create brand new tools for the animation, simulation, and look departments to use, just for the fur." In addition, each type of fur—fox versus bunny versus sheep—is completely unique. Decisions about color, texture, and volume had to be made anew for every animal species the team designed. "Each animal is utterly distinct," says Petti. "But they all had to feel as if they belong in Zootopia."

The crew spent more than eight months researching the physical properties of fur to solve this challenge. Among other things, "we went to the Natural History Museum to look at pelts," recalls Michelle Robinson, the character look supervisor. "We examined how the hair changes color from root to tip, and felt the textures of each animal. We observed how fur moves in the wind, and even took photos of its structure at the microscopic level." Each department grounded its work in this research, so the fur behaves as audiences expect it to and light refracts through its fibers in a way that feels true to life. "But we also tweak it away from reality when we want to, since ultimately we're making a stylized film with a specific vision. It's not a documentary," says Robinson.

The interaction between fur and clothes, and the immense variation in body size, presented further challenges on *Zootopia*. "We wanted to retain the scale of real animals, even though in the film they are bipedal and wearing clothes," says simulation supervisor Claudia Chung Sanii. "We had to figure out how to dress characters ranging from enormous elephants to tiny shrews and still make them feel like they're living in the same world." Beyond just attire, however, the animals are also covered in fur, and have layers of muscle and fat beneath the hair. "All of the elements had to interact correctly. Garments aren't sitting directly on skin, as they do on humans. The fur gives the clothes a unique volume and movement."

Cinematography helped solve another inherent challenge of *Zootopia's* all-animal world. With the wide variety of creatures living in diverse habitats, the team had to create and light a unique climate for each area. "We have a rainforest with lots of rain and trees, a desert with heat and dust, an arctic tundra with snow and ice," says Petti. The team consulted a climatologist for insight into generating an accurate sense of atmosphere for each neighborhood. "We were interested in what makes a place feel like it does," says Brian Leach, director of cinematography, lighting. "The most influential element is the presence of particulate, such as dust or water vapor, in the air. The more particulate, the more atmosphere you perceive, almost like a haze. We tried to capture that in the lighting."

Nathan Warner, director of cinematography, layout, wanted to push the camera language as well. "In animation, the camera is always perfectly exposed and moves smoothly. But in live-action, the camera operator sometimes makes mistakes," he says. *Zootopia* was the ideal film to employ a less-than-perfect technique. "[Director] Byron [Howard] described a looser style, more National Geographic-like. *Zootopia* should feel like there is a cameraman behind the camera, trying to track the action." The team also experimented with different camera lenses. "We based it off a 35mm camera like you might have at home. We played with distortion and depth of field. We tried to make the onscreen action feel as real as possible."

Layout and lighting worked in parallel to achieve the best results for both departments. "The goal was to make a beautiful-looking film, while challenging and pushing the boundaries of an animated film," says Leach. Warner agrees. "Hopefully audiences will perceive cinematography that is different than a typical animated film," he reflects. "But it's more important that it feel natural onscreen and becomes another tool in the storytelling."

> Dust gets kicked up from all the daily activity, which is partly why there are warmer colors at sunset than at sunrise. Arctic poles are so cold that any water vapor in the air freezes, creating an effect like diamond dust—sparkling bits of sunlight refracting through ice crystals in air.
> —Brian Leach, director of cinematography, lighting

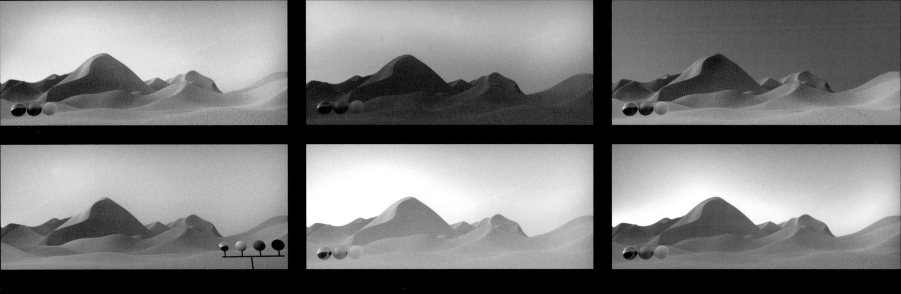

TUNDRA CLIMATE ENVIRONMENT LIGHT TEST

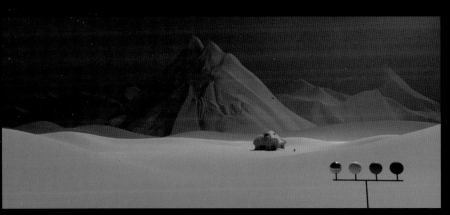

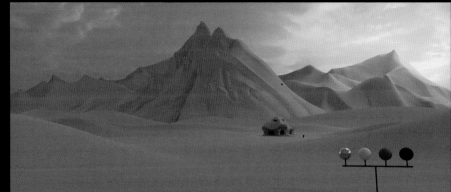

Gina Lawes / digital

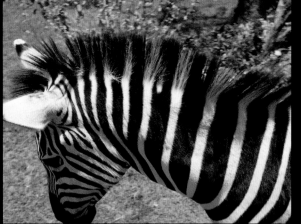

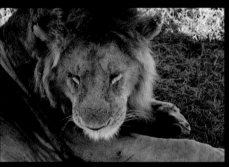
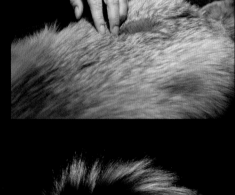
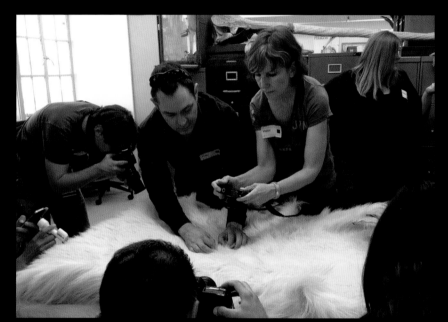

Every type of fur is different. Polar bear fur looks like fiberglass; it's nearly transparent and has a little sparkle. But honey badger fur is really coarse, wiry, and stiff. Bunnies have thinner hair and more of it, which gives it that softer feel.
—Michelle Robinson, character look supervisor

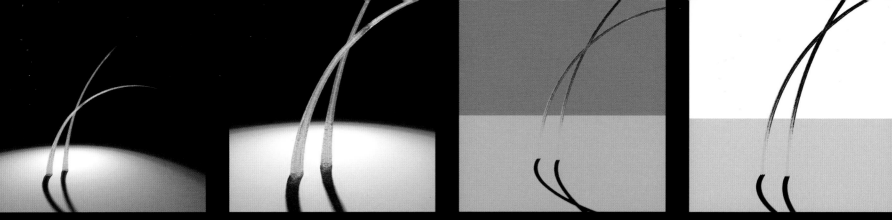

Computer-generated animals can look like taxidermy if you don't imbue their fur with enough warmth. We allow skin to show through the fur in places, like around mouths and the interior of ears, to get a sense of blood running through their veins.
—Cory Loftis, art director of characters

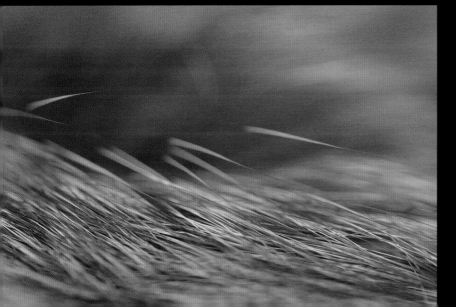

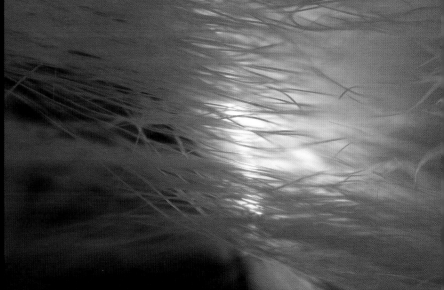

Color Script

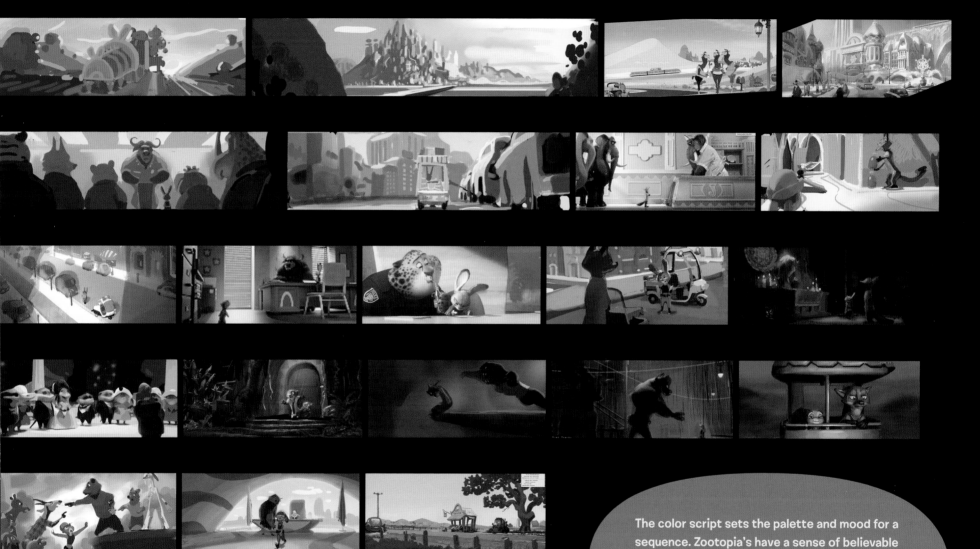

The color script sets the palette and mood for a sequence. Zootopia's have a sense of believable outdoor light and appealing environmental clues. Keys for Sahara Square have strong sunlight and heat. The Rainforest District is damp and dark. Tundratown is all cool colors.
—Dan Cooper, associate production designer

David Goetz, Dan Cooper / digital

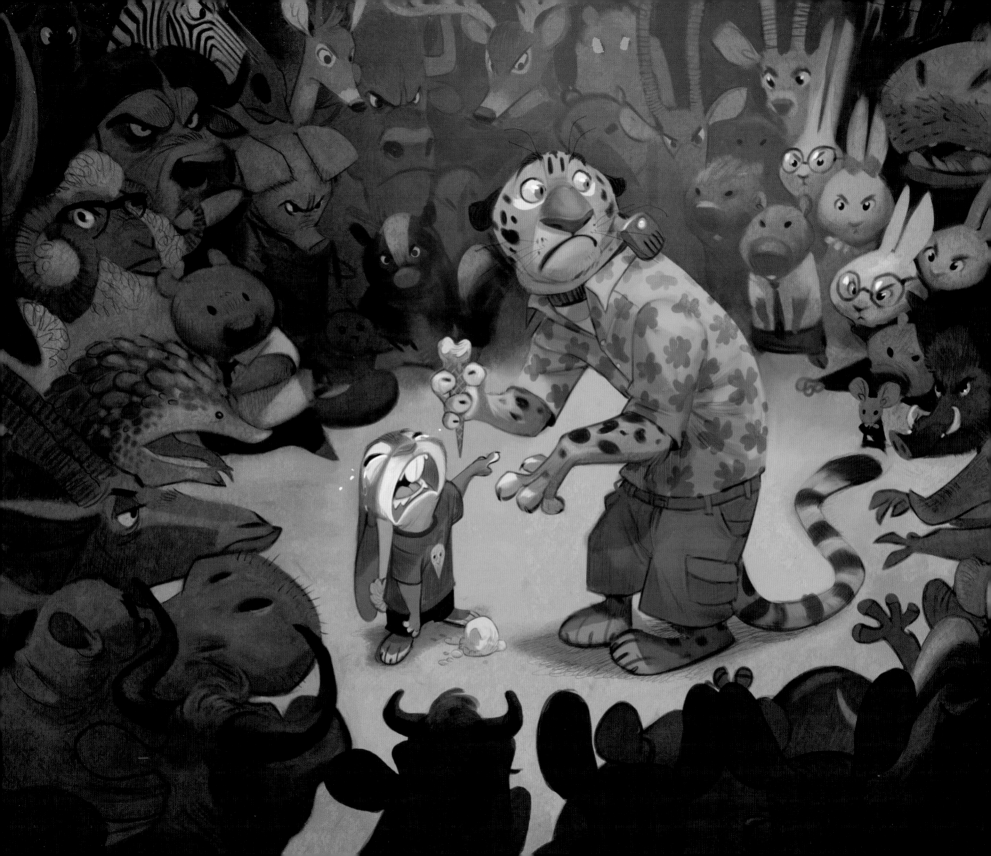

ACKNOWLEDGMENTS

The hard work that goes into creating a Disney animated feature film is surpassed only by the love that imbues every moment in its journey of creation. I am deeply grateful to Clark Spencer, Byron Howard, Jared Bush, and Rich Moore for trusting me to recount part of *Zootopia's* journey.

I am sincerely indebted to the individual artists who took time from their nonstop schedules to sit and talk with me for this book. I learned so much from each of you, and I hope I've done justice to your deeply thoughtful creative process and amazing talents. Particular thanks to Stevi Carter, Albert Ramirez, Eileen Aguirre, Claire Smith, and the entire *Zootopia* production management team—you are marvels of grace under pressure.

Extra special thanks to Renato Lattanzi, who always calmly keeps things in perspective; my editor, Beth Weber, who improves every draft immeasurably; Glen Nakasako, whose design brought this book to beautiful life; and Scott Hummel, my trusted transcriptionist. I love working with each of you!

To Maggie, Mom, and Shannon: your belief, encouragement, and support inspire me more than I can possibly express. I wouldn't be where I am today without each of you. Thank you, always and forever.
—Jessica Julius

Cory Loftis / digital

Nick Orsi / digital